design FOR INTERACTION

LISA BAGGERMAN

USER FRIENDLY GRAPHICS

print web product environmental

ROCKPORT

design FOR

GLOUCESTER MASSACHUSETTS

ROCKPORT PUBLISHERS

print web product environmental
USER FRIENDLY GRAPHICS ◄◄ LISA BAGGERMAN

INTERACTION

First published in the United
States of America by
Rockport Publishers, Inc.
33 Commercial Street
Gloucester, Massachusetts
01930-5089
Telephone: (978) 282-9590
Facsimile: (978) 283-2742
www.rockpub.com

ISBN 1-56496-652-6

10 9 8 7 6 5 4 3 2 1

Art Direction: Cathy Kelley
Design: Leeann Leftwich
Icon Illustration: Cathy Kelley
Cover Image: Photodisc

Printed in China.

‹ a c k n o w l e d g m e n t s ›

The combined talent inside these covers is truly inspiring—it's an honor to feature such a diverse and gifted group of individuals. A sincere thank you to everyone I interviewed, who all graciously offered their time, creativity, and inspiration, making this book possible. A tip of the hat to my editor, Jack Savage, who helped me along the way with insightful edits and gentle guidance. Lastly, I'm extremely lucky to have many wonderful friends and family who served as cheerleaders during the writing process, boosting the confidence (and often energy-level) of this first-time author. This book is dedicated to them.

—Lisa Baggerman

12

CHAPTER 1

Beyond Point And Click

64

CHAPTER 2

Interpreting Print

‹table of› **CONTENTS**

104

156

"There are only two enterprises that refer to their customers as users and one of them is illegal." Michael Hammer

‹ designing for the ›
USER

SUCCESSFUL USER INTERFACE DESIGN IMPROVES PRODUCTS. IN FACT, IN SOME WAYS THE USER INTERFACE IS THE PRODUCT, ACCORDING TO JAKOB NIELSEN, USER ADVOCATE AND PRINCIPAL OF THE NIELSEN NORMAN GROUP. "IF PEOPLE CAN'T USE A PRODUCT, IT MIGHT AS WELL NOT EXIST," HE OBSERVES. THIS CONCEPT IS ESPECIALLY TRUE IN A WORLD WHERE EVERY MARKETPLACE—FROM BOOKS TO ELECTRONICS—IS HIGHLY COMPETITIVE.

Nowhere is this more true today than on the Internet. With Internet design, the place where the push and pull between user and site is identified as the interface. Although the concept is more obvious in a medium where pointing, clicking, and scrolling determines the dissemination of information, the concept of interface design is applicable to every designed object. Be it the emotional quality a product evokes, the interpretation of a written piece, or the experience of navigating a physical space, interface design plays a major role in any design process. And unless your designs meet the needs of their users, they stand the risk of being misinterpreted, ineffective, or worse, unusable.

For a classic example of user interface design failures, look no further than the blinking 12:00 clock on your family room's VCR. "The running joke with VCRs is that no one can program them," Nielsen says. "Half of the machine's utility goes unused because it's just too difficult to do. The truth is, it's not too difficult to use, it's just not designed like the average user thinks. Statistics show that VCRs are only used for renting videos, very rarely for programming."

In this case, poor user interface design interferes with the usability of this product—if it were designed better, users would be able to use it better. If there were a VCR that effectively solved the problem of communicating more effectively through its user interface, it almost certainly would be a top seller. Since user feedback for products like

VCRs isn't as easy and immediate as it is on the Web, the product design ultimately suffers because designers assume that the user knows how to use the product.

"Manufacturers tend to think that using their products is easy," Nielsen says. "They aren't immediately being penalized for manufacturing bad products. With the VCR, when you take it home is when you discover you don't know what buttons to push. But the store already has your money, so they don't care. To do something about it, you've got to deal with the possibility of taking it back or contacting customer service."

Common Characteristics

There are a couple of standards that identify effective design across the board, regardless of media or discipline. The first consideration is determining who the user is. From here, the design will follow. The design must be as broad or narrow as necessary to accommodate the intended users.

Possibly the most important thing to keep in mind is that there's no recipe that's going to make your design appropriate for all applications and users. Vague, bland design fails by not appealing to anyone, and design whose interface is too honed in on a specific demographic effectively alienates other applications. Simply put, "There's no such thing as good design," says Nielsen. What to do? Simple. Listen to your users and observe them interacting with your design. Instead of designing for the world at large, other designers, or even your client, think ahead to who will actually be using your product and go from there.

Graphic designers have been reared on a variety of formulaic methods and approaches for successful design. Any design magazine or class references design in terms of white space, balance, aesthetic, and message. Although these concepts are crucial to well-designed pieces, it's necessary to make these decisions with one eye to the consumer. But more infrequently, the ideas driving the design revolve around how the piece is designed for and will relate to the user.

It helps to think of any designed piece as an interface, be it a book, shampoo bottle, retail store, or Web site. In order to make a connection with the user, the design's interface must achieve its mission, be it communicating information through the printed word, dispensing a product, projecting an image, or creating a space that's easy to navigate. Changing the focus from the designer's aesthetic to the user's need allows the product to be designed in a way that helps the user succeed. From here, the aesthetic considerations can follow.

Setting Goals

Once you figure out who your users are, it's necessary to determine what they are trying to achieve. Web sites provide a great paradigm for understanding this concept. "What users are trying to achieve is, curiously enough, undervalued by designers," Nielsen says. "Often, a site is designed around what the company and designers want them to do. People come to a Web site for a purpose—if you don't deliver on that purpose, they will leave. You need to fulfill their requirements, meet their needs. If you can't do what they want on a basic level, you'll never get a chance to meet their secondary needs."

It makes sense that the concept of user interface design has been tied so closely with the Internet and multimedia. "Because of the complexity of Web sites, there's more information there," says Nielsen. "The more information you have, the more complex the design becomes. Therefore, it's unheard of to design a complicated site without attention to usability or interface. When it happens, the site crashes and burns."

Most designers outside Web design have not been raised on the same user-based litmus test. Instead, the focus has been on expressing the product itself, the aesthetic of design, or the designer's own vision. In an age where the options are many and the competition is fierce, these designers may find themselves losing business to others who are doing what it takes to meet the needs of the user.

"In the long term, the better design will win," says Nielsen. "Design Darwinism will determine who survives." With Web design, designers get instant feedback, either directly through email, or indirectly, through reduced traffic and sales. Although less immediately obvious than in Web design, interface design is a factor in all other design, and the success of a designed product is largely determined by the way the user interacts with it and vice versa.

Golden Rules Of Interface Design

Interface expert Nielsen identifies five usability attributes designers should heed when creating a design interface, no matter what their medium.

1. EASE OF LEARNING

"Ease of learning is the first consideration," says Nielsen. From the first time a user interfaces with a designed product, its use should be intuitive and simple. When applied to Web sites, this concept means that the user is able to navigate the links well, always stays oriented within the site, and is able to easily access the information. When considering the interface of a magazine, this means providing users with a table of contents that effectively previews the content and uses typefaces that are easy to read, yet work in tandem with the design to convey the spirit of the copy and publication. With a product like a computer, it means not requiring the user to spend hours with a manual figuring out how it works. Users don't want to spend their time learning how to use a product—it's the designers' job to make the process intuitive.

2. EFFICIENCY OF USE.

"Once a user learns how to use something, the next time they return to it, they should be able to zip right though it," Nielsen says. Don't clutter the interface with too many extraneous options that serve more to confuse than clarify the process. With any successful interface, there should really be one efficient method of doing things, making the process easy and intuitive, and as clear as possible.

3. MEMORABILITY

Again picking on the beleaguered VCR, users shouldn't have to go through a complicated process each time they want to tape a show. Just because a user got it right once doesn't mean that she's going to have the same success the second time, maybe days or weeks later. Instead, the process should be simple and memorable, an intuitive series of steps that users will easily follow the first time as well as the next time, without having to learn the entire process over again.

4. MINIMIZE ERRORS

Create an interface with few user errors and no severe consequences for errors. Although this sounds obvious—after all, who would create a design that encourages users to fail—this tip underscores the need for user testing. Just because a design makes sense to everyone in your design studio doesn't mean that it will make sense to the average user. "People will make mistakes," Nielsen says. "A human being is not perfect. But an interface needs to do everything to prevent user mistakes and, when they do happen, make them easy to recover from. Every time you hear about human error when it comes to design, it is really a designer error."

5. SATISFY THE USER

"It's more of a frivolous quality, but it's important for any designer to consider during the design process," Nielsen says. "You want people to like what they're doing. With the example of the Web, it's a very voluntary activity—no one's forcing you to use it. There are so many different sites users can go to. Why should they stay at a site that's awkward or hard to use?" This is where the more ethereal qualities of interface design come into play, no matter what the medium. Although it's impossible to please everyone all of the time, it's important to use an interface's design to simply empower the user to get from the product what they need, while reflecting the image or spirit that the product supports.

Conventional design has a lot to learn from Web design, but the Web can also learn from other media. For instance, in most cases, it's not wise to strictly choreograph the user's experience through the site. "The Web is an environment where users can compose their own story," Nielsen says. "This is where sites can learn from urban design, theme parks or other environments where people can move around and construct their own experience. With an interface, the designer is establishing a foundation for user experience. One of the challenges is giving up that control. Designers think they know best. Although it shouldn't be a complete free-for-all, design shouldn't be a completely controlled environment, either."

Interface Design's Deadly Sin

An infinite number of qualities exist that will cause users
to fail to connect with a product from a design perspective;
however, there is one that Nielsen considers to be user
interface design's most lethal. "The main deadly sin designers
step into is designing for themselves," Nielsen says. "The
belief that 'If I like it, others will like it' or 'If I can use it
others will be able to, too' is the wrong approach."

The truth is that designers are almost always markedly
different from the users of their products. A Web interface will
naturally seem intuitive to the person who designed it. But
the real test is when you put typical users together to the
same task. This analogy can be applied to any designed
object—it is necessary to step aside from the design itself
and look at it as a functional object.

This admonition also cautions against overdesigning. More
often than not, a complicated design is created for its
aesthetic qualities. But when design takes over a project,
the interface becomes cluttered and confusing. When it
comes to interface design, less is more: It's best to keep
the design independent of any superfluous elements, keeping
the focus on function. Simply put, all design elements
should serve a purpose.

When In Doubt...

With all of these weighty considerations during the design
process, there is one simple thing you can do to make sure
you're on track—user testing. "Get a set of representative
users to do a series of representative tasks," Nielsen says.
"Observe what they do, see how fast they do it, see if they
like it, listen to their comments while using it."

But before you call a focus group, see if it would work with
the product you're testing. "One of the biggest mistakes in
the computer field is using focus groups," Nielsen says.
"Sitting around a table discussing something isn't interactive.
It's the experience of the user that counts."

Remember what software engineer and user interface author
Lowell Jay Arthur said, "The least flexible component of any
system is the user."

</intro>

We have the Internet to thank for turning the attention back to the user when it comes to any design discipline. As a relatively new medium, Web designers learn quickly when a particular Web interface doesn't work for the user. If designers are lucky, users voice their discontent directly through email; alternatively, discontented users simply stop using the site, resulting in lost sales and overall business. There is simply too much competition on the Web—if a user can't make sense of an interface, they'll find somewhere else where they can.

This chapter discusses the concept of interface design from its patron discipline: Web design. The popularity of the Web has produced millions of Web sites—but how many of those will survive over the next 10 years is another story. The survivors will have learned what it takes to service a customer, whether they are selling a product, a service, or just themselves.

The firms featured in this chapter are diverse, but are united by their fervent attention to how users interact with their site. Each featured firm or site has a lesson to

▶▶

‹ b e y o n d › **POINT & CLICK**

<web>

print product enviromental

share. For instance, Yahoo! proves that you don't need extravagant bells and whistles to become the Web's most popular destination. Boasting a streamlined interface that's accessible to virtually anyone with a computer (no matter how dated) and a Web connection (no matter how slow), Yahoo!'s interface is designed to allow users to spend their time finding the information they're looking for, not waiting for sizable images to download. Yahoo!'s interface also extols the virtues of making every pixel count, by being a site where almost anything you find is a hotlink to more information—a successful example of organizing a mountain of information in one space.

When it comes to setting the standard for Web design, Hotwired has been doing it since the Internet's stone ages (way back in 1994). Although the design is progressive and easy on user's systems, the best lesson Hotwired teaches designers is how to grow on the Web without outgrowing your site. What started out as a singular Web magazine—an online representation of Wired Digital—has subsequently grown into seven drastically different auxiliary sites. Hotwired's interface effectively brands these different sites, while promoting them individually and organizing them attractively in one handy site. Acting as a portal to the different Wired Digital auxiliary sites, Hotwired introduces users to a variety of different sites and does so within a hip, branded interface.

Many designers already know that the Web is a great way to show off their portfolio. Potential clients can research the firm, sample past work, and get a taste for the company aesthetic all in one place. Like the rest of the Web, competition for the online presence of different design Web sites is getting crowded—to truly stand out and show off, it's necessary to try something different. London's Itch used a completely innovative approach when designing its site's promotional interface by designing it in Macromedia Flash and allowing visitors to browse the site not by scrolling through static links, but by using their mouse to travel the physical space, which is laid out like a map. Information on the firm is found by clicking on icons and visitors need not drill down more than one level to find information. The interface is vastly different from the structure of

other sites, giving the user a distinct feel for Itch's personal style while keeping them oriented to where they are in the site.

Allowing the user to craft a personal experience is essential to a successful interface design. Instead of pre-scripting the user's experience, the designers of Plumb Design's Visual Thesaurus left the structure of the site and the user experience completely up to the visitor. To access an online thesaurus, the user simply types a word into the search field—how the word appears onscreen and the pattern that follows is completely up to the user. He determines whether the words appear in two or three dimensions, can drag words along on the screen, and search for new words at any time.

Lastly, the value of the Web is not lost on the large corporation. Although Turbonium.com doesn't sell Volkswagen's New Turbo Beetles through their site, the Web destination is an extremely important marketing tool. Volkswagen kept the Web design consistent with the streamlined design of their successful print and TV campaign. Another quality that makes Turbonium.com a success is that its interface wasn't designed as a dumping ground for mountains of information about the cars—instead, the information they chose to include is nicely organized, succinct, and friendly.

All of these qualities lead the way for successful Web interface design. Although every site featured here is drastically different in users (from Yahoo!'s Everyman approach to Itch's potential clients), the philosophy is the same—if you give users what they want, they will come back. It's an important lesson any designer can learn from the Internet.

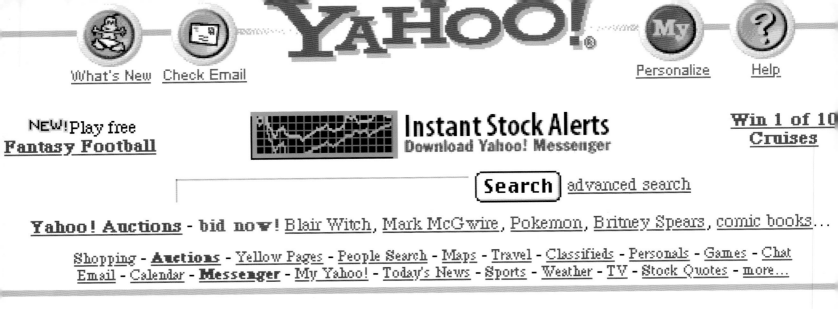

YAHOO!

What's New Check Email Personalize Help

NEW! Play free
Fantasy Football

Instant Stock Alerts
Download Yahoo! Messenger

Win 1 of 10
Cruises

[Search] advanced search

Yahoo! Auctions - bid now! Blair Witch, Mark McGwire, Pokemon, Britney Spears, comic books...

Shopping - **Auctions** - Yellow Pages - People Search - Maps - Travel - Classifieds - Personals - Games - Chat
Email - Calendar - **Messenger** - My Yahoo! - Today's News - Sports - Weather - TV - Stock Quotes - more...

Arts & Humanities
Literature, Photography...

Business & Economy
Companies, Finance, Jobs...

Computers & Internet
Internet, WWW, Software, Games...

Education
College and University, K-12...

Entertainment
Cool Links, Movies, Humor, Music...

Government
Elections, Military, Law, Taxes...

Health
Medicine, Diseases, Drugs, Fitness...

News & Media
Full Coverage, Newspapers, TV...

Recreation & Sports
Sports, Travel, Autos, Outdoors...

Reference
Libraries, Dictionaries, Quotations...

Regional
Countries, Regions, US States...

Science
Animals, Astronomy, Engineering...

Social Science
Archaeology, Economics, Languages...

Society & Culture
People, Environment, Religion...

In the News
- Turkey earthquake relief efforts
- Gates donates $5 billion
- Furor rising over PC wiretap plan

more...

Marketplace
- Loan Center - auto loans, mortgages, credit reports
- Yahoo! Visa - instant credit

more...

Inside Yahoo!
- Y! Messenger - instant messaging
- Y! Greetings - free greeting cards
- Y! Clubs - create your own

more...

World Yahoo!s *Europe* : Denmark - France - Germany - Italy - Norway - Spain - Sweden - UK & Ireland
Pacific Rim : Asia - Australia & NZ - Chinese - HK - Japan - Korea - Singapore - Taiwan
Americas : **Brazil** - Canada - Spanish

Yahoo! Get Local LA - NYC - SF Bay - Chicago - more...

[Enter Zip Code]

Other Guides Autos - Careers - Entertainment - **Health** - Local Events - Net Events - Message Boards
Movies - Music - Real Estate - Small Business - Y! Internet Life - Yahooligans!

Yahoo! prefers **VISA**

How to Suggest a Site - Company Info - Privacy Policy - Terms of Service - Contributors - Openings at Yahoo!

OPPOSITE: The most crucial interface issue with the Yahoo! site was finding a way to organize a wide range of information in a fixed screen size. Yahoo! met this challenge by linking virtually everything on its home page. The page effectively organizes, by category, all the information provided at the site, identifying subcategories by running them in a smaller font size beneath the parent section. The interface also offers users options for conducting their search—users can search by keyword in the search field or click through by category. The use of traditional text and link colors against the browser default background ensures that the page will download quickly and that its design won't discriminate against older browsers or platforms.

‹ INTERNET DIRECTORY SERVICE: YAHOO!›

AESTHETICALLY SPEAKING, THE SITE FOR THE DIRECTORY SERVICE, YAHOO! IS PLAIN. THE BACKGROUND IS A NONDESCRIPT LIGHT GRAY, AND THE LINKS AND TEXT ARE RENDERED SIMPLY IN THE BROWSER DEFAULT. YET, THE USERS HAVE SPOKEN: WITH ITS NO-FRILLS APPROACH, THE YAHOO! SITE RANKS NUMBER-ONE IN TRAFFIC ON THE WEB (AT PRESS TIME), DEFINITIVELY PROVING THAT EASE OF USE AND EFFICIENT DELIVERY OF INFORMATION OUTWEIGH THE VISITOR'S APPETITE FOR COMPLEX DESIGN. FOR ITS AUDIENCE, YAHOO!'S DESIGN IS RIGHT ON TARGET—JUST ASK THE MILLIONS OF USERS WHO VISIT EACH DAY.

Design For The Masses

When your audience is literally the whole wide world, you want to make sure that your interface alienates no one and delivers the information it promises. Yahoo! is precisely what it should be—an Internet directory service that provides a valuable service for its visitors by delivering the information they seek—quickly. "We recognized early on that if we didn't service our users, we wouldn't be a success," says David Shen, Yahoo!'s Director of Design. "We made sure to stay away from large images and technology that would slow our pages down."

When designers create pages that require the visitor to scroll to read all the information, they take the risk that the visitor won't do it. Successful interface design delivers the crucial information immediately upon the visitor's arrival, and delivers it up front in one compact package. This is an especially important consideration for the interface of a site's home page—designers want to make sure users absorb all the important information before deciding to move on. Subsequently, the Yahoo! home page is designed so it would fit—without scrolling—on almost any monitor. When Yahoo! first launched in 1995, the 640x480 resolution was the most common monitor size, so Yahoo! designers used that as the paradigm. With this approach, visitors with smaller monitors are not penalized for their computer setup but instead receive a similar experience as their large—monitored counterparts.

What's New... On the Web

What's New : **On the Web | Inside Yahoo!**

Daily Picks

- Day of 6 Billion - it's official -- Earth's crowded. (in Issues and Causes > Overpopulation)

- *Natural History* - the world of nature, from past to present. (in Environment and Nature Magazines)

- Young Survival Coalition - "young women united in the fight against breast cancer." (in Breast Cancer Organizations)

- Hyde Collection Art Museum - Louis and Charlotte Hyde throw an impressive open house. (in Art Museums)

- *Caroline in the City* - self-employed cartoonist makes good. (in TV Shows > Comedies)

Weekly Picks

Today's Top Net Events

(All times are U.S. Eastern Time)

2:00 pm - National Techies Day - have you hugged an engineer lately?
3:00 pm Java Chat at ClickTeeks?

4:00 pm - Fast Fall Cooking - seasonal meals on the run. Java Chat at
5:00 pm Yahoo! Chat

New Additions to Yahoo!

click a day for hierarchical, complete, or split listings of newly added sites

- Monday Oct 4 - 997
- Sunday Oct 3 - 145
- Saturday Oct 2 - 542
- Friday Oct 1 - 1005
- Thursday Sep 30 - 1273
- Wednesday Sep 29 - 1316
- Tuesday Sep 28 - 1439

In the News

- Nuclear Test Ban Treaty Debate
- Federal Reserve Meets
- U.S. Supreme Court Term
- AMD Unveils 700mhz Chip
- McGwire Wins Home Run Race

more

ABOVE: To ensure return visits, information must be kept fresh, friendly, and geared to the user. "What's New" is consistently featured in the upper left-hand corner of the Yahoo! home page. When you click here, a page with the freshest news on the site, things to look for, and a schedule of timely events is summoned. Here, visitors are also made aware of new additions to the site.

Welcome to **YAHOO! MAIL**℠

I'm a New User

Sign me up!

I'm already registered with Yahoo!

Yahoo! ID:

Password:

☐ Remember my ID & Password (What's this?)

[Sign in]

Trouble signing in?

Get help signing in here.

Want mail? Sign up for Yahoo! Mail. It's free!

- Get your own **Yahoo!** email address.
- It's free. It's easy.
- Access email from anywhere.
- You'll be registered with all of Yahoo!'s services.
- Get instant notification when you have new messages with Yahoo! Messenger

Yahoo! has a wealth of information and resources available to visitors, and the home page's interface design needed to convey this to users. Consequently, site designers were careful to make efficient use of every pixel in the limited space they had. One way this was done was by simply making everything onscreen hyperlinked text. Nearly every word links to more information about that category or topic, organized logically in an outline style. This way, visitors can immediately make targeted choices about the information they seek by diving in by category. "We found during user studies that most users know that an underlined word in blue is clickable," Shen says. "Not everyone knows that images can be hyperlinks. And text is always more direct than using an image, which may not be as clear."

Giving users a variety of options to find the information they seek upon arrival at a Web site is essential to creating an effective interface. These alternatives increase the chance of them finding what they want. A quality not unique to Yahoo!, but absolutely crucial to a successful directory service, is the use of a search box front and center on the page, allowing users to search for information by keyword. When the visitor arrives on the Yahoo! home page, he is immediately greeted with two obvious ways to search for information: by using the search text field or by drilling down through the categories using the hyperlinked categories.

It was crucial to create the site's interface to be navigable and obvious to Web surfers of all skill levels, from the most rudimentary beginner and beyond. With Yahoo!'s search functions, no matter how experienced the visitor is, chances are he will be able to find the information he needs without instruction. It's as simple as pointing and clicking when he happens upon a category he's interested in or entering a keyword into the search field.

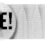

[Add Page - Options]

🖵 Edit ✕

ews of

Sep 7
8:17pm

Dili
ffer

Sep 7
8:50pm

Iassacre
an

Sep 7
8:50pm

Sep 7
5:09pm

Edit ✕

	10 pm
n City	Latin Beat
g	Local Programming
	Local Programming
1 &	Dateline NBC
ce	
	Pete Peterson: Assignment Hanoi

Edit ✕

ton Hotel

arch

Edit ✕

r saving them here.

d Investments
d Films
and Galleries
hy

, CA

✕

- Real Estate
- Restaurants
- **Shopping**
- Small Business
- Ski & Snow
- Sports
- Travel
- TV Listings
- Weather
- Yahoo! Home Page
- Yahooligans
- Yellow Pages

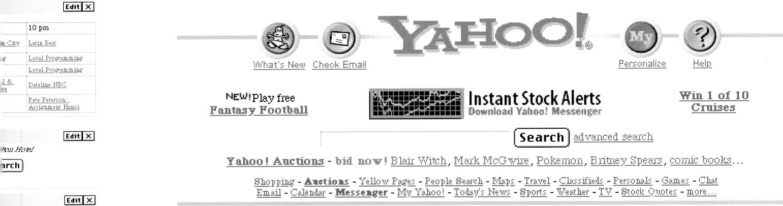

What's New Check Email Personalize Help

NEW! Play free
Fantasy Football

Instant Stock Alerts
Download Yahoo! Messenger

Win 1 of 10
Cruises

[Search] advanced search

Yahoo! Auctions - bid now! Blair Witch, Mark McGwire, Pokemon, Britney Spears, comic books...

Shopping - **Auctions** - Yellow Pages - People Search - Maps - Travel - Classifieds - Personals - Games - Chat
Email - Calendar - **Messenger** - My Yahoo! - Today's News - Sports - Weather - TV - Stock Quotes - more...

➡ [Content] [Layout]

e content-- ⬍ [Add]

OPPOSITE: To maximize the delivery of information to the user, Yahoo! designers chose to incorporate very few images into the design. Along the top of the Yahoo! home page, the interface includes the Yahoo! logo for identification and a few images that link directly to some of the most popular parts of the site. To avoid confusion about what the buttons represent, designers placed a text hyperlink below each one, identifying what it was.

Categorizing Information

Possibly the biggest interface hurdle was finding a logical way to categorize all of the information available on the site. When planning how to organize the site's massive amount of information, site developers used a hierarchical method for structuring the site. "We couldn't predict how people would seek information on our site, and we accepted that," Shen says. "We basically translated the larger categories and alphabetical listings to the Web interface, allowing people to search first by category, then alphabetically within that category."

On Yahoo!, all links are not created equal. The information is clearly organized in a hierarchical way. Buttons along the top of every page identify the different legs of Yahoo's services— from email to personalized pages. Primary search categories are rendered in a larger font, with subcategories in smaller font sizes directly underneath. In a table pulled out along the right-hand side, special features are highlighted and linked. The bottom of every page includes specific information about contacting Yahoo!, Yahoo! Guides, and general company information. Font sizes indicate what categories are primary and which are secondary.

A key element of Yahoo's successful design is how quickly the site downloads. The lack of visual pizzazz allows visitors to find what they need more quickly. Limited visual pizzazz means the site downloads fast, crucial for a site where visitors are likely to return frequently. A cutting-edge design firm can get away with an elaborate site designed in Flash, where the company's Web site serves to show the aesthetic breadth and capacity of the firm. With an information destination like Yahoo!, the purpose is to give as much information as simply as possible.

Several design elements maintain the simplicity that allows the site to download quickly. The color and design are intentionally understated. Even the use of small GIF images are kept to a minimum. The same page can be used by someone with the most archaic browser as by someone using the newest version of Netscape Navigator or Microsoft's Internet Explorer.

YAHOO!

Secondary Page Design

While the home page is designed to fit horizontally on a 640 x 480 screen, secondary pages scroll vertically, organizing the information first according to what the search functions deem relevant to the search query, then alphabetically. The strength of this interface design is that it offers users a variety of options, allowing them to drill deeper according to their needs. A simple outline-like link system provides information about the link and where the visitor stands in the hierarchy.

A valuable aspect of the secondary page design is that it provides users with links to topics related to the search, like Web sites, news, and Internet events. This gives them even more options, but by setting these links off in a different table, the options don't overwhelm the user. Literally every pixel of the Yahoo! interface empowers users with choices that help them find the information they're looking for.

"Not everyone knows that images can be hyperlinks. And text is always more direct than using an image, which may not be as clear."

HOO! Personalize

iness and Economy > Companies > B

afts

OPPOSITE: As Yahoo! grows, it is responding to user needs by adding more visitor services, including chat rooms, messaging systems, regional weather reports, email, and much more. The Yahoo! logo is featured prominently in the upper right-hand corner of almost every page, reminding users that each area is a part of Yahoo!.

BELOW: For a site like Yahoo!, it was important for interface designers to create a site architecture that would keep users oriented at all times. Design consistency is one of the ways Yahoo! chose to do this. As the user drills deeper into each subsection, a hyperlinked path of categories along the top of the page identifies the path he used to get there. To back up a level (or two), the user simply clicks on the category he's interested in. Clicking on the Yahoo! logo takes the user back to the home page at any time.

YAHOO! <u>Personalize</u>

<u>Home</u> > <u>Business and Economy</u> > <u>Companies</u> > <u>Books</u> > <u>Shopping and Services</u> > <u>Booksellers</u> >
Arts and Crafts

oks > <u>Shopping and Services</u> > Books

Communicating The Yahoo! Brand

Since debuting in March of 1995, Yahoo! has grown significantly. At this printing, Yahoo! provides free email services, an online calendar, clubs and chat capabilities, and much more. As Yahoo! grows, it must keep the brand identity strong through solid, consistent interface design, so people consequently associate each component of Yahoo! with one another, therefore strengthening overall brand recognition.

"We aimed for consistency across the board," Shen says. This is done simply by running the Yahoo! logo (always red) in the upper left corner of every page, along with the repetition of other visual and navigational themes. Each corresponding section also echoes the design with the gray background, the user's browser default font, and text colors. This is a rather clever identity device in an age when many sites end up looking the same as site designers clamber after copycat sophistication. Yahoo's identity lies in its lack of embellishment, creating a unique niche for itself by keeping it accessible to the widest Web audience possible.

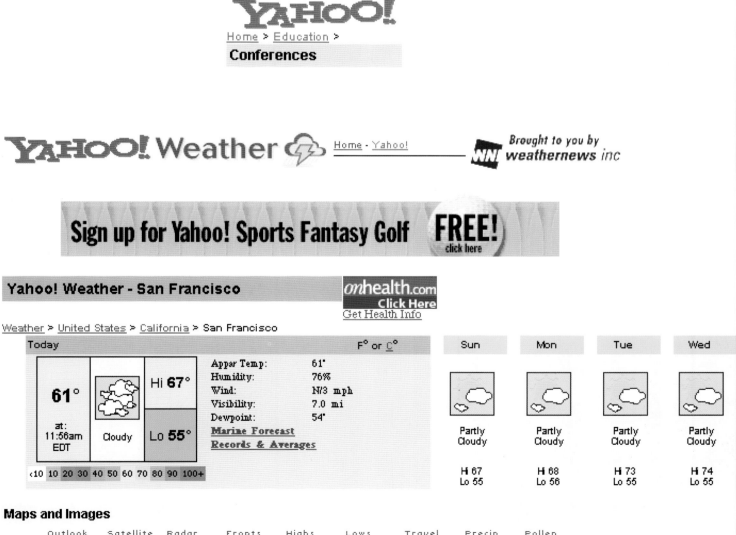

HOTWIRED

Get HotWired delivered by **email** or **PointCast**.

webmonkey
GUIDES

▸ **plan a trip**
▸ **find a job**
▸ **buy a car**
▸ **find MP3s**
▸ **and more...**

Webmonkey Guides
We help you accomplish more online.

Outside The
Actor's Studio

Suck.com
Biting Web commentary

Wired News

Continuous Updates from the Digital Front

2:25 pm AltaVista Hazy on Searches
Some AltaVista search results will be soon be generated by money, and some by machine. The ad agency says we'll be able to spot the difference. Critics aren't so sure. By Polly Sprenger.

4:30 pm Feds Need Privacy Lesson

Animation

Animation Express: Click. Sit. Laugh.

A How-to Guide for Web Developers

nkey

Domain-name Game Features New Rules
The reign of InterNIC is ending, and an alphabet soup of new players is moving in. Heidi supplies the who, what, when, why, and

Special Reports:

IPO Outlook

Infostructure

MP3 Rocks the Web

The Wired Index

Y2K Watch

Microsoft on Trial

Stocks

Rants and Raves

Animations and More:

See the Current Show

Browse All Animations

Animation Store

Plug-in Tester

Submission Guidelines

Timing is Everything

Yucca Magic

How to Eat

Crash Courses in:

Animation

Info. Architecture

Web Design

‹ TECHNOLOGY WEBSITES: HOTWIRED ›

HOTWIRED HAS BEEN AROUND SINCE THE DAWNING OF THE WEB. WAY BACK IN 1994 (EVEN BEFORE NETSCAPE LAUNCHED ITS FIRST COMMERCIAL BROWSER), WHAT GREW TO BE THE WIRED DIGITAL ONLINE TECHNOLOGY EMPIRE SAW THE POTENTIAL OF THE WEB AND EFFEC-TIVELY STAKED ITS CLAIM ON THIS NEW FRONTIER. IN DOING SO, WIRED HAS HAD AN ENOR-MOUS IMPACT ON ONLINE INTERFACE DESIGN, LEADING BY EXAMPLE AND DEVELOPING CONTENT THAT MODERN USERS SEEK.

Wired Digital now hosts seven auxiliary sites, including: Wired News (hard news from the digital front); Webmonkey (a how-to guide for Web designers), Hot Bot (Wired's own search engine); Animation Express (an experimental gallery of online animation); Wired Magazine (the print counterpart to the online empire); Suck.com (a forum for Web commentary); and RGB Gallery (an experimental gallery of online design). At the hub of all this activity is Hotwired, a Web page that promotes these diverse sites, organizing them all in one place.

Hotwired used to be more of an online publication in and of itself, but now acts as a "front door" to all of the online legs of the Wired empire. But how does Hotwired's interface meet the needs of everyone from the online news junkie to the purveyor of digital art? More importantly, how does this site's interface effectively organize all this information without overwhelming the user?

Simplicity And Predictability

"Hotwired's approach is split down the middle between functionality and presentation," says Jeffrey Veen, Wired Digital's Executive Director of User Interface. Despite the fact that Wired Digital has been a pioneer in pushing the limits of Web interface design, Hotwired proves that standard interface design serves its users better than experimental, cutting-edge design. Hotwired's interface features the "traditional" three-panel layout using horizontal frames (two smaller frames sandwiching the frame that contains the main content) that's favored by thousands of Web sites. This design allows Hotwired to meet the needs of a wide variety of users—from experienced to novice—by presenting information in a familiar format.

Immediately providing the tools the user needs to find the information he wants is key to successful user interface design. To meet this goal, Hotwired greets visitors with a keyword search field anchored in the top frame, with a pull-down menu that lets visitors target their search by each of Hotwired's individual sites. The top frame also acts as a static mainstay of the site; it includes the Hotwired logo, which brands the site while acting as a signpost that one click will deliver visitors to the Hotwired home page.

Wired News

3:00 am Andreessen Buzz: So What?
Netscape's co-founder may go down in history as the Web's first poster boy, but on Friday's message boards, his glow wasn't so bright. By Craig Bicknell and John Gartner.

3:00 am Big Boost for E-Biz

Animation

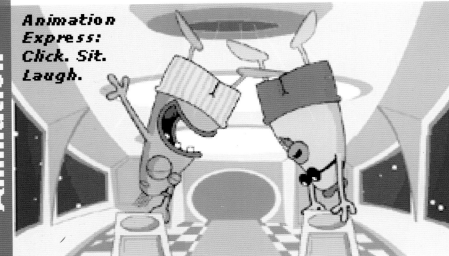

Animation Express: Click. Sit. Laugh.

Webmonkey

A How-to Guide for Web Developers

Using Stylesheets with IE 5
The browsers still don't have great support for stylesheets, but Internet Explorer 5 is able to handle some of the bells and whistles of CSS2. Mulder investigates.

Learn about:

E-Business ⬍ | go

RGB gallery

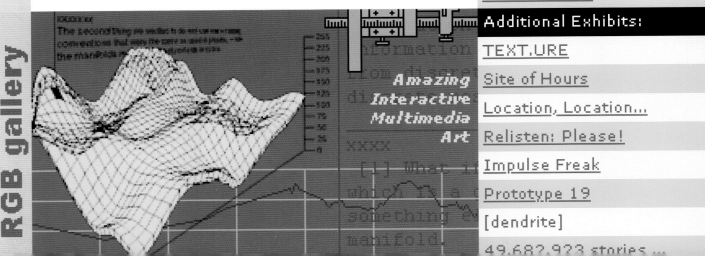

Amazing Interactive Multimedia Art

Current Hoo-Ha:

IPO Outlook

Infostructure

MP3 Rocks the Web

The Wired Index

Y2K Watch

Executive Summary

Stocks

Rants and Raves

Animations and More:

See the Current Show

Browse All Animations

Animation Store

Plug-in Tester

Submission Guidelines

Sex Slave 6

Wenchell Bogum 3

Little Nell

Crash Courses in:

Animation

Info. Architecture

Web Design

Beginning JavaScript

Advanced JavaScript

Site Optimization

Dynamic HTML

Dreamweaver

Additional Exhibits:

TEXT.URE

Site of Hours

Location, Location...

Relisten: Please!

Impulse Freak

Prototype 19

[dendrite]

49,682,923 stories ...

Focus On The Center Frame

The center frame of the site acts as the interface's focal point, introducing the user to each auxiliary site and providing enough information to give him a feel for the site. The trick to getting this part of the interface right is determining just the right amount of information to attract interest. After all, when you're trying to promote seven sites in one, space is at a premium.

When it came to designing the site's main content, Hotwired designers used a modular magazine-like layout, an approach familiar to nearly any visitor. Hotwired uses a thin vertical column on the left side of the screen to draw users' attention to special features and provide links to administrative necessities, like help pages and email feedback. This format allows the user to quickly scan for essential information and get where he wants to go faster.

To the right of the left-hand column is a large HTML-constructed table with information about Wired's major auxiliary sites: Wired News, Animation Express, Webmonkey and RGB Gallery. The information about each site is also organized with a magazine-like format that effectively brands, teases, and links to the content, all in one place. The interface's makeshift table-of-contents is organized neatly, with each individual site inhabiting a horizontal HTML table row divided into three cells.

The left-hand cell of each row identifies the name of the site, running vertically and rendered in bright colors. By clicking on the site's title, the visitor is delivered to the home page of the corresponding site. Conveying the unique personality of each drastically diverse site together in one small place was a challenge, so this central cell was used to pitch each site's flavor and image. For Wired News and Webmonkey, this central cell features hotlinks to hard news stories and tutorials, respectively, while the Animation Express and RGB Gallery sites feature a colorful image pulled from the current collection.

The third table cell acts as a sort of hyperlink table of contents of the featured site. The cell is broken into a series of horizontal rows, colored with alternating bright colors, a unifying design element that is borrowed from Wired Magazine's own design. The alternating rows of bright colors were first found on the spine of Wired Magazine, the alternating rows symbolic for the 1s and 0s that are at the heart of computers' functionality. Each link used in this cell refers to a specific page or item in the site, a feature that allows the user to drill deeper into the site according to his interests. Instead of linking the visitor directly to the corresponding home page and leaving him to find the information he needs, these links take the user right into the content, saving time.

The final result is a neatly designed interface that at once conveys the spirit of each individual section, and allows visitors to click directly to targeted areas within each site without simply being delivered to the site's home page to hunt and peck for the content they seek. The design is clean and uncluttered, keeping the site unintimidating despite the vast and diverse amount of information it includes. These qualities are essential to get users to interact with the site.

Get HotWired delivered by email or PointCast.

webmonkey
GUIDES
▸ plan a trip
▸ find a job
▸ buy a car
▸ find MP3s
▸ and more...

Webmonkey Guides
We help you accomplish more online.

Outside The Actors Studio

Suck.com
Biting Web commentary

Wired Magazine
Browse by issue or topic

Archives
Four years of HotWired

HotBot Search
HotBot Shopping
The Web's #1 Search Engine

Need help?
Send us feedback
Wired Digital staff

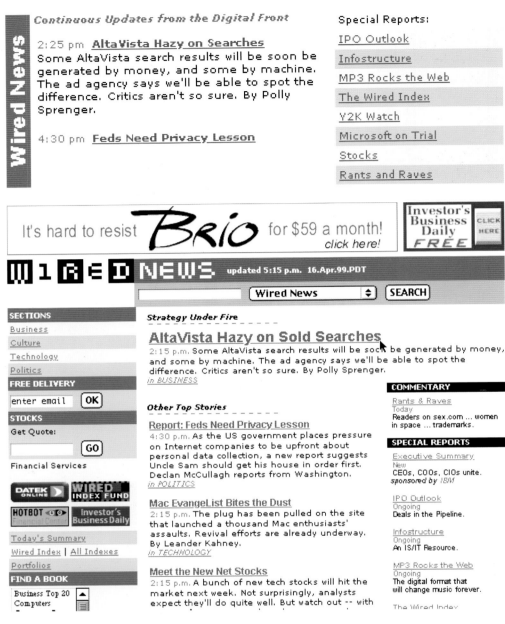

Continuous Updates from the Digital Front

Wired News

2:25 pm **AltaVista Hazy on Searches**
Some AltaVista search results will be soon be generated by money, and some by machine. The ad agency says we'll be able to spot the difference. Critics aren't so sure. By Polly Sprenger.

4:30 pm **Feds Need Privacy Lesson**

Special Reports:

IPO Outlook

Infostructure

MP3 Rocks the Web

The Wired Index

Y2K Watch

Microsoft on Trial

Stocks

Rants and Raves

It's hard to resist **Brio** for $59 a month! click here!

Investor's Business Daily FREE CLICK HERE

WIRED NEWS updated 5:15 p.m. 16.Apr.99.PDT

[Wired News ▼] [SEARCH]

SECTIONS
Business
Culture
Technology
Politics

FREE DELIVERY
[enter email] [OK]

STOCKS
Get Quote:
[] [GO]
Financial Services

DATEK ONLINE / WIRED INDEX FUND
HOTBOT / Investor's Business Daily

Today's Summary
Wired Index | All Indexes
Portfolios

FIND A BOOK
Business Top 20 ▲
Computers

Strategy Under Fire

AltaVista Hazy on Sold Searches

2:15 p.m. Some AltaVista search results will be soon be generated by money, and some by machine. The ad agency says we'll be able to spot the difference. Critics aren't so sure. By Polly Sprenger.
in BUSINESS

Other Top Stories

Report: Feds Need Privacy Lesson

4:30 p.m. As the US government places pressure on Internet companies to be upfront about personal data collection, a new report suggests Uncle Sam should get his house in order first. Declan McCullagh reports from Washington.
in POLITICS

Mac EvangeList Bites the Dust

2:15 p.m. The plug has been pulled on the site that launched a thousand Mac enthusiasts' assaults. Revival efforts are already underway. By Leander Kahney.
in TECHNOLOGY

Meet the New Net Stocks

2:15 p.m. A bunch of new tech stocks will hit the market next week. Not surprisingly, analysts expect they'll do quite well. But watch out -- with

COMMENTARY
Rants & Raves
Today
Readers on sex.com ... women in space ... trademarks.

SPECIAL REPORTS
Executive Summary
New
CEOs, COOs, CIOs unite.
sponsored by IBM

IPO Outlook
Ongoing
Deals in the Pipeline.

Infostructure
Ongoing
An IS/IT Resource.

MP3 Rocks the Web
Ongoing
The digital format that will change music forever.

The Wired Index

Incorporating Banner Ads

The third and final frame of the Hotwired site houses what many Web designers know as a necessary evil: banner advertising. Basically, Web designers needed a way to set apart the advertisements from the rest of the content, while making sure the advertisers were getting their money's worth. "My job is to play with puzzles when constructing sites," Veen says. "If I did my job perfectly, visitors would have no reason to click on an ad—they'd never be distracted."

Using the scrolling bars to frame Hotwired's content, the frames are organized to clearly set apart the advertisements from the rest of the content, while giving the advertiser the prominent position and thus, incentive to advertise. But the most important reason to use this treatment for advertisements in this interface is to set the advertisements apart from the editorial so users clearly understand the nature of the information provided.

"Hotwired's approach is split down the middle between functionality and presentation," says Jeffrey Veen, Wired Digital's Executive Director of User Interface.

RGB gallery

Amazing Interactive Multimedia Art

Additional Exhibits:

TEXT.URE

Site of Hours

Location, Location...

Relisten: Please!

Impulse Freak

Prototype 19

[dendrite]

49,682,923 stories ...

THIS PAGE: The Wired News home page is in stark contrast to the home page of RGB Gallery. The interface of RGB Gallery is much more graphic, indicative of the content included. Although the design is progressive, all the crucial elements of interface design are included: The site's logo (used conspicuously) effectively brands the site. The main feature is given prominent billing on the home page, offering links to different aspects of the site. Links to items from the permanent collection are included alongside a thumbnail from that collection. A pull-down menu in the top frame allows visitors to jump to the other Wired sites. And the advertisements are clearly set apart in the bottom non-scrolling frame, distinguished from the content with a different background color.

HOTWIRED RGB gallery

Go to: | HotWired Frontdoor ⬍ | **now**

Tech problems? Let us know.

RGB gallery presents

david opp's
4YB-200

■ **enter**

■ about david opp

Click here to see three other exhibits.

From the permanent collection:

Fork Unstable Media
A German multimedia house conceptualizes home in this rich, poetic project.

Construct
Classic comic book meets virtual reality in a futuristic urban narrative.

Ole Luetjens and Leo Neumann
The sound of a picture? A Java-based exploration of sense and memory.

■ **Browse the entire collection.**

at Wired Digital | Advertise with us | About Wired Digital | Our Privacy Policy

Variation On A Theme

Despite the traditional three-frame approach to Hotwired's front door Web design, Hotwired's design wasn't always this simple. As a matter of fact, in 1998, Hotwired used the more sophisticated technology of dynamic HTML (DHTML) as part of its home page to add movement, and a cutting-edge feel to the site. However, designers found that the visitors were not all that interested in learning a new interface, especially one that demanded the most sophisticated browsers and high-speed connections.

"We found that users demand simple, consistent functions with Web interface design," Veen says. "They don't want to have to wait for a page to load or learn a new interface over and over." Consequently, this bleeding-edge site decided to go a little more traditional, replacing the DHTML coding with more traditional Javascript and traditional HTML programming. Although they had to sacrifice the use of some of the more interesting effects of DHTML, Veen says that the tradeoff was worth it. "Now our pages are a lot more stable and easier to make. We've found that there's a lot of hype about technology that's just not ready yet."

</hotwired>

ABOVE: To ground the site's identity, the Hotwired logo appears in the upper right-hand corner of the page. Users can use the keyword to search any part of the Wired Digital sites by specifying the site they want with the pull-down menu. The user is then taken directly to the topic they requested, without having to first go to the site, then navigate through a menu.

BELOW LEFT: Webmonkey is a site created specifically for Web designers, so its interface is a little more sophisticated than Wired News or Hotwired, in response to the expert level of the user. A subtle GIF animation is used with the logo, while the user can still access all the other Wired Digital sites through the bar running across the top. The site is constructed using frames to set the banner ads that run across the bottom from the scrolling content in the center frame.

BELOW RIGHT: Although Webmonkey's home page design is rather sophisticated, the interior pages are created with more of a standard interface construction, to help visitors quickly find the information they are looking for. The search bar along the top allows users to search by keyword, and a table of contents runs along the left-hand side, allowing users to jump directly to content areas based on their interests.

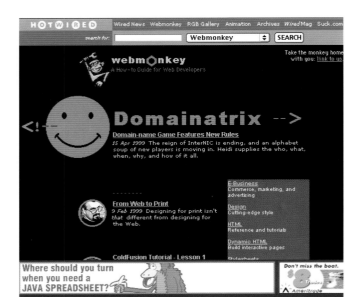

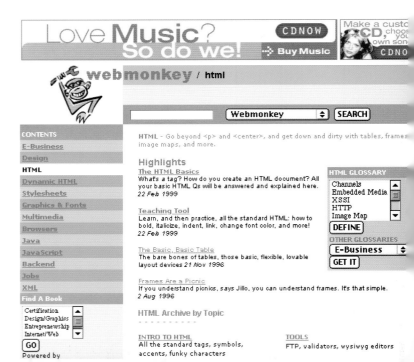

Address: ▼ http://www.hotwire

Favorites
History
Search
P

Love N

web

CONTENTS

E-Business

THIS SPREAD: Although the Hotwired's different auxiliary sites each have their own flavor, there are several unifying interface elements that brand these sites. For instance, on the home page for RGB Gallery, an online gallery of experimental art, the Hotwired logo appears predictably in the upper left-hand corner and a pull-down menu in the top frame allows users to jump easily to any other Hotwired branded site. Like the other Hotwired sites, this page is assembled in three horizontal frames, and the center one is where the content runs. But the individual works overtake the screen when called up, providing the intended experience.

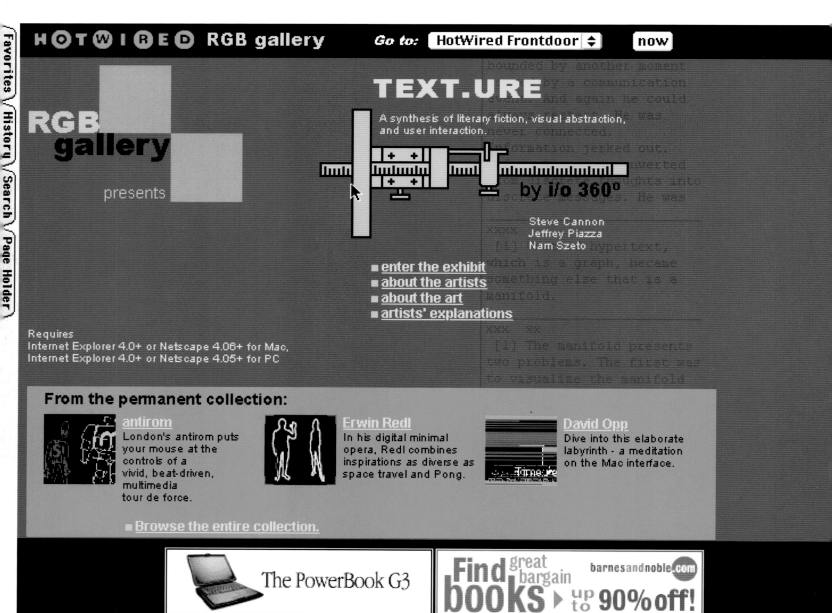

itch

| you will need | shockwave | ENTER |

designs and builds things that do things

Studio B3L : Metropolitan Wharf : Wapping Wall : London E1 9SS

Tel 44 (0)171 265 014 6 : Fax 44 (0)171 265 0638 : mail@itch.co.uk

THIS SPREAD: Itch used Macromedia's Director and the Shockwave plug-in to create its site's innovative interface. Users are notified right away to download Shockwave before proceeding. Data like phone, fax, email, and address information is included as a consistent part of the design so users will know exactly how to contact Itch if they want to—after all, the site is first and foremost a promotional tool for the firm. As the Shockwave plug-in loads, a simple animation holds users' attention, using hatch marks to count off how long it takes to load.

‹ PROMOTIONAL WEBSITE: ITCH ›

THERE'S NO SET FORMULA FOR DESIGNING AN EFFECTIVE WEB INTERFACE—THERE ARE INFINITE WAYS TO CREATE SITES THAT ENGAGE THE USER AND EFFECTIVELY DELIVER THE INFORMATION. ALTHOUGH MANY QUALITIES MAY EXCLUDE A SITE'S INTERFACE FROM BEING USER FRIENDLY— POOR NAVIGATIONAL TOOLS, LIKE THE INABILITY TO NAVIGATE THROUGH THE SITE ARCHITECTURE, AND CONFUSING GRAPHICS—EXPANDING FROM THE CONFINES OF TWO-DIMENSIONAL POINT-AND-CLICK PAGE DESIGN ISN'T ONE OF THEM.

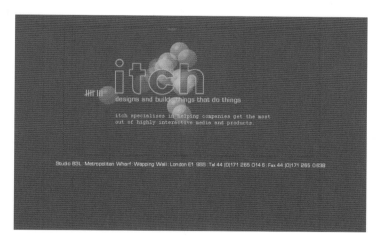

Itch, a London-based interactive design company, designed its firm's promotional Web site to break the boundaries of traditional site design. Using Macromedia Shockwave to create an animated interface that engages the user beyond mere point-and-click, Itch has created a destination that conveys the firm's originality and shows off its portfolio and design aesthetic in a memorable way. Using a mouse to navigate, the user physically traverses through the information that's plotted out onscreen to access information. He can either wander throughout the site at leisure, following threads designers have marked, or simply explore wherever his mouse takes him, or swiftly jump to different areas by category using the site's icons. With this site, Itch has created an interface that allows users to access information in a whole new way.

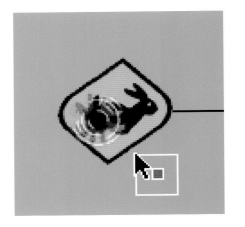

LEFT: Animations are a crucial part of the interface and give the user subtle clues about how to interact with the site as well as adding visual interest. For instance, when the user rolls his cursor over the rabbit icons that appear at different points throughout the site, the hind legs start spinning—clicking on the rabbit rockets you to a different part of the site. Designers wanted to use these animated rabbit icons to indicate to users that these would let you quickly jump around the space, another option to scrolling along the visual trails.

OPPOSITE: The first things users see when they reach the site are the company logo and motto, "Itch designs and builds things that do things." From there, the user is given the tools he needs to explore the space. An icon of a rabbit attached to a horizontal line leading off the screen invites the user to start exploring the space by experimenting with clicking on and scrolling across the screen's green area.

Mapping The Information

There were several shortcomings of traditional sites that compelled Itch designers to create the unique site interface. "Inspiration for the site design started with us getting frustrated with spending time on other Web sites," says Andrew Hirniak, co-founder of Itch. "Users often get lost within the menu structure, not knowing where they are within the site or how big it is. We wanted to create a site that was designed, in essence, to be a sort of geographic view of the information."

The interface is designed as a real-world model anyone can relate to—a map. Visitors can roll their mouse in any direction to physically travel throughout the site area and access the variety of information included. "It's easy for people to conjure a mental image of a map and what it represents," Hirniak says. "We wanted people to be able to build up a geographic knowledge of the site to navigate around." Set against a bright green background, straight lines literally connect different nuggets of information from the site's central hub, and light green paths identify routes to different sources of information. The user can zoom out for an overall view of the site's structure and connection of information, or zoom in to explore the area at 100 percent.

Unconventional Navigation

Since the site's interface was so unconventional, Itch provided users some options for how to navigate through it. The first way users can explore the space is by simply scrolling around with their mouse, following the threads and visual cues (like arrows and icons), or just wandering, serendipitously discovering information along the way. Instead of presenting information in a static, page-like setup, the interface allows the user to navigate with real-world metaphors, exploring the space "on foot" at will. The ability to zoom in and out allows users to orient themselves by taking a global look at the entire site, then zooming in to check out specific information.

Although this method of navigating the site allows visitors to access information and search the site in an exploratory way, it isn't the most practical way to get information. Just because site designers chose an unconventional approach with the site's interface didn't mean that they had to sacrifice efficiency. A more direct way users can access information is with the use of icons (designed as jackrabbits) that "jump" users directly to different areas within the site. These links allow visitors to quickly access the information they need while supporting the design structure of the interface.

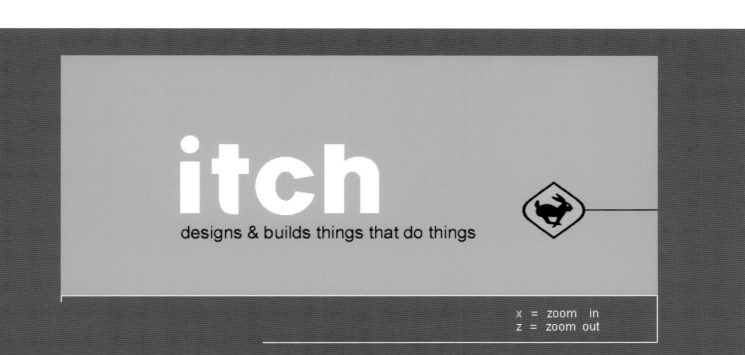

itch

designs & builds things that do things

x = zoom in
z = zoom out

Studio B3L : Metropolitan Wharf : Wapping Wall : London E1 9SS : Tel 44 (0)171 265 014 6 : Fax 44 (0)171 265 0638

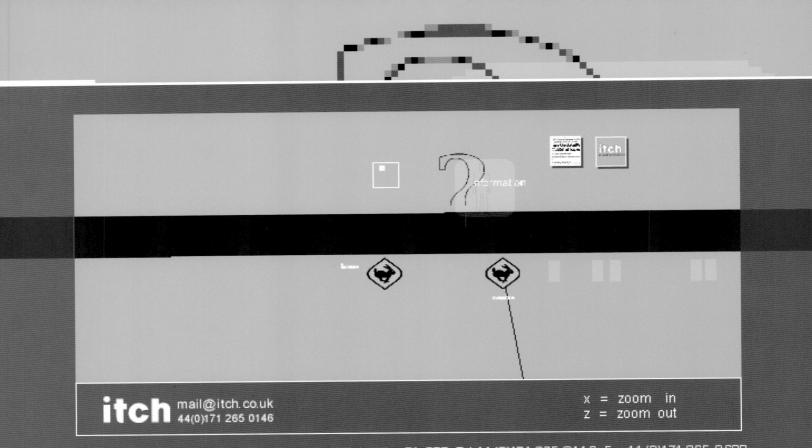

? information

itch

itch mail@itch.co.uk
44(0)171 265 0146

x = zoom in
z = zoom out

Studio B3L : Metropolitan Wharf : Wapping Wall : London E1 9SS : Tel 44 (0)171 265 014 6 : Fax 44 (0)171 265 0638

Site Architecture

The map interface wasn't the only way designers designed the site to keep users oriented. Rather than using a hierarchical link structure, Itch chose to keep all the information on the site very close to the surface, thus preventing users from getting lost as they use links to drill down for information. At any point, visitors are only one click away from information on the variety of topics. The links are still broken into different categories (like information about Itch as a company or samples of CD-ROM work), but instead of burying links to this information under the subject header of each category, icons for each piece of information are included alongside the categories directly on the map. Visitors will not have to go deeper than one level to access any of the information provided on the site.

The site's central area acts as the "hub" where designers have provided jackrabbit links to every main area of content featured on the site. From this central location, visitors have the opportunity to link to everything from information about the site itself to screens and games the firm has designed. At any time, if the user gets disoriented or lost, all he needs to do is click on the Itch logo—it will deliver him back to the beginning area of the site.

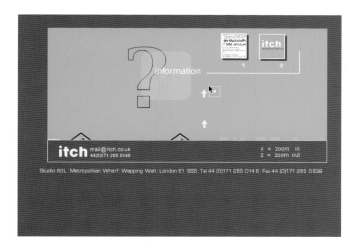

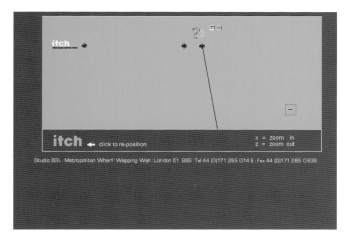

THIS SPREAD: The interface design allows visitors to zoom in and zoom out to visually orient themselves to where they are geographically within the site's architecture and to get an idea for how big the site is. With the closer view, users can inspect in detail the type of content they're likely to find in the information area, while zooming out allows visitors to see how this section is connected to the site as a whole.

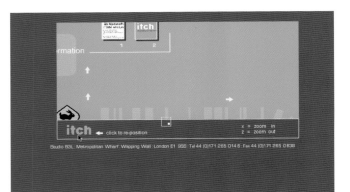

Entertaining Elements

For Itch's interface to succeed, it was necessary to incorporate elements that would draw visitors into the site. To facilitate this, designers included a variety of elements that were strictly entertaining. Piquing visitors' interest by incorporating unexpected elements into the interface was a way that site designers hoped to invite users into the interface. Playful elements like animated ladybugs that crawl randomly across the area add entertaining content to the site. "Our intent during the design process was to create a space where, if the user scrolls around following a route, he's going to discover unexpected things along the way," Hirniak says. "When visitors discover the animated characters when exploring the site, although these elements don't represent any work per se, they do offer entertainment. There's not enough entertainment on Web pages. We wanted to create a site that offers entertainment, value, and pleasure for visitors." These unexpected discoveries in the site's interface also encourage visitors to explore more, just to see what other surprises the site holds in store.

Another fun element incorporated into the site's interface, that also helps communicate with the user, is animation. When the user rolls his cursor over any of the rabbit icons, the animal's back legs spin, inferring that this link is going to swiftly transport you to another area. Itch designers also used animated rollovers with all the icons used in the design to add interest and information. "By using animations, we were able to get across more information," Hirniak says. "What happens when you roll over the different icons suggests what information you will get."

This interface helps Itch convey its style and individuality to visitors of this site: Internet users and potential clients. "This site is really for anyone who's interested in what Itch does," Hirniak says. "We tried to make the design interesting—anything that's interesting, people will look at. Whether it's from potential clients who we send to our site or just anyone looking at it, we'll get business via this route. We want people to enjoy looking at the site and come away with some pleasure. But we also want them to walk away with information about who we are and what we do."

</itch>

"When visitors discover the animated characters when exploring the site, although these elements don't represent any work per se, they do offer entertainment. There's not enough entertainment on Web pages. We wanted to create a site that offers entertainment, value, and pleasure for visitors."

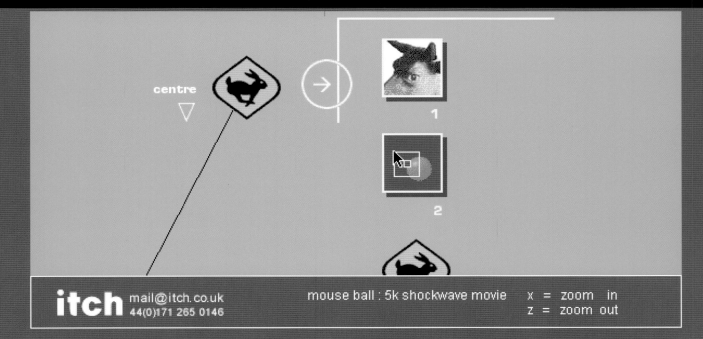

products

itch mail@itch.co.uk
44(0)171 265 0146

networked products : text & picture x = zoom in
z = zoom out

Studio B3L : Metropolitan Wharf : Wapping Wall : London E1 9SS : Tel 44 (0)171 265 014 6 : Fax 44 (0)171 265 0 638

centre

1

2

itch mail@itch.co.uk
44(0)171 265 0146

mouse ball : 5k shockwave movie x = zoom in
z = zoom out

Studio B3L : Metropolitan Wharf : Wapping Wall : London E1 9SS : Tel 44 (0)171 265 014 6 : Fax 44 (0)171 265 0 638

What itch does

itch specialises in helping companies get the most out of highly interactive media and products.

There is an ever increasing demand for more satisfying and stimulating interactive solutions. Our aim is to use our experience and knowledge to enable companies to be at the leading edge of interaction design.

We combine a well established knowledge of traditional design disciplines with emerging technologies, to provide uniquely inventive and creative answers

itch mail@itch.co.uk
0171 265 0146

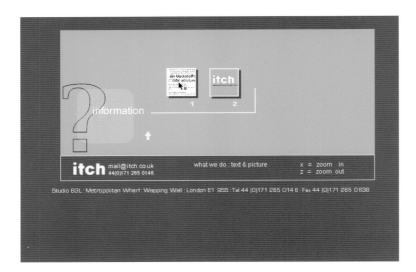

ABOVE & LEFT: Instead of creating a site with a variety of layers of information, Itch's design is fairly linear. At any point, users are only one click away from information about a variety of Itch projects, from CD-ROM design to games and Shockwave movies. To access this information, the user simply clicks on the icon. This calls up one page of information about the project. This interface element allows the user to stay close to the actual architecture of the site, not getting lost in subsequent pages. From the information pages, the user can simply return to the main screen and continue to explore the site learning about more information and work the company has done.

LEFT: The interface of the Itch site is designed just like a map—users can literally travel to the edges of the two-dimensional site's space while exploring. This effect strengthens the analogy to a physical space, while supporting the user's ability to explore every inch of the space.

OPPOSITE:In the middle of the site's area is a central hub, where site designers have provided jackrabbit hotlinks that jump users to all the information provided on the site. Here, users have the opportunity to jump directly to everything from Itch's design for the screen to games and interactive textures. Zooming out shows how all the elements of the site branch out from this central location, giving users a good feeling for how the site is set up.

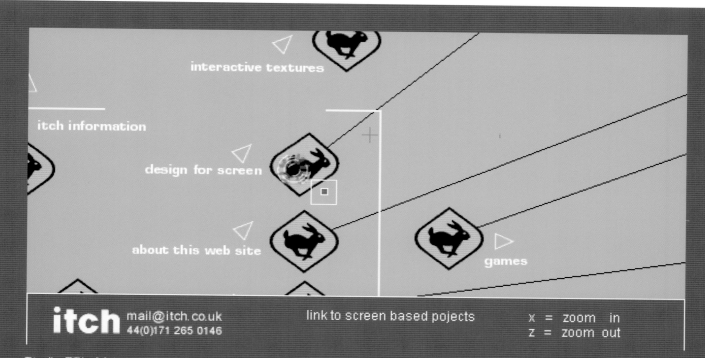

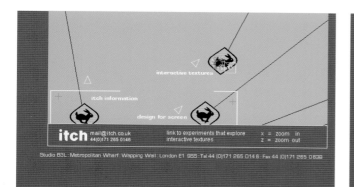

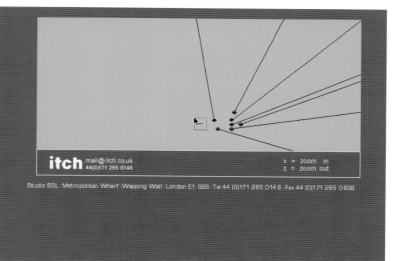

plumbdesign
VISUAL THESAURUS

loaded, click to launch.

not loading? click here. visual thesaurus 1.0 (build 1998012901)

About Instructions Help Comments

CREATED WITH
TH!NKMAP

The Plumb Design Visual Thesaurus is an exploration of sense relationships within the English language. By clicking on words, you follow a thread of meaning, creating a spatial map of linguistic associations. The Visual Thesaurus was built using Thinkmap™, a data-animation technology developed by Plumb Design.

OPPOSITE: The technology that allows visitors to experience the innovative Visual Thesaurus is powered by a Java applet developed by Plumb, named ThinkMap. This technology uses a database of words to build, as Plumb describes it, "a spatial map of linguistic association."

‹ VIRTUAL THESAURUS: PLUMB DESIGN ›

WHAT MAKES PLUMB DESIGN'S VISUAL THESAURUS INTERFACE MOST REMARKABLE IS THAT UNLIKE MOST OTHER WEB SITES, IT HAS NO PREDETERMINED AGENDA FOR THE USER'S EXPERIENCE, AND VERY FEW OBVIOUS NAVIGATIONAL CLUES. RATHER, THE INTERFACE PLACES THE USER WITHIN ITS FRAMEWORK, ALLOWING HIM ALMOST COMPLETE CONTROL OVER THE EXPERIENCE WITH NO PRE-PLANNED EXPECTATIONS OR PATHS.

An adjunct to Plumb Design's company site, the Visual Thesaurus is precisely what its name suggests—an online, dynamic visual database of words and their synonyms. To use it, the user types a word into the search field in a navigational bar at the bottom of the screen. A database of words is summoned by using a Javascript applet named Thinkmap (also designed by Plumb). The selected word appears dynamically onscreen as if it were floating, with synonyms branching out from it, creating what has been called "a dance of words."

Online Art

As you've probably already guessed, another quality that makes Plumb Design's Visual Thesaurus unique is the fact that it isn't the quick-byte, information-overload, useful tool that so many other Web sites are. As a matter of fact, if you're looking for synonyms to spice up that paper you're writing, you're best off visiting other more straightforward sites on the Web. So why bother with this site at all if there's no immediate practical payoff?

"The Visual Thesaurus is a site for people who love words," says Mark Tinkler, Creative Director for Plumb. "We were looking to create an interface specifically for information design, while creating a solution that was a visually stimulating demonstration of our Thinkmap technology. We decided that the best way to do that was to create something that was beautiful and inspires possibilities."

If you don't think Web surfers have the time or desire to spend time at such a site, guess again. Word about the site spread like wildfire. At the time this book was being written, the site received more than 100,000 word lookups per day.

"The reaction has been overwhelmingly positive," Tinkler says. "Our visitors range from people who are learning English as a second language to downright interface junkies. We found that the more users interacted with it, the more they learned. The design drives visual thinking."

plumbdesign

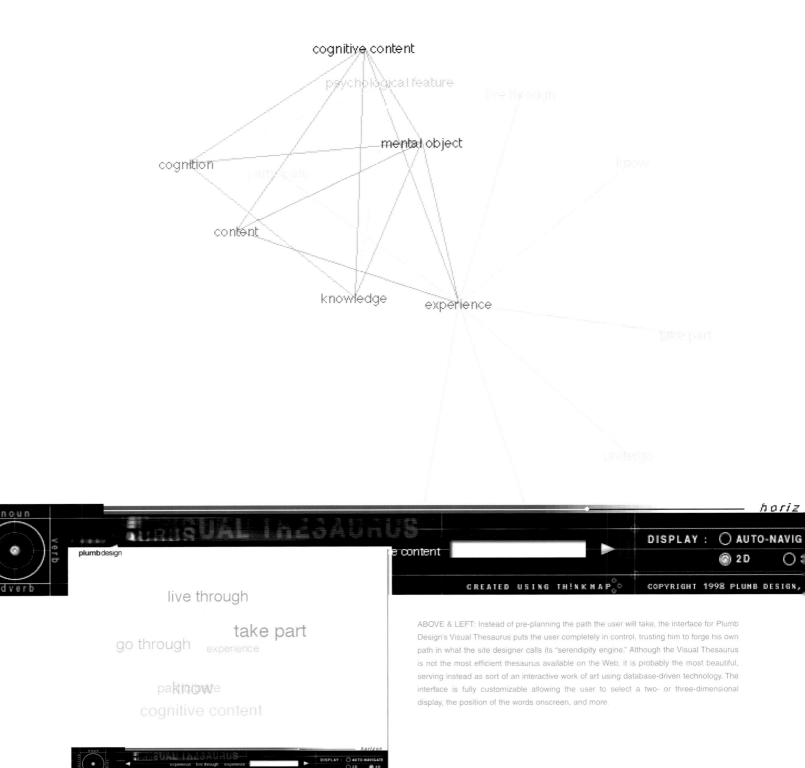

ABOVE & LEFT: Instead of pre-planning the path the user will take, the interface for Plumb Design's Visual Thesaurus puts the user completely in control, trusting him to forge his own path in what the site designer calls its "serendipity engine." Although the Visual Thesaurus is not the most efficient thesaurus available on the Web, it is probably the most beautiful, serving instead as sort of an interactive work of art using database-driven technology. The interface is fully customizable allowing the user to select a two- or three-dimensional display, the position of the words onscreen, and more.

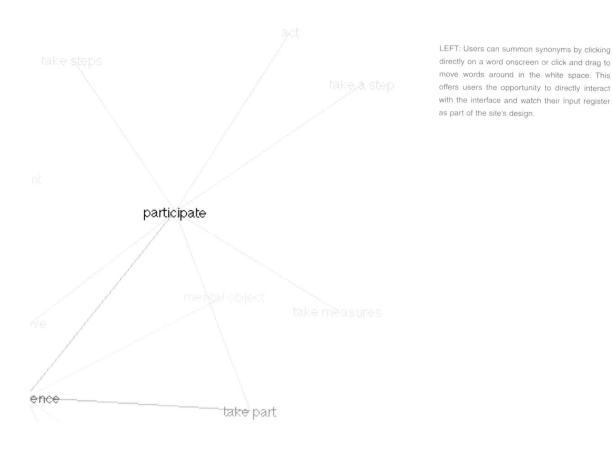

LEFT: Users can summon synonyms by clicking directly on a word onscreen or click and drag to move words around in the white space. This offers users the opportunity to directly interact with the interface and watch their input register as part of the site's design.

Deconstructing The Design

"Every word acts as a magnet," says Tinkler. "All words repel one another, and related words are tied together. The words appear to be floating, as if underwater." The interface is completely intuitive: To invoke synonyms for another word onscreen, the user simply clicks on it. To summon an entirely new word and its corresponding synonyms, the user simply needs to type it into the text field at the bottom of the screen. From here, a subtle rhythm of words and design builds, with an infinite number of possibilities.

Since the Visual Thesaurus' interface is so simple, users can focus on the words and the designs they create instead of the interface itself. The words appear in a large, white field that almost fills the entire screen, save a small area for the navigation bar, which runs along the bottom. This large area allows the words plenty of room to move, connect, and branch off. The visual clues Plumb uses to orient the user within this interface are subtle, but extremely effective. Active words are rendered in a darker-gray color, while secondary words are scaled back in a lighter gray. Faint red lines indicate connections already made.

A thin navigation bar with bold colors and modern graphics runs along the bottom of the screen, yet the focus remains on the screen above. The navigational bar includes a field where users can key in new words and a compass-like indicator identifying the word in question as a noun, verb, or adjective. Also part of this navigational bar is a running log of the words that have been requested. As the words already requested gradually fade on screen, making room for new ones, the log along the bottom similarly fades into the edge, providing an analogous connection with the screen above. This device orients the user to where he's been, and provides a linear, practical reference that grounds the site, in contrast to the more fluid, ephemeral words floating onscreen that are the site's focus.

noun

verb

djective

experience participate

DISPLAY : ○ AUTO-NAVIGA
◉ 2D ○ 3

ABOVE: The Visual Thesaurus' navigational bar is anchored at the bottom of the screen,
preventing the site's tools from interfering with the flow of words on the white screen area
above, where the words are featured. This navigational bar provides users with a variety of
tools that allow them to monitor and customize their Web experience.

BELOW: The interface allows the user to track the history of words as they fade in and out
of the screen. As words are entered into the search field, or summoned by clicking
onscreen, a list runs from right to left of the history of words called up. And, in symmetry
with the screen above, as words fade away to make room for new words, the trail of words
also fades away to make room for new ones.

Customizing The User Experience

With this design, Plumb provides the loose framework and tools for users to create their own
unique experience. The most obvious example is the ability of the user to click on a word and
drag it anywhere on screen. This gives the user control over how the screen will appear and a
dynamic way to interact directly with the words. Since the site does not remain static, the
words constantly move and float around the screen, in a constant push-and-pull with the user.

Another interesting option available to users is the ability to adjust the "horizon," or the area
from which the words emerge and fade. This function is adjusted using a slider bar that is
found along the top of the navigational bar. This tool was designed to be as intuitive and
lifelike as possible. "When you move the sliders, the updates lag behind a bit," says Tinkler.
"We wanted it to be analogous to real life, with nothing shocking or jarring about it. We took
the idea of fluidity of movement to the nth degree."

Lastly, the user is able to select from two- or three-dimensional views using radio buttons on
the navigational bar. And if the user is feeling particularly lazy, he can select auto-navigate
and watch the page unfold as new words are automatically accessed and a pattern develops
all on its own.

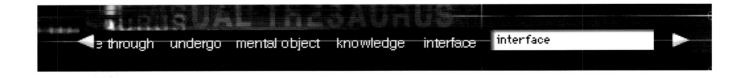

e through undergo mental object knowledge interface interface ▶

"The Visual Thesaurus is a site for people who love words," says Mark Tinkler, Creative Director for Plumb.

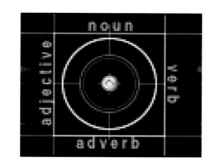

LEFT: The Visual Thesaurus' interface allows users to be specific about words they enter, making the site both beautiful to look at and practical. When the user types a word into the search field, he can specify if it's a noun, verb, adjective, or adverb to further target their query.

BELOW: The Visual Thesaurus interface is designed so the user can fashion his own experience and configure the interface to his preference. The "horizon" is adjustable using a horizontal sliding bar at the bottom of the screen, manipulating the space where the words appear. Users can click and drag on words to push or pull them on their screen.

horizon

interface
interface

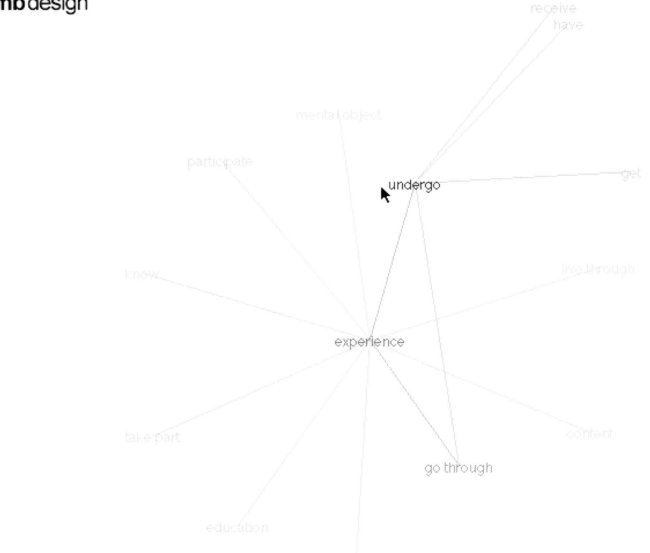

DISPLAY : ○ AUTO-NAVIGATE
○ 2D ◉ 3D

LEFT: The user has several choices for how to interact with the Visual Thesaurus. He can choose to let the database engine run wild, and summon words all on its own, watching what unfolds by selecting Auto-Navigate. For two different visual experiences, users can specify to view the words two- or three-dimensionally.

BELOW: Instead of using the jarring, click-to-change approach many Web sites use, Plumb built in a natural lag time from when an adjustment or action is made to when the change is made, making the experience more analogous to real life. (After all, you don't open a door, greeted by an entirely new environment in everyday life.) If you click and drag a word, the screen gradually, gently readjusts, maintaining the casual rhythm and approach of the site. This is yet another way that the user can play with the interface to customize it to his preferences.

OPPOSITE: Subtlety is at the heart of the design philosophy behind the Visual Thesaurus. Visited words are identified using a thin red line to connect them instead of gray, orienting the user to where he has been.

plumbdesign

receive
have

mental object

participate

get

undergo

know

live through

experience

take part

content

go through

education

The Aesthetic Approach

If there's one idea to take from Plumb's work with the Visual Thesaurus, it's that when designing a user interface, the approach needn't be clinical or overly scripted. By trusting the user to forge his own path and providing infinite options, Plumb has designed an interface that not only respects the user, but gives her a reason to return again and again to see what unfolds. The minimalist, yet lovely, design and choreography of words shows off Plumb's eye for aesthetics. "The idea was to give the site an organic feel, while it is still technical and computed," Tinkler says. "We wanted the site to offer a feeling for the depth, size, texture and complexity of the English language."

In the firm's online mission statement, they say, "by embracing the uniqueness of the 'viewer,' it is possible to create a situational discourse whose content need not be static, finite or essentialized, but rather ultimately determined by the user. As information architects, perhaps the most effective thing we can do is to provide the template or setting for the dynamic situations in which people play out their lives, rather than trying to script their actions in minute detail or trying to choreograph their interactions with mass culture."

The design of the site was based primarily on theories of visual design—from here, the technology followed. "Our philosophy is that of 'subtle complexity,'" Tinkler says. "We wanted to create a site that figured out how words move—what do they feel like?" The interface gives you a better feel for this ethereal notion than you're likely to find anywhere else.

</plumb design>

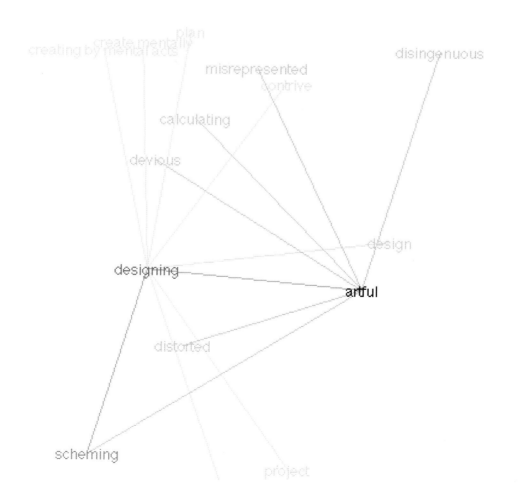

THIS SPREAD: There are no superfluous elements to the design of the Turbonium site. The Web experience starts with a splash screen featuring spare, clever copy and animated images featuring the car itself. The use of Flash animation helped designers convey significant concepts they wanted users to take away from visiting the site: that the New Beetle Turbo was a fast, hip automobile for the modern age and for a variety of people.

‹ TURBONIUM WEBSITE: VOLKSWAGEN OF AMERICA ›

AN EFFECTIVE INTERFACE LEAVES THE VISITOR TO THIS SITE WITH A DISTINCT TASTE FOR THE PRODUCT'S IMAGE. THIS IS AN ESPECIALLY IMPORTANT CONCEPT FOR COMPANIES THAT USE A VARIETY OF MEDIA—PRINT, TELEVISION, RADIO, AND THE WEB—TO PROMOTE THEIR PRODUCT. UNLESS THE INTERFACES OF ALL PROMOTIONAL MATERIALS TELL THE SAME STORY, THE PRODUCT'S IDENTITY IS LIKELY TO GET LOST. BECAUSE OF THE INFINITE POSSIBILITIES OF PROVIDING INFORMATION AND MEDIA ONLINE, THE WEB IS A PERFECT PLACE TO BRING ALL THESE EFFORTS TOGETHER, AND EVERYONE FROM FAST-FOOD COMPANIES TO CAR MANUFACTURERS ARE DISCOVERING THIS.

Scientists have discovered a new element

When the "New Beetle turbo" —the modernized New Beetle with a beefed-up engine—was born marketers had to promote basically what many would consider a contradiction in terms—a powerful, speedy Beetle. Although the passionate public connection to the New Beetle was a fortunate image to inherit and exploit in terms of the car's promotion, this powerful image also came with a great deal of responsibility. It was necessary to use the car's marketing plan to build on this momentum, while effectively communicating the new car's image.

In contrast to the vintage Beetle's heyday, it was essential to give the New Beetle turbo a Web presence. This site had to convey this car's mighty new image in a fun, playful way through the relatively detached medium of the Web to service its wired audience. From here, Turbonium, the new "element" created to promote this new product, was born, a symbol of the powerful new incarnation of this modern classic.

But when developing the site, it was necessary for Turbonium.com not to fall into the trap that several corporate Web interfaces fall into: Using the Web site as an online repository for all the information on the product that the company can cull. A targeted, sleek interface is every bit as important online as it is on the airwaves. This is where designers got the inspiration for the companion site.

Television and Internet Synergy

"The reputation of the Beetle in the 1960s and 1970s was that it was a little slow," says Tesa Aragones, the New Beetle Marketing Manager for Volkswagen of America. "Turbonium.com was designed to give equal weight to the practical and emotional aspects of the car. We had a great story to tell. When you're positioning a car to consumers, you're not just selling metal, you're selling an image."

Interface design is most successful when it draws from familiar media and supports existing resources. Although most people consider television and the Web two drastically different media, the online branding of the New Beetle took all of its cues from a successful broadcast campaign, providing another function to the marketing and responding to the user demands of accessing information online. Designers finessed the two to work together in perfect synergy.

"The television ads are popular," says Aragones. "We would have been crazy not to leverage that popularity on Turbonium.com. You can get a lot of information in a 30-second TV spot—a lot of lifestyle information and a lot of product imagery. But to really understand the car, you need some technical information. How horrible would the television spot have been if it included spec information about the car? If you build the image of the car using television and use the site for technical information, by integrating them, you give one voice. With consumers being bombarded with thousands and thousands of messages daily, it's important to keep your message consistent."

Tying the broadcast advertising and site closely together was obvious, considering how Web savvy the potential Volkswagen customer is. "We have an extremely high proportion of customers who have told us they are on the Internet and are looking for information on the Internet," Aragones says.

"Research told us that 98 percent of New Beetle owners say that they have visited www.vw.com [Volkswagen's home site], and this site averages more than 1 million visitors per month. We've only given our customers what they have asked for."

When Your User Is Everybody

Most advertising that is done for car companies is clearly targeted to a specific demographic. What set the advertising for the new Beetle apart is that there really was no target user profile that the promotions were hoping to reach. "The demographics for the New Beetle were all over the place," Aragones says. "New Beetle purchasers include teenagers, twenty-somethings, thirty-somethings, Baby Boomers, and grandparents. Because of this, you'll notice that the commercials are void of people—who would we show driving the car? Instead of trying to show everyone, we showed no one—that way the consumer can make up his or her own mind. We have done the same thing with Turbonium.com. There are no lifestyle shots, just product silhouettes."

Considering most car campaigns feature their products perched atop the Grand Canyon, or speeding effortlessly through rain-drenched roads, this meant the designers had to find a new way to position the car. Instead of trying to somehow adapt the car to the wide variety of people who were potential customers, the interface went the other route, by contrasting the automobile against a plain, white background.

"We were lucky that the car is powerful and distinct enough to stand on its own," Aragones says. "You can show the car against a white studio background and people will get it and think the car is interesting. There aren't many cars you can do that with. Since it's a unique shape, we had the unique luxury of being able to play off that."

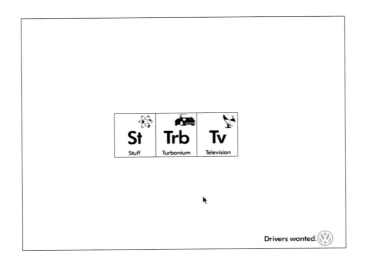

LEFT: Instead of using Turbonium.com as a place for Volkswagen to dump all the information available about the New Beetle Turbo, the interface and content for this site was kept intentionally spare. The main three areas are Stuff (where visitors can buy Turbonium promotional items), Turbonium (where they can learn more about the details of the car), and Television, an online tie-in to the car's successful television campaign.

OPPOSITE: Flash adds interactivity to the site's interface, especially with the use of rollovers. Not at all subtle, when the user rolls his mouse over a particular area, the button grows exaggeratedly large and is punctuated by audio clips.

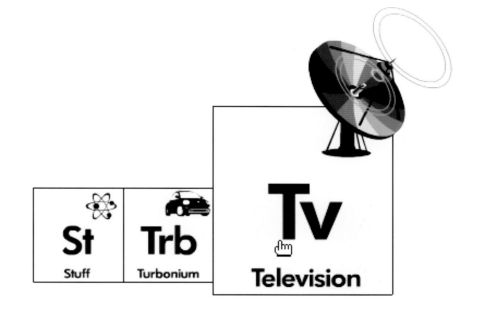

St
Stuff

Trb
Turbonium

Tv
Television

Drivers wanted.

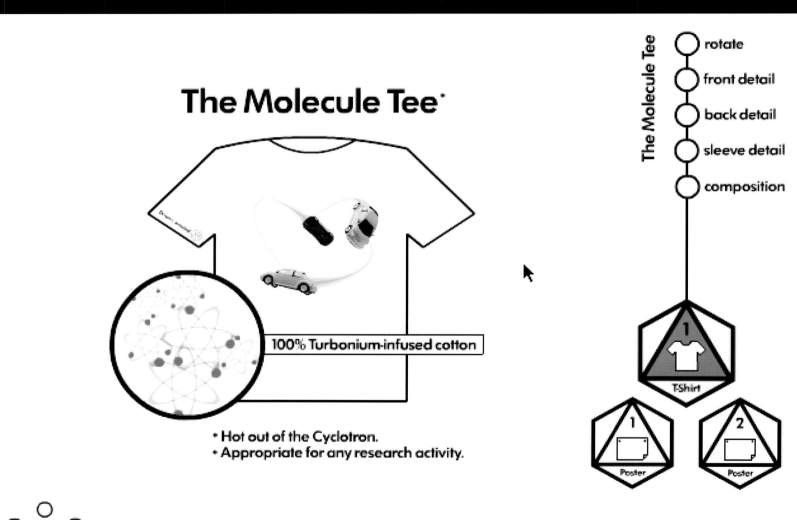

The Molecule Tee*

100% Turbonium-infused cotton

* Hot out of the Cyclotron.
* Appropriate for any research activity.

The Molecule Tee

○ rotate
○ front detail
○ back detail
○ sleeve detail
○ composition

1
T-Shirt

1
Poster

2
Poster

Drivers wanted.

```
>> Turbocharger.
>> 4 Cylinders.
>> 5 Valves per Cylinder.
>> 1.8 Liter.
>>
>> More data.
>> Exit.
>>
>>
>> Observation:
>> Compression ratio = (9.5:1)
>> Relatively high compression
>> ratio with compact
>> compression chamber.
>>
>> Result:
>> Rapid motion does not correlate
>> to rapid fossil fuel consumption.
>>
>> Recommendation:
>> Adjust budget accordingly.
>>
```

OPPOSITE: Turbonium.com is as much about selling the New Beetle's popular image as it is selling the actual cars. Several items are for sale on the site, from T-shirts and posters to music used in the commercials. The interface of the Stuff section pays just as much attention to the detail of the products as the Turbonium section pays to the detail of the car.

RIGHT: The Web site for the New Beetle Turbo was the perfect place to offer the technical information about the car that the advertising didn't cover. In the Turbonium area, visitors can learn about specific mechanical aspects of the car along with an illustrated diagram of the part of the engine detailed. But again, designers didn't want to include every mechanical detail about the car—it was important to keep the site streamlined and not an online recitation of the car's statistics. Subsequently, only the sexiest facts—essential statistics regarding the engine, options or safety—made it onto the site.

Streamlining The Online Experience

One of the qualities that makes Turbonium.com interface so successful is that it doesn't overwhelm the user with too much information. In fact, the entire site includes only 30-40 pages. "It's quick, it's smooth. You can get in easily and it loads fast," Aragones says. "Our feeling is that if the user has gone to the trouble to type in our URL, the least we could do is make the experience easy for them."

The first thing designers did when designing the site's interface was streamline the amount of information included. The site is broken into three main categories: Stuff, which is an e-commerce leg that sells miscellaneous Turbonium promotional items like T-shirts and posters; Turbonium, which is a look at the car itself and its technical options; and Television, which includes video clips from the commercials and a behind-the-scenes look at their development. Or as Aragones explains, the site provides "e-commerce, information, and entertainment."

"When you go to the site, you're not given a myriad of options," Aragones says. "The site's not intimidating, so you don't mind looking around for information. This way, we've filtered down the important information for users and helped make decisions for them. Instead of being a site that tries to accomplish everything, we chose to be a site that did a few things well."

For a user drawn in by the fun, alternative image of the New Beetle, the first turnoff would be a site overwhelmed with technical statistics about the car. Yet, it was important for the site to give the user enough information to hopefully inspire them to take it to the next level—approach a dealership. "When designing the site, we had to balance the design between the tech heads who wanted the solid information and the people who just think the car is cute," Aragones says.

The solution was to include the Turbonium section of the site, providing information about the statistics of the car. But they went easy on the statistics, only including information likely to appeal to the user in an emotional way. "For every spec we included, there were ten more we could have included," Aragones says. "What we did was select the attributes of the car and engine that we felt would elicit the most emotional response. The specs had to be really sexy to make it on the site. The last thing we wanted to do was turn the site into an online spreadsheet."

See the commercial.
Download it.

Drivers wanted.

See the commercial.
Download it.

Drivers wanted.

LEFT: Considering that the modern consumer is bombarded with hundreds of advertising and promotional messages each day, it was crucial for Volkswagen to keep its message consistent across different media in style and approach. The television commercials promoting Turbonium were successful, so the site borrowed from the spot in both design and content. Users can download the commercial, check the schedule for when it next appears, and go behind the scenes during its filming.

LEFT: In order not to interfere with each page's interface, the navigational icon sits in the bottom left corner, a simple black-and-white image—simple, that is, until the user rolls his mouse over it and different options for navigating through the site pop up in color.

OPPOSITE: The use of Flash in the interface's design afforded designers the opportunity to allow visitors to test out different options when configuring their dream Beetle. Here, users could try out colors for the car, combining infinite combinations.

Flashing The User

With literally millions of Web sites competing for users, it's important to find a way to stand out and make your message unique. Since the message Turbonium wanted to convey was the powerful, speedy engine of the new classic, incorporating both sound and swift animation was a natural choice. Subsequently, site designers chose to design the site using Macromedia's Flash.

Set against a white backdrop, the images used are spare, but also powerful and compelling. Swift and clean, the car zips around the screen, effectively conveying the idea that the Turbo Beetle is no slouch in the speed department. That concept was also echoed in the site design. "The car is all about speed and fun, and we wanted the site to be the same way," Aragones says. "The last thing we wanted was users to be slogging through this huge, graphically intense site, when that's not the image we wanted to give the car. The car has a very nimble feel to it, so we wanted the site to feel the same way."

Flash was also a great way to add sound to the site, a key way to convey the turbo quality of the car. "What we were able to do with Flash was take the power of what the program can do and offer people an animated site, one that isn't static, one that plays off people's senses," Aragones says. "Instead of having something that's just visually stimulating, it was something that's stimulating to the ear as well."

Using Flash to design the interface also lent a dynamic quality to how users navigate the site. Mouse rollovers are used to pop up images when the cursor hits them. Animations featuring the car are almost TV-like. The venerable New Beetle Turbo speeds around the screen with appropriate accompanying audio that underscores the speedy image designers hoped to convey.

From a user standpoint, the problem in using Flash is alienating those who have not installed the Flash plug-in. This problem was solved by mirroring the Flash version of the site with a standard HTML version. "We designed the site in Flash first, then we picked and chose all the elements that we thought we could translate into an HTML version of the site," explains Aragones.

Users who don't have Macromedia's Shockwave plug-in installed are immediately forwarded to the standard HTML version of the site. Although this version isn't as dynamic as the Flash version, users won't feel slighted. The same information and graphics style accompanies the presentation, and movement is depicted through the use of animated GIFs of speedy Turbo Beetles, conveying the key characteristic—a powerful engine—that makes this car distinctive.

"The car is all about speed and fun, and we wanted the site to be the same way," Aragones says.

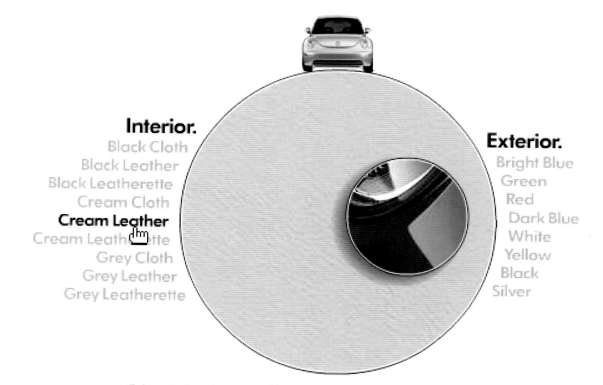

Interior.
Black Cloth
Black Leather
Black Leatherette
Cream Cloth
Cream Leather
Cream Leatherette
Grey Cloth
Grey Leather
Grey Leatherette

Exterior.
Bright Blue
Green
Red
Dark Blue
White
Yellow
Black
Silver

Colors displayed may not all be available on your dealer's lot or for order from the factory at any given time. Contact your dealer for current color availability.

Drivers wanted. VW

Pure Turbonium

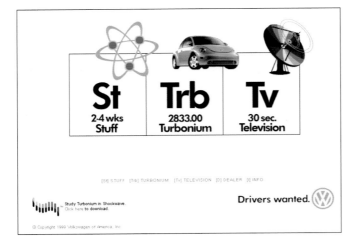

St	Trb	Tv
2-4 wks Stuff	2833.00 Turbonium	30 sec. Television

[St] STUFF [Trb] TURBONIUM [Tv] TELEVISION [D] DEALER [I] INFO.

Study Turbonium in Shockwave.
Click here to download.

Drivers wanted.

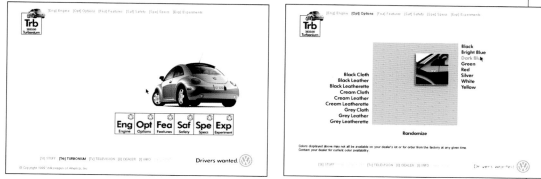

That's Entertainment

The concept of return on the user's investment—time investment, anyway—was an important part of the site's interface design. Site developers wanted to make sure that users were amply rewarded for choosing to spend their online time at the site. Using Volkswagen's image as a company producing a fun, entertaining product provided an obvious segue to providing entertaining content on the site.

"The main thing we wanted to do with Turbonium was provide users with one or two things that they really didn't expect, sort of a reward for coming to visiting the site," Aragones says, "like behind-the-scenes shots of the commercials."

The entertainment portion of this site is also the part with the most planned development in the future. "In the future, we may have screen-savers, game giveaways, behind-the-scenes clips and more," Aragones says.

What makes this site so successful from a user interface standpoint is that it accomplishes a specific, targeted goal of conveying a controlled amount of information very well, rather than dumping a lot of information online for the user to wade through. Through the site's clean design, the product's aesthetic is clearly communicated. And the Web site carries on the message of the successful television commercials to the user's television screen with a message that is clearly integrated with the product's marketing. From a user perspective, it seems odd to laud a company for doing what may seem obvious—keeping the Web site part of the overall marketing plan. But all you need to do is take a spin on the Web to see how that's not necessarily the case.

</volkswagon>

Most designers don't evaluate—or even consider—print design in terms of its interface. Print is just print, and although there are different philosophies for how to lay out a page, everyone reads content and processes images the same way, right?

Wrong. At least, not in a world where desktop publishing has revolutionized the options for page layout and where users process information differently depending on the product and their own personal preferences. In order to stand out from the barrage of print images and products a user encounters each day, designers must use the piece's interface to connect directly with the user.

If you're skeptical about the importance of the interface of a two-dimensional medium like print, look no farther than a newsstand, magazine rack, or bookstore. In each instance, the products are strategically designed to catch the customers' eye and sell themselves to users upon first glance. With the most successful print designs, the external interface carries through the entire product, making it easy for users to process the information, navigate through the piece, and understand the content. ▶▶

‹ i n t e r p r e t i n g › **PRINT**

web <print> product environmental

It also helps to think of how an interface can fail a print piece. If a book's cover doesn't connect with and communicate to the user, it may never get picked up off the bookstore shelf. Without a navigable table of contents, the users will give up trying to find the information she seeks in a magazine. And if a publication like an annual report doesn't make an attempt to render its financial information in layman's terms, the stockholder isn't going to know any more about the company she's invested in than when she picked it up.

This chapter starts with an analysis of the mother of all interfaces—typeface design. Typefaces are possibly the most valuable communications device designers have—knowing how to use them well is essential to crafting a successful interface. MetaDesign's Erik Spiekermann discusses how font contributes to a variety of different designs, and its successes and failures throughout history.

When it comes to periodical design, *Speak* magazine uses its interface to effectively balance hip, graphically adventurous design with strong copy. While publications like *Ray Gun* were praised in the design world for their innovative approach to design, they failed from a user interface standpoint because the content was clouded and overpowered by the magazine's very design. *Speak* pushes the envelope of magazine design, but does so in a way that respects the content. Rather than existing independent of the content, *Speak*'s interface design serves as another layer of interpretation to the magazine's copy.

Annual reports are notorious snoozers. No one really reads them closely (although that probably depends on the amount of money the reader has invested in the company), but these yearly pubs are often written and designed not for the people investing in the company, but for the people already working there. Cahan & Associates took this reality as a challenge, and effectively created annual reports for two high-tech firms that portrayed what they do and what they've done in a fun, playful, informative interface that even people without a Ph.D. in computer science can understand.

Book design is a discipline that gets more competitive every day—in order to stand out in an age of book superstores, you've got to use your design in a way to get noticed. When Chronicle Books designed the interface for *Fat Tire*, a book celebrating the sport of mountain biking, it didn't use the action shots and blurred photography favored by other books on the subject. Instead, it stood out by designing the book with the same logo treatment, same color, and same aesthetic as a bike designer would, appealing to the reader on a base level. To add a tactile element, a raised rubber tire tread was glued to the cover, making it an object that begged to be handled.

What the interface of each of these publications proves is that with a targeted approach, designers can use a project's interface to speak and interact directly with the user. It is at this point that the design transcends two dimensions and becomes interactive with the user—a sure sign of a successful interface.

</printintro>

OPPOSITE: The most successful typefaces were designed to meet a specific need within an interface. Times' readability and elegance was crafted specifically to meet the needs of the venerable *New York Times'* readership, and hold up well when printed on newsprint. The utilitarian, classic qualities of Times made it into an instant classic, a face adapted and used by a variety of sources, from print books to the Web.

P:69

<metadesign>

‹ FONT DESIGN: METADESIGN ›

IN ITS MOST BASIC FORM, TYPE IS AN INTERFACE. IT COMMUNICATES AN INTENDED MESSAGE TO THE USER, FACILITATES COMMUNICATION, AND INCITES A RESPONSE (IF ONLY AS COMPREHENSION). TYPE'S APPLICATION IS VERSATILE—THE WRITTEN WORD COMMUNICATES EFFECTIVELY ACROSS DISCIPLINES: IN ENVIRONMENTS, IN PRINT, ONSCREEN, AND ON PACKAGING. BUT AS SIMPLE AS THE RELATIONSHIP BETWEEN TYPE AND COMMUNICATION MAY SOUND, JUST ANY TYPEFACE WON'T ALWAYS WORK. AS WITH ANY ASPECT OF USER INTERFACE DESIGN, THE TYPE USED MUST RESPOND TO THE USER NEEDS AND FORM A RELATIONSHIP WITH THAT PERSON. FOR A DESIGN DEVICE WITH FAR-REACHING APPLICATION AND SUCH A VITAL MISSION, IT'S ESSENTIAL TO KNOW HOW TO USE TYPE EFFECTIVELY.

Solving A Specific Problem

As with any effective user interface design, using the correct typeface for the job is based on solving a problem and meeting a need. A frequent mistake designers make is choosing typeface according to their own tastes instead of according to user needs. This is a dangerous trap to fall into: Instead of serving as a vehicle for the artist's expression, an effective interface design is first and foremost a communication tool tailor-made for the user.

What a user needs to take from an interface depends on the interface itself and the intended communication. "There are certainly physical considerations when it comes to typeface design, like resolution, size, and contrast," says Erik Spiekermann, founder of MetaDesign in Berlin. "But the most successful typefaces have been designed to solve a specific problem. They don't come from a designer's whim."

When in doubt, consult the masters. Some of the most popular typefaces today were crafted specifically to meet the needs of past design projects. "Bodoni designed all his faces for specific books," Spiekermann says. "Times was designed for the newspaper of the same name—Frutiger for signage at Charles de Gaulle airport. Helvetica was designed to appeal to certain graphic designers and Bell Gothic for American telephone books. Gill was designed for a storefront, Century for a magazine, Meta for a German post office, and Officina for office correspondence on laser printers."

As essential components of successful interfaces with wide audiences, these typefaces became classics. "Most classics were purpose-made," Spiekermann says. "They never tried to solve all problems at once. Typefaces that try to do that fail, because they have to be bland beyond recognition. Those that have all the qualities of the historical models that have survived centuries but offer slight variations tend to be more successful than vain faces that shout, 'Look here! I'm new!' And you can always mix one designer's face with his other designs. All good designers have a personal style that will never be too explicit, but will guarantee a happy marriage of different fonts on one page."

AaBbCcDdEe
FfGgHhIiJjKk
LlMmNnOoPp
QqRrSsTtUu
VvWwXxYyZz
1234567890

ABOVE: Since the first rule of interface design is communicating with the user, a clean, no-frills face lends a quality of versatility to a variety of different interfaces. Common threads in the world's most versatile typefaces are simplicity, economy of space, and a clean look, as evidenced by the ubiquitous Helvetica. Introduced during the 1950s, this face has endured over time as an example of universal, clean, rational design.

What made these typefaces classics were that they embodied several common design tenets—like readability and aesthetics— with subtle differences that made them particularly applicable to different media. Their widespread use is a natural segue when considering that a variety of interfaces have similar design needs. For instance, the classic elegance of Times, originally designed for *The New York Times*, makes it an obvious choice for setting type for books or other text-heavy interfaces.

"What works well for one problem works well for another," Spiekermann says. "Faces that were designed for challenging production conditions—like newspapers or phone books—will also work well on screen, because resolution, size, and contrast pose similar problems. Even faces designed to be used in small sizes will work well on signs, as they are perceived from a distance, making the type look as small as that on a page that is read from 10 inches away. Definition, critical shapes, figure-ground contrast (positive verses negative space) are the main issues, regardless of media."

Connecting Through Type

Consequently, the most important thing to do when selecting an appropriate typeface for an interface is determining the needs of the user. Issues like where the type will be read, the message it is trying to communicate, and who the user is should all be taken into consideration. "There are physical laws [to consider]—our eyes, our brain, light, contrast," says Spiekermann. "You can't ignore these if you want to communicate to many people. Then, you must consider the cultural parameters like reading habits, literary culture (or lack thereof), and expectations. We read best what we read most. These laws of perception as well as cultural traditions have to be taken into account."

Therefore, it's important that the emotional and practical weight of a typeface be evaluated in terms of the media and the user it is associated with. You don't want to use nine-point type for a publication aimed at senior citizens, or necessarily use an ultra-conservative serif when designing a poster for a punk-rock band. When determining what the right type is to use for a job, it's important to think of the user.

And no matter who the audience is, you have to make sure that the type is coherent within its interface. In other words, type should first and foremost be a vehicle of communication, not the message itself. "There is very little room for 'creativity' in typeface design," Spiekermann says. "There tends to be too much movement away from what the reader perceives to be something that exists without having been specially designed and a face attracts too much attention to itself instead of to the text. A successful typeface has to look almost like all the others, but just be a little different."

Again, this is a simple issue of knowing your user. As Spiekermann says, "What some people consider noise, others pay $16 for in a record store. What some people find ugly and illegible, others are attracted to. Tribal language has tribal type. If you're used to the *Wall Street Journal*, small type won't frighten you."

Depending on the interface that type is used with, sometimes comprehension is downright crucial. "How people interpret information could even be a matter of life or death," Spiekermann says. "The difference between being a survivor and being a casualty could be as simple as finding a 'Way Out' sign." Although not every interface will have such dramatic consequences, it does go to show that you don't want to chance your message to interpretation by confusing your user with the interface.

BELOW: As the interface medium changes, so do the standards for optimum communication. Since many tried-and-true fonts weren't holding up onscreen, typographer Matthew Carter developed a sans serif (Verdana) and a serif (Georgia) specifically for screen-based typography. Each font was designed with a larger x-height (the height of the lowercase letter "x"), which meant that onscreen, these letters were larger, and therefore more legible. Letter combinations like "fi," "fl," and "ff" were designed clearly so they wouldn't touch. Spacing between characters is much more generous, making this onscreen typography easier for readers to scan quickly.

VERANDA

AaBbCcDdEeFfGgHhIiJjKk
LlMmNnOoPpQqRrSsTtUu
VvWwXxYyZz1234567890

GEORGIA

AaBbCcDdEeFfGgHhIiJjKk
LlMmNnOoPpQqRrSsTtUu
VvWwXxYyZz1234567890

AaBbCcDdEeFfGgHhIiJjKkLlMmNnOoPpQq
RrSsTtUuVvWwXxYyZz1234567890

OPPOSITE: Although practical considerations like readability and communication are essential when it comes to interface design, it's just as important that the aesthetic and mood of an interface appeal to its target user. If readability were the only consideration when it came to interface design, alternative font designs wouldn't be so popular. Using charged, charismatic, nontraditional fonts like Crackhouse and Randomhouse (designed by House Industries), designers can use the piece's typography to carry through the character of the interface, while appealing specifically to a targeted demographic.

BELOW: Different media demand different things when it comes to typefaces. Erik Spiekermann designed Officina to respond to the interface needs of the standard office memo, fax, or other business correspondence. The face is slightly condensed, allowing more information to fit on the page, and the font's serifs are prominent so they won't deteriorate, even at small sizes or under the stress of copiers or fax machines.

OFFICINA SANS

AaBbCcDdEeFfGgHhIiJjKk
LlMmNnOoPpQqRrSsTtUu
VvWwXxYyZz1234567890

OFFICINA SERIF

AaBbCcDdEeFfGgHhIiJjKk
LlMmNnOoPpQqRrSsTtUu
VvWwXxYyZz1234567890

OPPOSITE: The popular contemporary typeface, Meta, was born when the German Post Office (Bundespost) commissioned Erik Spiekermann to design a typeface for all their printed material. When designing this face, Spiekermann defined the goals the correspondence's interface hoped to achieve: "Being legible, particularly in small sizes, neutral—neither fashionable nor nostalgic, economical in use [space-saving], available in several clearly distinguishable weights, and unmistakable and characteristic." Although Bundespost canceled the project in favor of the "safer" bet, the tried-and-true Helvetica, the same qualities that Spiekermann earmarked as part of this design clearly were applicable to other interfaces. Meta predictably became the "house font" of MetaDesign, and a favorite with design magazines like I.D. and HOW.

Cross-Cultural Considerations

When considering interface design across cultures, the issue recalls the user interface design mantra: It's simply a matter of knowing your user. There's no recipe for the best type to use with the right interface in the right culture. What's important is knowing what is necessary for the user to take from the interface and selecting a typeface that achieves that goal.

"Words look different in other languages," Spiekermann says. "So does type. And certain traditions have created certain reading habits. If you can't read Chinese, that doesn't make Chinese unreadable, just illegible to you. I can still read Fraktur (German Black Letter), because I learned it at school in the 50s. My sister, who is only three years younger than me, can't read it because they stopped teaching it by the time she went to school. That doesn't mean that she's less intelligent than me any more than it means that Black Letter is unreadable."

It's for these reasons that Spiekermann makes a plea for effective information design in interfaces. "We're constantly bombarded by messages, all trying to make us look, to make us listen, to make us react," he told MetaWeb in an online interview. "Some of these messages, however, are more important than others...This is where the information designer comes in. It's his or her job to know that what's required here is more than just 'good' design. What's the point of creating a swell-looking layout and printing it in attractive colors when all the wrong questions are being asked in all the wrong ways?"

</metadesign>

META NORMAL

AaBbCcDdEeFfGgHhIiJjKk
LlMmNnOoPpQqRrSsTtUu
VvWwXxYyZz1234567890

META BOLD

AaBbCcDdEeFfGgHhIiJjKk
LlMmNnOoPpQqRrSsTtUu
VvWwXxYyZz1234567890

meta

SPEAK

film fiction **conver** music **sation** art

HO-HO

TRADE MARK

november/december $4.50
$6.75 Can

OPPOSITE: In an attempt to connect with readers on a base level, *Speak*'s design incorporates a hand-drawn quality into many of its design elements, not the least of which is the logo. Constructed from chartpack tape and letterforms, the logo's lines are rough and uneven. This approach gives the user something few contemporary magazines offer: a tactile feel. This effectively sets the tone for the rest of the magazine and gives the reader a very different experience from the slick, glossy, computer-perfected magazines currently populating newsstands.

BELOW: Strong visual elements that are used throughout each issue of *Speak* are echoed in the table of contents and masthead to provide a cohesive quality to the issue and tie the different articles together. For instance, Venezky used an orange as a visual element in two different features in this issue. This image is repeated throughout this entire section, echoing the design element used in each of the feature stories. Also, the issue number here is pulled out, and made large and bold, underscoring the progression of issues, and *Speak*'s visual thumbprint, the colon, is used to offset the different sectors and separate titles from their feature heading.

‹ MAGAZINE DESIGN: *SPEAK* ›

WHEN *RAY GUN* DEBUTED IN THE FALL OF 1992, IT WAS REALLY THE FIRST WIDELY DISTRIBUTED MAGAZINE TO CHALLENGE CONVENTIONAL PUBLICATION DESIGN BY USING A BOLD DESIGN APPROACH AS A WAY TO ENHANCE CONTENT. ALTHOUGH THE DESIGN WAS LAUDED AS REVOLU-TIONARY, AN OFTEN-HEARD COMPLAINT FROM THE READER WAS THAT IT WAS OVERWHELMING— INSTEAD OF ADDING TO THE TEXT, MANY READERS FOUND THE VISUALS WERE COMPETING WITH IT BECAUSE THEY WERE TOO DISTRACTING. NOT TO MENTION, THE COPY WAS OFTEN RENDERED IN BARELY LEGIBLE FONTS AND SUBSEQUENTLY LARGELY IGNORED. FROM A USER INTERFACE POINT OF VIEW, THE DESIGN FAILED—ALTHOUGH IT MAY HAVE BROKEN NEW GROUND WHEN IT CAME TO STYLE AND FORM, IN MANY CASES, IT FAILED TO CONNECT WITH THE READER BEYOND THE SURFACE OF DESIGN.

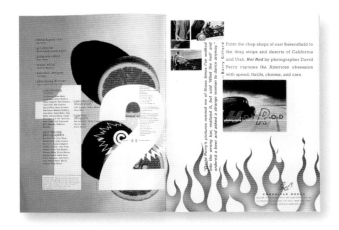

When it launched in October 1995, *Speak* magazine fell into many of the same trappings. Although this literary and popular culture magazine's design was relatively conservative when compared to *Ray Gun*, most of the attention it received at first was from designers who embraced its progressive design, but didn't necessarily connect with the content. Despite the enthusiastic praise of the design community, most designers failed to look farther than the design, often glossing over the copy. "We did a large reader survey and it was remarkable that almost everyone who described themselves as designers or design students had no comments on the content of the magazine, although they spoke ad nauseam of typefaces, headlines, and the like," says Dan Rolleri, *Speak*'s editor and publisher.

Speak didn't want to be exclusively an art object—the editorial staff worked as hard to perfect the content as the designers did its look. From the reader response to the first few issues, it was clear to the *Speak* staff that design was overwhelming the content. For *Speak*, design was to be the vehicle, not the destination. From here, the staff set out to make this a magazine with progressive design interface that didn't overwhelm the copy.

Reinventing Conventional Design

Part of repositioning the magazine to appeal to people outside the design community meant defining who the target user was. "The intended reader is someone who gets pleasure out of the combination of smart editorial and interpretive design," Rolleri says. From this editorial profile, the interface design followed.

The first thing that was done to appeal to the newly defined target user was tone down the interface by using a more conventional approach. "After the first few issues, we made a concerted effort to make the magazine a lot less design-intensive," says Martin Venezky, *Speak*'s art director and head of San Francisco's Appetite Engineers. "The layout itself is kind of conventional. It's regimented in certain elements, but what we do with those elements keeps changing."

Like most magazines, every feature starts out with a spread including the title, byline, and subhead along with a visual element used to open the piece. And the body copy is relegated to two standard faces: Century Expanded and Univers Condensed. Profiles are all identified with a standard identifying visual element.

However, it was how these contemporary elements were used that made the interface unique. "We intentionally created some parts of the magazine to be formatted to keep a consistent look," Venezky says. "But we also wanted something that was very flexible." Images may be blown drastically out of proportion or scaled into the background. Quotes are pulled out in large type, with wildly exaggerated justification. Standard publicity photos sent to accompany a piece may be colorized or cropped in an unusual way, creating a new perspective, and effectively reinventing them. The logotypes created to identify the profiles are a collage of type, color, and images. Additionally, the background for the profile is altered by the sex of the subject. "For 'girls,' we use a red Doris Day picture in the background and for 'boys,' we use a cowboy," Venezky says.

By using a standard interface in an unusual way, *Speak*'s design changed the user experience of reading the magazine. Instead of competing with the copy, this design approach adds another layer of interpretation to the content— when designing, Venezky is very careful that the magazine's design does not interfere with the legibility of the text. "We want to make things legible, but not boring," Venezky says. "We like the visual aspect of *Speak*, but wanted to be more of a magazine you read with a striking visual presence than simply a design magazine. Most importantly, we wanted the visuals to work with the text."

Visual Elements

Speak uses a few recurring visual elements as a way to subtly underscore the magazine's focus, drive, and identity, a constant branding of the magazine to the user. Derived from the magazine's title, a colon is used as a frequent element in everything from page numbers to endstops.

"We use a colon because the magazine's name was '*Speak*,' and a colon is what is typically used after questions in an interview," Venezky says. "We just sort of followed that through in the design." The page numbers are wedged between the dots of an oversized, horizontal colon at the bottom of each page and a series of three colons serve as an endstop at the end of each story. Turn to the table of contents and the colon is used to set off each of the different categories. The colon is also integrated in many other random ways throughout the design of each issue.

Another recurring element of the magazine's design is the use of different fonts to set quotes apart from the rest of the text in each story. Again preserving the legibility of the text itself, Venezky chose fonts that are simple, readable, and clear, while varying the fonts to pull out the quotes and set them off from the rest of the text, a way to draw the user's eye to the difference between the two in the copy. "With everything but the fiction section, we do the quotes as serif and the text as sans serif," Venezky says. "For fiction, it's the other way around. By separating quotes visually from the rest of the text, I think we make it more readable. It's more time-intensive to design, but I don't mind because I'm happy with the result."

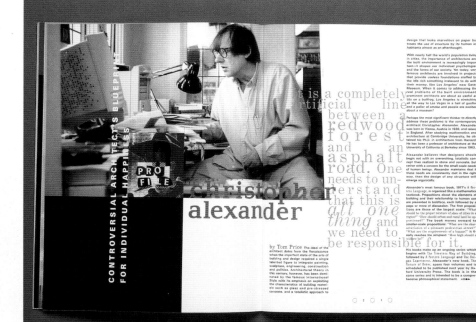

...times I've walked that the hell' and to dance anyway."

—Barry Gifford

Fro the an Pe wi

SPEAK is not responsible for unsolicited artwork.
SPEAK (ISSN 1088-8217) is published bimonthly by
SPEAK Magazine,
301 8th Street, Suite 240
San Francisco, CA 94103 •••
main: 415 431 5395
events: 415 431 5396
fax: 415 431 5397
advertising: 562 496 1720

E-mail main: publish@speakmag.com
advertising: jwlockhart@earthlink.net
art: venezky@sirius.com
web site:
http://www.speakmag.com/speakmag
postmaster: send address changes to
SPEAK Magazine, 301 8th Street,
Suite 240, San Francisco, CA 94103.
application to mail at periodicals
postage rates is pending at
San Francisco, CA, •••
subscriptions:
15.00 for six issues
60.00 (international air)
All rights reserved.
Reproduction in whole or in part
without permission is
prohibited.

right 1 9 9 8 by Speak magazine.

"David Perry's into the wrong ordered a bee

PROFILE

CONTROVERSIAL ARCHITECT'S BLUEPRINT FOR INDIVIDUAL HAPPINESS

christopher alexander

by Tom Price The ideal of the architect dates from the Renaissance when the imperfect state of the arts of building and design required a single talented figure to integrate painting, sculpture, engineering, construction and politics. Architectural theory in this century, however, has been dominated by the famous international Style with its emphasis on exploiting the characteristics of building materials such as glass and pre-stressed concrete, and a totalistic approach to design that looks marvelous on paper but treats the use of structure by its human inhabitants almost as an afterthought.

With nearly half the world's population living in cities, the importance of architecture and the built environment is increasingly important—it shapes our individual psychologies and the forms of our society. Yet today, very famous architects are involved in projects that provide useless foundations staffed by the idle rich something irrelevant to do with their money, like Los Angeles' new Getty Museum. When it comes to addressing the real problems of the built environment, prominent architects are about as useful as tits on a bullfrog. Los Angeles is stretching all the way to Las Vegas in a hail of gunfire and a gallop of smoke and people are excited about a museum?

Perhaps the most significant thinker to directly address these problems is the contemporary architect Christopher Alexander. Alexander was born in Vienna, Austria in 1936, and raised in England. After studying mathematics and architecture at Cambridge University, he obtained his Ph.D. in architecture from Harvard. He has been a professor of architecture at the University of California at Berkeley since 1963.

Alexander believes that designers should begin not with an overarching, totalistic concept then realized in stone and concrete, but rather with a concern for the small-scale needs of human beings. Alexander maintains that if these needs are consistently met in the right way, then the design of any structure will emerge organically.

Alexander's most famous book, 1977's A Pattern Language, is organized like a mathematics textbook. Propositions about the elements of building and their relationship to human use are presented in boldface, each followed by a page or more of discussion. The first propositions are those of the largest scale: "What should be the proper mixture of sizes of cities in a region?" "How should urban and rural land be apportioned?" The book moves onward to smaller-scale propositions: "What are the characteristics of a pleasant pedestrian street?" "What are the requirements of a house?" It finally reaches the simplest: "How high should a window be?"

His books make up an ongoing series which begins with The Timeless Way of Building, followed by A Pattern Language and The Oregon Experiment. Alexander's new book, The Nature of Order, spans four volumes and is scheduled to be published next year by Oxford University Press. The book is in the same series and is intended to be a comprehensive philosophical statement. •◆•

is a completely artificial line between a redwood forest and an asphalt road. One needs to understand that this is all one thing and we need to be responsible for it.

0 2 0 5 0

ABOVE: Although many people consider *Speak*'s design to be cutting-edge and experimental, upon closer examination, there are actually many regimented qualities about the magazine's design. It's how the design uses these different elements that sets *Speak* apart. For instance, a visual icon sets off the profile section in each issue. When a man is profiled, a blue cowboy is used in the background; when a woman is profiled, a pink Doris Day is used. Over this, the word "profile" is spelled out in collage-like letters. While the title runs vertically up one side, the subhead is rendered large in an imperfect, crudely justified (but readable) column. Type is featured in a dark sans serif, while quotes are rendered in a traditional serif font, Century Expanded.

ABOVE: As a way of adding an interactive user element to the magazine's traditional 8-1/2 x 11 inch size, Venezky designed a gatefold, which is run in the middle of the magazine. This is an element that the user must unfold in order to work with, which also gives the magazine a different size to represent the story. Here, the reader is given a feel for the vast space in this convention center where willing people wait to get their treasures appraised for the television show, Antiques Roadshow. When the pages are folded in, the user gets a close look at some of the treasures included and attention is drawn to the piece's photography.

LEFT: Although this spread may not look like what you'll find in a typical magazine (one of the qualities that draws readers to *Speak*), it's got all the essential design elements that any other magazine may have. Included are the title, subtitle, and byline, which set off the articles' text. But the featured woman's picture is scanned in sideways and tinted pink, then scaled back to provide a backdrop for the spread. The title is an imperfect, jarring marriage of two different typefaces, adding extra meaning to its words: "I'm breaking hearts..." (take special note of how the "b" itself is bisected). A visual element identifies this as a music piece and the author's contribution to the text of this Q&A is set off in serifed all-caps, while the text itself is an easy-to-read sans serif.

"We like the visual aspect of *Speak*, but wanted to be more of a magazine you read with a striking visual presence than simply a design magazine. Most importantly, we wanted the visuals to work with the text."

Connecting With The Reader

In order to connect with the reader on a fundamental level, Venezky's designs intentionally avoid the slick, sterile approach of many contemporary magazines. Many of the magazine's design elements are created by hand, giving them a tactile, low-tech look. The magazine's logo conveys this approach before the user even picks up the magazine. A sort of rocket ship arrow, the new logo (which debuted with the July/August 1998 issue) was created simply using chart-pack tape (the sticky, thin, black tape that pre-desktop publishing designers used for creating rules and linework by hand) and letterforms. "If you look closely at it, you'll see that the lines are very crudely drawn," Venezky says. "Even the spacing and diagonals aren't perfect between the letters." The imperfect approach to the magazine's style gives a sort of gritty charm to the design. The end result is a magazine that users are more likely to spend time with and inspect closely, unlike the computer-regimented perfection you're likely to find on the newsstands.

Along the same lines, much of the type you'll find in *Speak* is manipulated by hand in an attempt to give unique ownership to their use with the corresponding story. Letters are cut from other magazines to use in subheads and others are hand-drawn. Also, the photos used may be old, damaged photos giving the subject a gritty feel. Fabrics are scanned into the background and used as elements to give the pages texture. *Speak* has truly set itself apart from other contemporary magazines with this approach in a day when electronic publishing allows designers a great degree of precision.

With print, there are fewer obvious ways for the user to directly interact with the design. *Speak* found an interesting way around width through the use of gatefolds. Often used with the issue's lead story, the gatefold must be unfolded, effectively doubling the 17 x 11 in. spread size. "We like the tactile quality of the magazine," Venezky says. "That's one of the reasons why we have a gatefold. It is something the reader actually has to open up and interact with."

Interpretive Fiction

Since the fiction section is the most mercurial element from issue to issue, it is the least regimented section of the magazine. Venezky uses the design as an added layer of interpretation of the story. "When designing the fiction section, I try to interpret the copy openly but carefully," he says. "I choose imagery for the design that goes with the fiction, but isn't a direct illustration. It's a couple of steps removed—you really have to read the article closely to pick up on the correlation of the images."

During the design process, Venezky sometimes brainstorms with *Speak*'s editor and publisher, Dan Rolleri. "I tend to toy with him a bit," Venezky says. "I think I know what he thinks I'm going to do and do the opposite. For instance, if it's a violent article, I may come up with something really sedate. We have some fun with that."

But the images are never chosen at random. "You can tell when people aren't reading the articles when they say, 'I like your random style,'" Venezky says. "It's only random if you don't read the articles."

By making the design an extension of the copy and not an end in and of itself, Venezky adds another dimension to the text. This approach makes *Speak* even more of what it aims to be, as Rolleri says, a magazine that "challenges people's expectations both editorially and artistically. You won't find typical product endorsements, celebrity profiles, fashion layouts, music reviews, etc. in our pages. And regarding design, you won't ever find Martin taking the obvious or easy way out. A small detail in a piece of fiction, for example, may provide inspiration for an entire layout."

</speak>

LEFT & BELOW: The least regimented section of the magazine's interface is the fiction piece in each issue. Here, Venezky spends time with the copy and comes up with a design that complements the text. "I choose images that are surprising, that go with the fiction, but aren't direct illustrations," Venezky says. "You have to read the article closely to see the correlation of why the images are there. I want it to be a couple of steps removed." For this piece, Venezky did the photography himself to illustrate the piece, but on the succeeding spread he leaves the focus clearly on the text itself so visuals don't compete with the copy.

ABOVE & RIGHT: *Speak* makes its interface work by using traditional magazine design elements, but in an unusual way. For instance, the World section has all the elements of a standard magazine column—a feature head, sidebars, and artwork to illustrate the content. But the pages take on an interesting personality all their own by scaling art into the background and playing with the leading and kerning of type in pullout quotes. The page holds together as its own entity with the layout, but the individual style offers interpretation to the copy.

"When designing the fiction section, I try to interpret the copy openly but carefully," he says. "I choose imagery for the design that goes with the fiction, but isn't a direct illustration. It's a couple of steps removed—you really have to read the article closely to pick up on the correlation of the images."

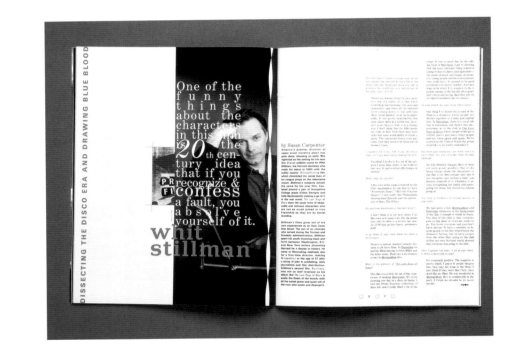

Although *Speak*'s interface design does have great reverence for traditional design tenets, it does have fun pushing the limits of some of the more traditional rules. The title for this profile runs vertically to the edge of the page. The subhead justifies the text in an exaggerated way, allowing words to run together and even overlap. Although the design is experimental, it doesn't interfere with the readability of the content.

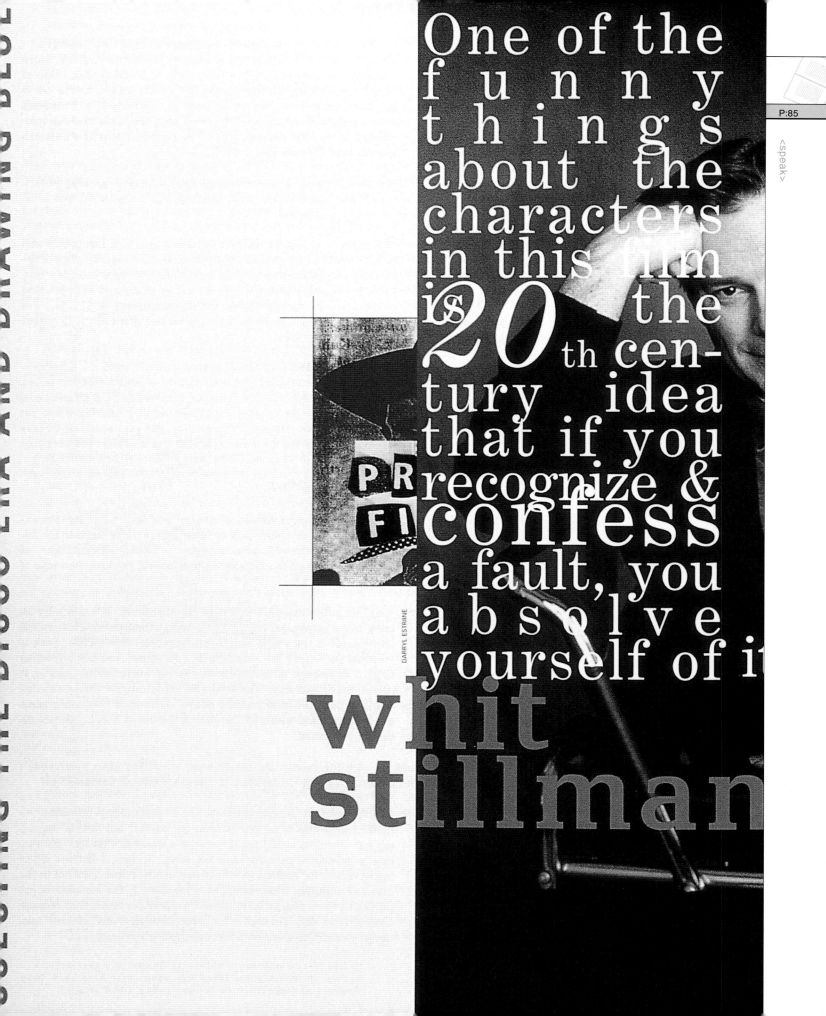

One of the funny things about the characters in this film is 20th century idea that if you recognize & confess a fault, you absolve yourself of it

whit stillman

DARRYL ESTRINE

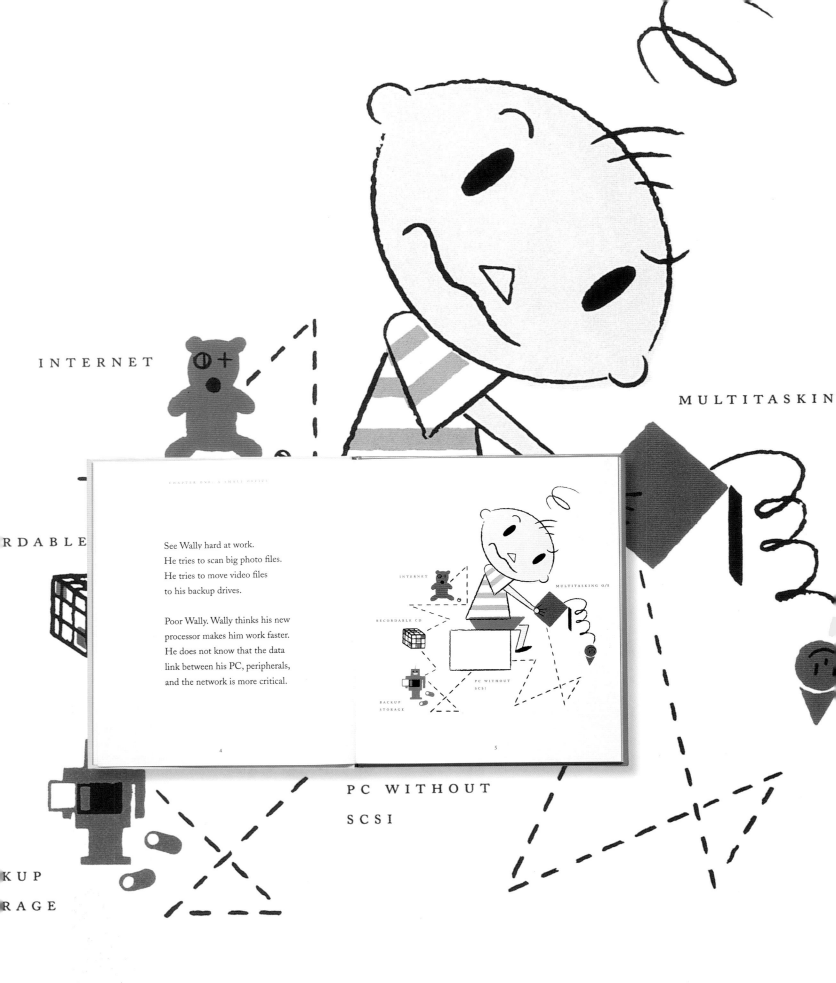

CHAPTER ONE · A SMALL OFFICE

See Wally hard at work.
He tries to scan big photo files.
He tries to move video files
to his backup drives.

Poor Wally. Wally thinks his new
processor makes him work faster.
He does not know that the data
link between his PC, peripherals,
and the network is more critical.

INTERNET

RECORDABLE CD

BACKUP
STORAGE

MULTITASKING O/S

PC WITHOUT
SCSI

4

5

OPPOSITE: Instead of overwhelming the reader with a variety of bar graphs and spread-sheets, the report's information is communicated through the unintimidating interface of a children's book. In this way, the complicated concepts about data and networking are presented through the patently simple story of Wally and Molly. The copy is written in the simple language of children's books, while integrating words like "processor," "data link," "peripherals," and "network." Keeping with the theme, the artwork was created in a simple, cartoonish style by illustrator Richard McGuire, who kept the tone playful, the approach simple, and (most importantly) the annual report interesting.

‹ ANNUAL REPORTS:
CAHAN & ASSOCIATES ›

ANYONE WHO HAS EVER DESIGNED AN ANNUAL REPORT KNOWS THAT THE FIRST OBSTACLE IS FINDING A WAY TO GET PEOPLE TO READ THE DARN THING. SO, WHEN YOU'RE DESIGNING AN ANNUAL REPORT FOR A HIGH-TECH COMPANY, YOU MIGHT AS WELL THROW IN THE REQUISITE BAR GRAPHS, LETTER TO THE SHAREHOLDERS, AND CALL IT A DAY, RIGHT?

Child's Play

The key to any successful interface is effective communication, a considerable challenge when you're pitching a topic like data networking systems to readers who probably don't have an electrical engineering degree. With the design of Adaptec's 1996 annual report, the intimidation factor of the material is eliminated by couching it in the most friendly way possible—by using an interface modeled after a children's book.

The interface is about as unintimidating as possible. The annual report is bound in a colorful hard cover and illustrated with the cartoon images of Molly, Wally and their dog, Data. The copy, set in the large typefaces characteristic of children's books, tells how Wally isn't able to work quickly since big file sizes are slowing his processor down. Molly, however, is wiser. The story tells how, with the aid of her Adaptec host adapter, Molly is able to multitask and work much more efficiently. As the copy reads, "See Molly at work. She is doing all the things that Wally is trying to do. Only she does them better. ... From her PC to peripherals, and even to her network, she really works fast!"

ABOVE: When Adaptec approached Cahan & Associates to design their annual report, once again the design firm found a way to have fun with a subject (networking systems and data transfer) that is of little interest to anyone who isn't a computer scientist. First, they needed to identify the information that is important for shareholders to know about. The interface's design was elementary, if you'll forgive the pun. The approach was to broach this complex subject within the most simple interface possible—a children's book. The annual report was presented to share-holders as a children's book titled A B C & D or All About Being Connected to Data, told through the cartoon characters Wally, Molly, and their dog, Data.

The playful introduction to Adaptec's basic mission paves the way for the story of Adaptec and financial statement. The spirited text and illustrations consistently carry the annual report's theme while allowing readers to glean solid information along the way.

Believe it or not, Bill Cahan, principal of San Francisco's Cahan & Associates, found a way to get shareholders to enthusiastically read the annual reports for Adaptec, a Silicon Valley high-tech networking and data transfer company, and Molecular Biosystems International, a company that develops ultrasound and echocardiogram technology. Best of all, the solution didn't involve bribery or subliminal messaging. Instead, the thoughtful, creative interface of these annual reports allowed the user a deeper understanding of the company by expanding the focus beyond statistics and marketing copy. The result was beneficial for both the company, who used the report as a strong communication tool for shareholders, and the reader, who gleaned a better understanding for the company with whom they had invested their money.

Balance between the playful tone and factual information was extremely important to this report's interface. Just when things start getting a little dry with a letter to the shareholders, the book's design brings the light theme back to the forefront by capping off the letter with a caricature of the letter's authors: the chairman of the board and president/CEO. In this way, the playful design balances with meaty, factual information, allowing the annual report to be both informative and a lot of fun to read.

computing performance as are multitasking operating systems or the latest generation of central processing unit.

With the adoption of exciting applications and tools like distributed storage, data warehousing, and RAID, the need for reliable, high-performance connectivity is expanding rapidly.

Businesses today are built around the availability of computers and data. The value of the data to the business can be incalculable, yet the cost of the devices storing and using it is really very small. This is where Adaptec's core competencies of performance, compatibility, reliability, and ease of use, add sustainable value to our customers. We enable our customers to exploit the full value of their data by reliably, easily, and speedily moving it to wherever users need it.

Despite our many products, our expertise in silicon design, and our broad software competencies, Adaptec's business is elegantly simple: we provide technology to manage the bandwidth our customers need to use information more quickly and more easily. As in past years, our annual report's thematic section is designed to communicate our business and its value in a memorable, straightforward way. Together with the information in our financial section, we hope it tells a compelling story of Adaptec's value. As always, we thank our employees, shareholders, partners, suppliers and customers for their support. We look forward to sharing our future with you.

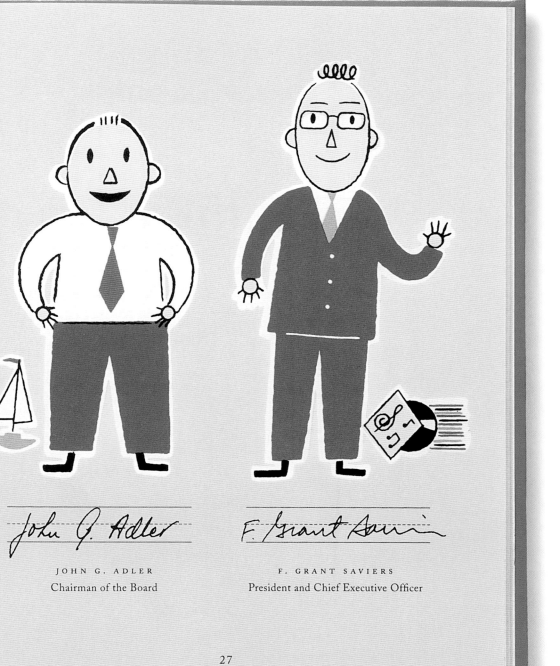

JOHN G. ADLER
Chairman of the Board

F. GRANT SAVIERS
President and Chief Executive Officer

Invoking Interest

From the very first glance, this annual report stands apart—and its unusual format is another secret to its successful interface. Curiosity about this annual report masquerading as a children's book simply won't allow readers to ignore it, meeting the first (and most important) goal of an effective interface—capturing the reader's interest. Cahan's hook was to simply make this report irresistably quirky and unusual.

Not only does the design invite the user to pick it up, but it does so in a completely innocuous, nonthreatening way. Virtually any stockholder, regardless of her experience or comfort level with Adaptec's technology, is going to be overwhelmed by information pertaining to data networking technology and its subsequent financial history over the past year. But when Adaptec gently pokes fun at its complex subject matter and potentially dull statistical information by conveying these facts in a playful, unintimidating way, the interface immediately eliminates barriers with its audience, and opens the lines of communication.

Content And Design

Although Cahan carried the motif of the children's book throughout the book, the information included is no less meaty than what you would expect to find in any other annual report. All the facts, figures, and statistics that an Adaptec shareholder would expect to find in an annual report are there. The only thing really different about the content of this report is its unconventional presentation.

Balance is a very important component of an unconventional interface like this one: It was important for the tone not to be too playful, undermining its authority, or too serious, undermining its whimsical approach. The content and design work in tandem to propel the reader through the report. For instance, when the report gets a little dry with miscellaneous facts, the lighthearted design comes to the rescue. Following the letter to shareholders from the president/CEO and chairman of the board, a cartoon drawing of both men is featured with their signatures. Underneath the "Results of Operations" statement, an exuberant Wally is shown jumping up in celebration of the impressive figures.

Tiny details like these further humanize the company, make the people who work there seem approachable, and demonstrate their sense of humor. But most importantly, these details carry the theme throughout the report, maintaining the tone and the reader's interest. And the novelty of the annual report doesn't outweigh the heft of the information provided—although the design is bold, it is still the content that carries this report.

Did Cahan & Associates just luck out with a daring client who was willing to take an unconventional approach to the company's annual report design? Not quite. Despite the irreverence and wit surrounding the piece, Adaptec was understandably hesitant to jump into this new approach, concerned about if the product and company were taking themselves a little too lightly, design awards aside.

<cahan & associates>

Wow!

ADAPTEC

BANDWIDTH MANAGEMENT

HIGH-PER

APPLICATI

SELECT THE WHITE FORD TAURUS

1. 2.
3. 4.

Breaking Traditional Design Barriers

You thought data networking was a complex topic? What about the development of echocardiography or ultrasound imaging technology? The company directors of Molecular Biosystems International (MBI) needed a way for its shareholders to understand what the company does long enough to keep their money invested with them. So when Cahan & Associates landed the job of designing MBI's annual report, they knew that they'd better come up with a way to convey the intricate technology this company develops in a way that makes sense to shareholders.

Right off the bat, readers know this report is going to be different because, like the Adaptec annual report, the MBI report interface is markedly different from how one would expect it to look. Breaking the barriers of the typical 8-1/2 x 11 in., perfect-bound brochure, the report's 10-1/4 x 12-1/2 in. format looks less like an annual report and more like a magazine. Cahan efficiently used visual cues like this in the report's design to establish the nontraditional approach and to immediately orient the reader.

The first pages of the report's interface don't mention ultrasound images at all, a curious decision for an annual report dedicated to reporting on the success of this technology. Instead, these pages feature a series of faintly visible images rendered in duotone. Brief captions challenge the reader to identify the

images. Is the figure in one image Bigfoot or a lumberjack? Is that a picture of meatloaf or foie gras? Is that a UFO or a Frisbee? And what's the reading on that home pregnancy test? These images, offered outside of any sort of context, work as a kind of tease—a clever device to appeal to the user's curiousity and get her to read more.

The reader's curiosity about the nature of these frustratingly low-contrast images plays perfectly into the report's message. Following the intriguing series of images, the report's copy reads: "The mythical creatures depicted on the cover of this book illustrate an important point: It is difficult without contrast to distinguish between reality and illusion."

The reader is then asked to examine the non-contrast image on the facing page and determine if this echocardiogram indicates an: A) blood clot; B) wall thickening; or C) artifact. The copy goes on to explain that MBI's product creates contrast in echocardiograms, a vital innovation that allows cardiologists to better interpret them. But the reader doesn't need to be a cardiologist to determine that the same lack of contrast that made the previous images ambiguous can mean the difference between the life-or-death decisions when considered in the context of echocardiograms.

WITHOUT CONTRAST,
INTERPRETING IMAGES CAN
BE A LOT OF GUESSWORK.

BELOW: Just because this particular design project was an annual report didn't mean that the piece's design had to be dowdy or traditional. Designers for this project used bright colors to draw attention to the sparingly used copy and product. Instead of peppering the annual report with random facts glorifying the scientific triumphs of the product, the copy and design remain focused on the primary concern to shareholders—the new product and what it means to business and profitability.

WELCOME TO THE NEW AGE OF ULTRASOUND IMAGING. DEVELOPED BY MOLECULAR BIOSYSTEMS, OPTISON™ CONTRAST ECHO HELPS CARDIOLOGISTS DIAGNOSE WITH CONFIDENCE. NO MORE FUZZ-O-GRAMS.

OPTISO
(HUMAN ALBUMIN M
Octafluoropropane forma
Contains 5.0 - 8.0 x 10
Discard unused portion. S
Do not administer witho
layer is cloudy or turbid
milky white suspension
size distribution, and d

MARKET EXCLUSIVITY IN TWO OF THE WORLD'S THREE LARGEST MARKETS. OPTISON IS ESTABLISHING ITSELF QUICKLY AS THE CONTRAST AGENT OF CHOICE.

Simply put, the interface design succeeds by challenging the reader to make judgments similar to what doctors—the users of MBI's technology—make. Using analogous imagery, the reader is able to understand what makes this product special.

"The annual report engages the shareholders with problems similar to what doctors face when reading ultrasounds," says Bill Cahan, principal of Cahan & Associates. "They are able to put into context the importance of positively identifying low-contrast images."

The Meat Of The Report

Point made, the following pages contain the meat of the report. Still far from your typical corporate annual report, the pages are designed with a balance of colorful images, large type, and, of course, the requisite stockholder information, like reports on liquidity and capital resources. But the copy doesn't overwhelm the reader. It is kept brief and to the point—for emphasis, spreads are used to drive certain key concepts home.

Before losing the reader with too many dry financial statistics, the last eight pages refocus the reader on the featured technology with another eight-page series of low-contrast images. This guessing game lent itself well to more direct interaction, and Cahan seized this opportunity. Included in the annual report is a business-reply envelope where recipients can submit their guesses for what the objects featured in the fuzzy images are. The respondent with the most correct answers will receive a not-too-shabby 100 shares of MBI stock. The contest encourages the reader to participate in a way beyond simply reading the report, while giving careful thought to the concept MBI wants the reader to understand. In this way, the report's interface invites the user to interact with the report and engage in the content. It's not likely after judging the series of images provided in the contest that the user will forget what MBI's product is all about and why it's important.

As Kevin Roberson, the designer assigned to this project, says, "I believe a message is more memorable if the audience is called to do something other than sit back and flip pages." Before this annual report, no one really knew how fun echocardiogram technology could be.

</cahan&associates>

FAT TIRE A celebration of
the mountain bike

OPPOSITE: The book was constructed in a unique way, further setting itself apart from the other books on the shelves. The book is perfect-bound, with the coverboard printed in bike-inspired colors with a tire tread glued down the front of the perfect-bound, paperback "guts" of the book.

P:97

<chronicle books>

‹ BOOK DESIGN:
CHRONICLE BOOKS ›

SO YOU'VE GOT THIS BOOK TO DESIGN. IT'S MORE ABOUT DIRT, SPEED, AND ADRENALINE THAN IT IS ABOUT PLEASURE READING. YOUR AUDIENCE IS ULTRA-HIP AND ENTRENCHED IN THE SPORT'S SUBCULTURE. BUT IT'S STILL A BOOK, SO YOU CAN'T GET AWAY WITH VISUAL CLICHÉS THAT MIGHT WORK WITH A MAGAZINE.

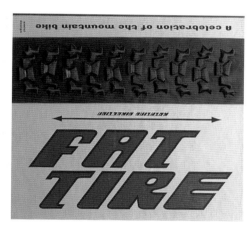

ABOVE: *Fat Tire* is a book dedicated to the passionate—at times, borderline maniac—demographic known to the world as mountain bikers. When designing a book glorifying the sport that was not only informative and factual, but beautiful, Chronicle Books and Amici Design went right for blood. Designers set out to capture an audience largely influenced by MTV-like media with a graphics-intensive interface. Type used was big, bold, and brash. And yes, that's a real tire tread right there on the cover.

Well, in the case of *Fat Tire*, a veritable love letter to the sport of mountain biking, you create a masterpiece specifically tailored for this niche audience, but that's intriguing enough to pique the interest of your average couch potato. Designed by San Francisco's Chronicle Books, this book's interface effectively appeals to its target audience, conveys a hip feel without dating itself, and allows the reader the vicarious experience of mountain biking through its bold, brash design.

Starting With The Cover

An interface is nothing without its user, so this book needed an immediate way to stand out on the shelves and jump into the hands of readers. Consequently, the first thing you notice about *Fat Tire* is its unique cover. An homage to the gritty nature of mountain biking, Creative Director Michael Carabetta decided to use a rubber tire with thick, raised treads running vertically right down the front of the cover to immediately entice the reader's eye.

"We wanted to design an unusual cover that would appeal specifically to the niche audience," Carabetta says. "It wasn't easy, because this audience had seen virtually every kind of image around—the same action shots you can find in any magazine."

A potential production nightmare, Chronicle Books explored a variety of options before deciding upon an idea that worked. "We tried taking actual tires, cutting them into strips and gluing them down," Carabetta says. "But since the tires were round, getting them to stick proved difficult, to say the least. After much searching, we found the material we wanted to use to create the tire tread, and found it to adhere well."

And the effort was well worth it. In essence, the "fat tire" is at the heart of mountain biking—it's what sets these bikes apart from their skinny-tired cousins. But beyond acting as a symbolic hook for the user, this visual device also forged a sensory relationship with the user—the three-dimensional tread stands out and invites touch.

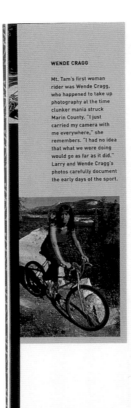

WENDE CRAGG

Mt. Tam's first woman rider was Wende Cragg, who happened to take up photography at the time clunker mania struck Marin County. "I just carried my camera with me everywhere," she remembers. "I had no idea that what we were doing would go as far as it did." Larry and Wende Cragg's photos carefully document the early days of the sport.

A group of friends from the town of Larkspur began riding cast-off one-spee coaster-brake, newsboy bikes on the dirt trails of Mt. Tamalpais as early as 19 The heavy bikes were driven or walked to the top of the mountain, then t riders bombed down the steep trails, coaster brakes smoking. Once a ye these self-proclaimed Larkspur Canyon Gang riders ran a race from the top the mountain back to Larkspur Canyon. Racers could choose any tr According to one account, first prize was an envelope of marijuana, althou the riders were not necessarily all pot smokers.

Charlie Kelly, in a 1979 *Outside Magazine* article, described some of their explo

> The canyon gangers were doing such stunts as riding at 40 miles
> hour under a gate (with two inches of clearance above
> handlebars) to maintain enough speed to launch the bike off a sh
> crest for a 40-foot jump.

The fun-loving Canyon Gang soon disbanded, but one member, Marc Vende joined Marin's road racing team, Velo Club Tamalpais, and introduced clunkin avid young road racing peers like Joe Breeze, Otis Guy, Gary Fisher, and Cha Kelly. Riding these fifty-pound, one-speed, retro bikes appealed to these riders variety of ways, a number of whom, like Breeze and Fisher, were clocking betw two hundred and five hundred miles per week on skinny-tired racers and vyin state and national events. Lumbering up Mt. Tam's switchbacks on these bike blue jeans and hiking boots also provided a novel and valuable training regime

But the tire tread itself isn't the only effective aspect of the cover's design. Since the tone for the book starts with the cover, it was crucial to use this as a unifying part of the book. Starting with the cover, the book's interface is inspired by the aesthetics of the bike itself, an approach that will no doubt appeal to this audience. The cover consists of coverboard, printed and with a tire tread adhered onto a perfect-bound paperback book. The cover is metallic-silver, mimicking the titanium that the best mountain bikes are crafted from. The book's title is designed in a semi-retro, racy style, inspired by the logos found on bike frames. The title pops off the cover in fluorescent red. As a complete package, the cover invokes the same reverence for and nostalgia of its subject matter—the mountain bike.

"Mountain biking is a colorful, individualistic sport," Carabetta says. "The truth is, bikers love the way their bikes look. The finishes vary—from bright orange paint to the lustrous metal gray of titanium to polished aluminum."

A Non-Linear Approach

Knowing that this book would, for better or worse, be compared to and contrasted with the fast-paced, quick-byte media that helps promote the sport (like Web sites and biking magazines), the book's interface was designed so the user could flip to any page and be drawn in by the visuals.

"THE BIKE WAS A MOBILE PARTY. A WAY TO GET AWAY FROM THE COPS, THE CARS AND THE CONCRETE. WE WERE GOING PLACES WHERE THERE WASN'T ANYONE ELSE."

Gary Fisher

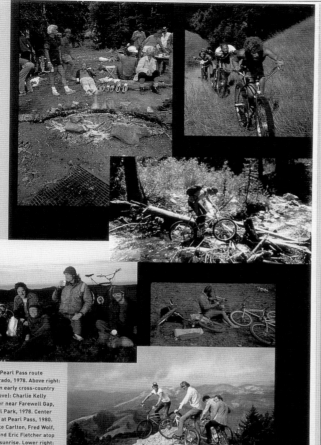

Above left: Campfire on the Pearl Pass route outside Crested Butte, Colorado, 1978. Above right: Action from "the Enduro," an early cross-country race, 1977. Center right (above): Charlie Kelly crossing the Little Kern River near Farewell Gap, now part of Sequoia National Park, 1978. Center right (below): Inspired rider at Pearl Pass, 1980. Center left: Joe Breeze, Vince Carlton, Fred Wolf, Gary Fisher, Charlie Kelly, and Eric Fletcher atop Marin's Mt. Barnaby for the sunrise. Lower right: Taking in the view on the north side of Mt. Tam.

For the audience to feel connected with the book, the interface needed to appeal to the mountain-biking aesthetic. Gritty, distressed fonts were used for callouts instead of more conservative serif and sans serif selections. The photography used may not meet the traditional photographic standards for balanced lighting or focus, but they do show the ideas of speed, motion, and dirt that mountain bikers will identify with. The design of this book is analogous to the magazines most popular with this sport's demographic—users can basically flip the book open at any point and find a cohesive, graphically driven spread.

"Like most books, *Fat Tire* can be digested from beginning to end," Carabetta says. "But because we knew that the people who this book would appeal to have been exposed to bike videos, catalogs, magazines and Web sites, we wanted to make this book as visually arresting as possible. Readers can dip in at any place and read a chapter, a sidebar, or a caption or flip through the pictures. The only part of the book that's linear is the history—naturally, we started with that. From there, there is no logical progression, but an engaging overview of the sport."

Flip though the book and the interface is more analogous to a magazine than it is a book. Due to the book's consistently bold design, the user is more likely to initially leaf through the book, pausing on eye-catching photographs or pulled quotes before settling down to digest the text. Its luscious design urges the reader to return to it again and again, rather than treat it as a book that is read and shelved.

The designers used a variety of strategies to sustain the energy and feeling of the sport in the interface's design, while offering variety and information. Maps are scanned in and scaled back, used as part of the background. Different quotes and snippets pulled from the copy are set in gritty, distressed fonts, and invite readers into the text. Bright colors are balanced with more muted earth tones. All of these elements propel the reader through the book. The periodic sidebars allow users to sample small bits of information at a time.

BELOW: Mountain biking is a sport that is taken seriously by its devotees (read: users), a notion that was respected in the design of the book. The progressive, bold design, colors, and fonts are balanced with informative copy about mountain biking's biggest names and the rise of the sport's popularity. Knowing that readers would demand technical information as well, designers worked potentially dry objects, like blueprints and diagrams, into the design of the spreads, balanced with photography and color. But to preserve the graphic integrity of the book, designers reinvented some of these items as graphic elements on the page.

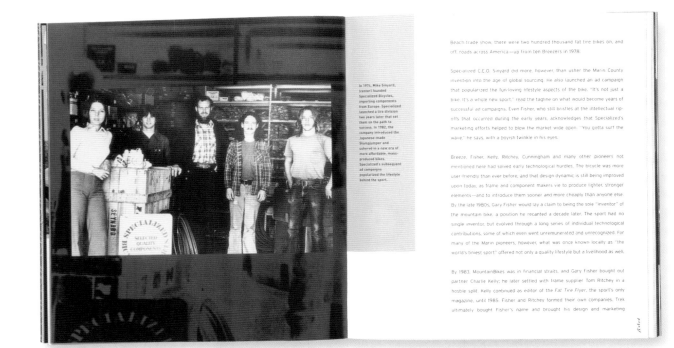

Appealing To The Audience

Enticing the reader into this book was all about creating an interface that is appealing to the different "camps" of people who are interested in the sport, without spreading itself too thin. This book needed to include diverse information that would appeal to everyone from the weekend warrior to the hard-core biker who had devoted herself to the sport.

The book's interface uses the tried-and-true approach of a table of contents to classify and identify the different topics addressed. Each main chapter is summed up with one word and partnered with a subhead, which offers more information. For instance, the "Technology" chapter is further described by the accompanying subhead, "The Anatomy of a Bike," and the "Culture" chapter is further identified as "Medalists, Messengers, and Mavericks." To further act as a factual reference for the sport, at the end, the book includes a handy glossary and mountain biking hall of fame.

To cater to all the various enthusiasts for this sport, the book's diverse content includes everything from the well-known athletes who have helped define the sport to the growing subculture of bike messengers and mounted police. In effect, the content itself is a key element of the user interface, appealing to the different people who identified with the sport. As potent as the design of the book is, the text gives the design elements meaning and appeals to the various aspects of the sport. In essence, the content and design fuel one another.

Proclaiming itself as the first comprehensive book dedicated to the sport of mountain biking, *Fat Tire* effectively devotes its 142 pages to the evolution of the sport, without using a boring textbook approach or information overkill. Far from a one-track record, *Fat Tire* carefully considers and appeals to the different curiosities the various readers may have. It serves two purposes: To act as a beautiful object and an authoritative written tribute to the sport.

we wanted to design an unusual cover that would appear specifically to the niche audience," Carabetta says. "It wasn't easy, because this audience had seen virtually every kind of image around-the same action shots you can find in any magazine."

In 1974, Mike Sinyard (center) founded Specialized Bicycles, importing component from Europe. Speciali launched a tire divisi two years later that s them on the path to success. In 1982, the company introduced Japanese-made Stumpjumper and ushered in a new era more affordable, mas produced bikes. Specialized's subseq ad campaigns popularized the lifest behind the sport.

The Anatomy of a Bike

The fat tire bike is an industrial art form, an amalgam of diverse influences: motorcycles and aeronautics, metallurgy and sculpture, extreme sports and the triathlon. There seems to be no limit to the speed or terrain mountain bikers reach for, and each successive plateau is achieved, in some part, by advances in technology. The examples presented in this chapter represent some of the most advanced technology the industry had to offer at the time of this writing. With time, evolving manufacturing capabilities should bring many of these design concepts within the financial reach of the average consumer.

Through the 1980s and 1990s, the sport benefited from the excess production capacity of the Japanese bike parts industry and affordable Taiwanese labor. The mountain bike's exploding market gave Japanese suppliers like Shimano and Sun Tour the opportunity to out-innovate and out-maneuver the European parts builders that had dominated the road bike market for so long. Talent wasn't hard to find on American shores, either. A slump in the West Coast aerospace industry left hundreds of engineers with time to ride bikes, and many began seeking work that could take advantage of their mastery of materials and machinery. Inventing bike components and concepts opened the doors to a new wave of entrepreneurship.

As the sport grew, more capital became available, and people discovered ways to make a living doing what they loved. Some small companies became empires as folks with big ideas for little toys got the chance to make their dreams real. Fat tire bikes became lighter, acquired more gears, and gained front and rear suspension.

The Bike As An Object

When designing this book, the designers took an approach that was a little different from what you might expect. In the "technology" chapter, the bike is deconstructed and looked at, artistically, as individual parts.

"We wanted to capture the beauty of the hardware, the gear," Carabetta says. "So, we took parts of the bike and looked at them for their own inherent beauty. I think most mountain bikers appreciate the design of a bike's parts, the materials and finishes."

Each part is shot against a stark white background and addressed for its own unique function. By deconstructing the bike to a series of parts, the book was able to give greater appreciation of the whole. The aesthetic angle of a sport is often overlooked in the books devoted them, but the book's authors took a risk that the readers would have an almost romantic connection with the bike itself and associated gear.

page 35

The Ultimate Test

The final test of a successful interface is if the whole thing
holds together as a cohesive object. From cover to cover, this
book passes with flying colors. The potency of the graphically
intense cover is carried through with the powerful interior
design. Yet, the design doesn't overwhelm the reader, adher-
ing loyally to the interface cardinal rule of balance. The con-
tent is vast without boring the reader and the overall design's
nonlinear approach works well with its audience.

</chroniclebooks>

Every designer knows that a variety of choices must go into the design of a given product—everything from color to size to materials. But from an interface point of view, all of these design decisions should stem from one source—how the user interacts with the object.

A product's interface has to serve a variety of different roles. It must support the given brand, and use its design to connect with the user on a base level. These are mostly cosmetic concerns, ones that must communicate with the user immediately about the product's use, and do so in a clear, evident way. But beyond the surface, the product has to use its interface design to deliver on its usability as well, merging form with function.

This chapter looks at the interface design for a variety of different products and how designers used the interface of these items to connect with their users and enhance the products' functionality. In each case, the designer stepped back and let the users themselves guide the interface design.

Audio CD packaging has the unique challenge of representing a relatively ethereal concept—music—in a visual way. Not to mention that the design must sell the CD in an increasingly visual and competitive marketplace, while providing a safe home for the fragile disk. ▶▶

‹ f a c e - t o - f a c e w i t h ›
P R O D U C T D E S I G N

web print <product> environmental

Sagmeister, Inc., has had a lot of fun diving into the subject matter of the bands whose CDs they have designed. In each example, Sagmeister has created a design interface emblematic of the group that appeals to fans, new and old alike. But it has done so in a way that encourages users to interact with the packaging and, in the process, understand more about the music. In doing so, it proves that you can have great fun with the audio CD design while serving a very basic function.

Nowhere is the concept of product image more heightened than with the cosmetics industry. But behind the attractive facade of each lipstick tube or jar of face cream is a product that needs its packaging to meet specific standards. The interface firstly must project the notions of the beauty and elegance its products represent, and do so in a way that makes that brand memorable. But the packaging must also ably dispense the product, and remain compatible with the product's chemical composition. Elizabeth Arden has done a great job of meeting all these different needs with its cosmetic line, each product's interface a great example of form in synergy with function.

A quality often overlooked when it comes to interface design is the emotional bond a particular item can forge with the user. IDEO is a product design firm that saw the potential of designing products where technology and sentimentality weren't mutually exclusive. Instead of trading factual, generic text communication, the interface of the Kiss Communicator is designed to transmit a "kiss"—a light pattern created by blowing into a receiver—between two individuals. As an effort to add some personalization and identity to email communication, homEmail was designed to transmit email messages written personally through a stylus, rendered in a handwritten font, and with colorful backdrop. The product itself is designed not to look like a computerized product, but more a beautiful piece of furniture, allowing the interface to integrate the product into the user's everyday life.

Another product that hopes to add a layer of personalization to email product design is PostPet, a software client designed for Sony by Japan's PetWORKS that makes sending and receiving email both fun and friendly for new users. The user chooses a cartoon "pet" that delivers email to friends and even sends messages to its owner. Like the popular virtual pets, it's necessary for the user to care for the pet, keeping it fed, playing with it, and using the friendly, colorful interface to interact with it. The interface is designed to be unintimidating to new users and provide entertainment value that other email clients don't provide. Best of all, the interface design allows users to creatively compose messages beyond standard formatted email messages.

Anticipating user needs and product capabilities is another important part of interface design. With the design of the S25 mobile phone from Siemens, designers integrated a variety of different communication and organization tools in one unit, providing functionality that other mobile phones didn't yet provide. By integrating the functionality of personal organizers, the latest mobile phone technology, and even Web access, the S25 stands out as a valuable product. But it's the user interface that makes it successful—despite its small size, the product allows users easy access to a variety of functions through intuitive keypad design, icons, and an easy-to-use menu.

Although each case study in this chapter is vastly different from the next, they all share basic lessons in user interface design that are applicable cross-platform and discipline. Again, it shows how the concept of interaction and interface design goes far beyond point and click.
</productintro>

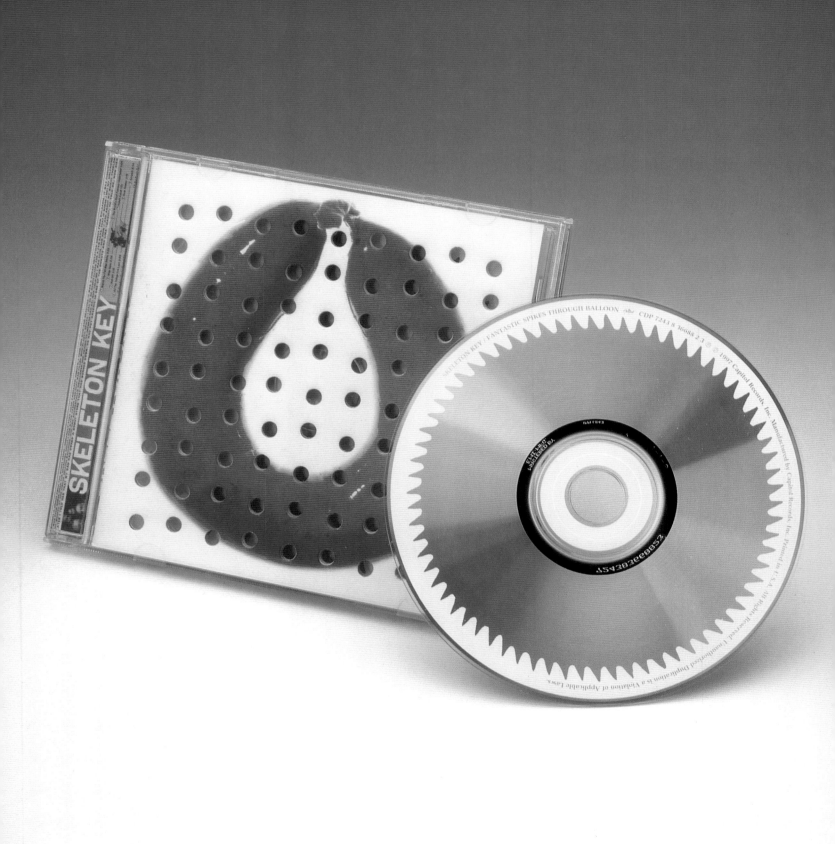

‹ MUSIC CD PACKAGING: SAGMEISTER, INC. ›

DESIGNING PACKAGING FOR MUSIC CDS PACKAGING OFFERS A UNIQUE ADVANTAGE OVER OTHER DESIGN NICHES: A POTENTIALLY LOYAL, CAPTIVE USER. "WITH MUSIC, YOU CAN EXPECT THAT THE LISTENER WILL BE DEVOTING A CERTAIN AMOUNT OF TIME WITH THE CD AND ITS COVER," SAYS STEFAN SAGMEISTER, PRINCIPAL OF SAGMEISTER, INC., IN NEW YORK CITY. "THIS ISN'T TRUE WITH A POSTER, SO THERE'S NO REASON TO INCLUDE TIME-CONSUMING DETAILS AND INTRICATE ELEMENTS." WHEN SAGMEISTER CRAFTS HIS UNIQUE CD DESIGNS, HE DOES SO WITH THE IDEA IN MIND THAT USERS COULD VIABLY SPEND, AS HE SAYS, "10 SECONDS, 10 MINUTES, OR 10 HOURS WITH IT."

Irreverent Design For An Irreverent Band

The first step to connecting with the user with audio CD interface design is correctly conveying the spirit of the band and the essence of the music. When Capitol Records asked Sagmeister to design the new CD release from the band Skeleton Key, he jumped at the chance, especially since the band is a personal favorite. The group's music is unique and unconventional, spirited and driven—these audio cues were what Sagmeister used as a springboard for the CD's design.

The first thing Sagmeister did before starting work on this project was vow that his designs would convey the distinct character of this band, not just reuse the same visual clichés that other alternative rock CD designs have used. "The band wanted to avoid the typical things used in CD design, like out-of-focus photography, distressed type, or scratchy illustrations," Sagmeister says. When brainstorming for the design, Sagmeister turned to the band's music and lyrics. "There is a deliberate imperfection to Skeleton Key's music and we hoped to convey that through the design."

The CD's name-"Fantastic Spikes Through Balloon"—was inspired by the magic trick. Sagmeister chose to use the title as a unifying theme for the CD's interface design. Sagmeister brainstormed a list of balloon-like objects to use in the CD's design. "I wanted the feeling to be irreverent and silly, just like the band," Sagmeister says. He ended up coming up with whoopee cushions, propane tanks, sausages, blowfish, and more. Consistent with the title and theme, Sagmeister's design proceeded to feature these images prominently in the CD's foldout and punch a series of holes throughout the paper.

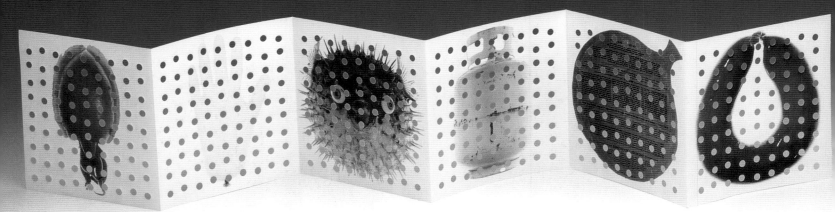

Since music fans often connect so intimately with their favorite bands, Sagmeister intentionally incorporated characteristics of the band into the CD's interface design. For example, the CD itself brandishes a saw blade, which (of course) spins when played. Sagmeister chose to use this as part of the design because unorthodox elements—like saw blades—are frequently used as part of the band's drumset. "There are two drummers in the band and you can't find any of the pieces from their drum kits in a music shop....Using the saw blade on the CD itself supports the symbolism of the drum kit."

Choreographing The User Experience

Although the CD is visually arresting upon first glance, Sagmeister incorporated several different subtle layers to the interface so users would continue to discover additional elements each time they picked it up. When designing it, Sagmeister was careful to implement a variety of different interactive elements with the design. For instance, since holes are punched through the paper, when the user unfolds the paper it makes popping sounds, underscoring this design element. Although this wasn't intentional, Sagmeister was very pleased with what this brought to the design.

A more bold approach to the user design was printing the lyrics in mirror image on the foldout. This was done because the band told Sagmeister that they did not want users reading the lyrics while enjoying the music. "They told me, 'It's not poetry—we don't want people reading our lyrics while listening to the CD,'" Sagmeister says. However, by using the mirror-like underside of the CD, users can hold it opposite the lyrics and read it there. This element is clever, however, since users can't do this while the CD is playing. This CD element conveys subtle user direction based on the band's wishes— in a way, this helps the band and user interact during the experience of listening to the music.

As a way to continually engage the user and keep him invested in the design, Sagmeister also incorporated a variety of hidden elements. For instance, on the flip side of the spine, there is— written in very small type—a short, silly anecdote about a donut written by the band.

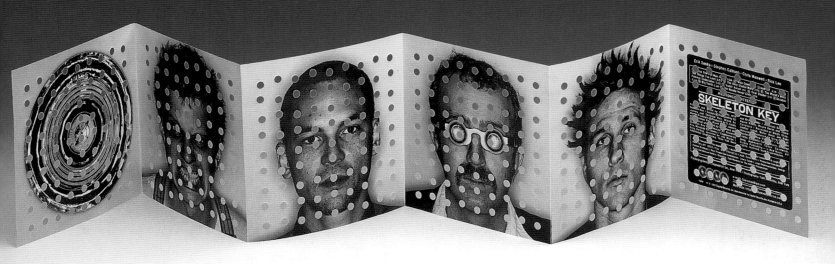

ABOVE: The most important part of designing CD packaging interface for a band is communicating its spirit to the user. When Sagmeister, Inc., designed the CD for Skeleton Key's "Fantastic Spikes Through Balloon," they zeroed in on the band's irreverent spirit and unconventional sound by creating a completely unique CD design. In keeping with the CD's title (inspired by a famous magic trick), the designers brainstormed for different balloon-like objects, then proceeded to pierce them with holes cut out through the paper. An interactive element occurs when the listener unfolds the paper—the punctured paper makes an unexpected "popping" sound. Although not intentional, Sagmeister says, "This was an accident we liked a lot."

BELOW: The band wanted the CD's interface to guide the user experience, and part of that included discouraging listeners from reading the lyrics while listening to the CD. "They told me, 'It's not poetry,'" Sagmeister says. To remedy this, Sagmeister printed the lyrics in mirror image—the user could viably read the lyrics when the CD is not playing by holding up the mirrored side of the CD to the lyrics. This is a clever way for the band to communicate to the listener that they don't take themselves too seriously.

When designing it, Sagmeister was careful to implement a variety of different interactive elements with the design.

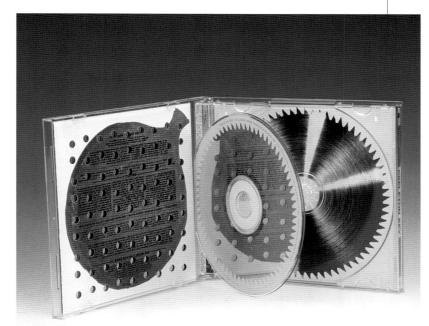

LEFT & OPPOSITE: The best way Sagmeister knew to convey the precise nature of the jazz music by the Pat Metheny Group was by creating a series of images used as a visual code as part of the CD's interface design. This approach established a clean, minimalist design for the CD while creating layers of depth for the user who wished to spend more time with the CD. A simply designed bellyband was used to provide the necessary information about the band and the CD's title (necessary to get the CD off the shelves and into the hands of the band's fans). The band provided an option for users-they could keep it on, or discard it for the "code-only" cover.

A Different Approach For A Different Band

When it came to designing the packaging for Pat Metheny Group's Imaginary Day release, Sagmeister had a drastically different musical group to work with—and thus a drastically different user to design for. "Pat is one of the only artists who does what he does with the jazz guitar—he's one of the only ones who switches around so dynamically," Sagmeister says. "His avant-garde style inspired the approach we took with this CD design."

In order to design a CD interface that the users would bond with both visually and musically, he again turned to the music itself for inspiration. "When Pat first came in to talk about the design for his CD Imaginary Day, he said he wanted to use a collage with the design because he felt that it represented the complexity of his music," Sagmeister says. "I didn't like this idea. To me, it seemed that using a series of visual images would represent Pat's music more correctly. His music is precise, composed, virtuoso. Good collages have randomness, they don't show precision or evoke the visual that Pat's music does. The working titles of his music evoked imagery, so I used imagery for all the working titles."

In keeping with the theme of images, Sagmeister conjured up a host of images that Pat thought of while writing the music, then together they narrowed it down to the images they used in the design. These images were used to create a code, which carried the design of the CD. Images include everything from a railroad crossing sign to a bee to a pyramid. The coded interface invites the user to spend a lot of time with it, working to decode the design, while representing the precision of the music on the CD. "I thought the symbols were a nice way of thinking of an imaginary day."

Sagmeister designed the entire CD package as part of the coded interface. Everything from the cover to the spine is coded, and a coded poem is featured on the interior packaging written by Metheny. The CD itself is used as a sort of "decoder ring." Each of the different symbols used in the design is printed on the CD. To decode a section, you simply line up the arrow printed on the CD with one of the three color blocks that precedes each section. The three different possibilities for each code provide three different levels for the code—just when the user thinks he has the code down, the design adds another dimension to the code by assigning a new property to each symbol, designated by a different colored block.

Design Compromise

Despite the ingenuity of the coded design and its symbolic relationship to the music, the CD's interface still needed to communicate to customers on an immediate level, identifying the group, and selling the CD. The solution that Sagmeister came up with was simple, and didn't interfere with the spare nature of the coded design. A simple blue bellyband is included horizontally across the CD, plainly identifying both the group and the CD's title. "The bellyband was a nice compromise with the record company," Sagmeister says. "The user has the option of taking it off for the pure cover if they wish, or leaving it on as well."

Since even the spine is encrypted in code, the bellyband includes the information here as well. Sagmeister says that he and the band had to fight for the coded title on the spine, but that in the end it paid off, due to the band's support and endorsement. "Our argument was that the whole CD had to be integrated and the band was on our side 100%. When the musicians are on the designer's side, much can be done. If they care, they can get good packaging," he says.

When Do You Go Too Far?

But did the users "get" this design? The answer is yes, whether or not they spent the time to decode the different messages encrypted in the design or not. The symbols speak to the precision and symbolism of the music, while deeper messages exist for those willing to spend the time with the design. "Pat told me that within 24 hours of the CD's release, a decoded version of his poetry appeared on the Internet," says Sagmeister. "And the album has been out since 1997, and although it's unusual for a music reviewer to mention the design of a CD in the review, this happened a great deal with this CD."

</sagmeister, inc.>

<sagmeister,inc.>

"When Pat first came in to talk about the design for his CD Imaginary Day, he said he wanted to use a collage with the design because he felt that it represented the complexity of his music," Sagmeister says.

BELOW: When looking for inspiration for how to design the CD's interface, Sagmeister turned to the music itself. Interpreting it as clean and concise, he took the design in this direction with individual symbols rendered within a grid on a white background. An indication of the complexity of the music, the seemingly simple symbols actually represented a complex code that needed to be decrypted to read the hidden messages.

OPPOSITE: One of the advantages of an audio CD interface design is that the designer can assume that the user is a fan-and more often than not, willing to spend time with the CD packaging itself as an extension to and reflection of the music. The CD is designed so the user can completely engage in decoding the interior information if he wishes. The CD itself acts as the packaging's secret decoder ring. To decode a block of text, the user lines up the arrow printed on the CD with the colored block that precedes the line of code on the packaging.

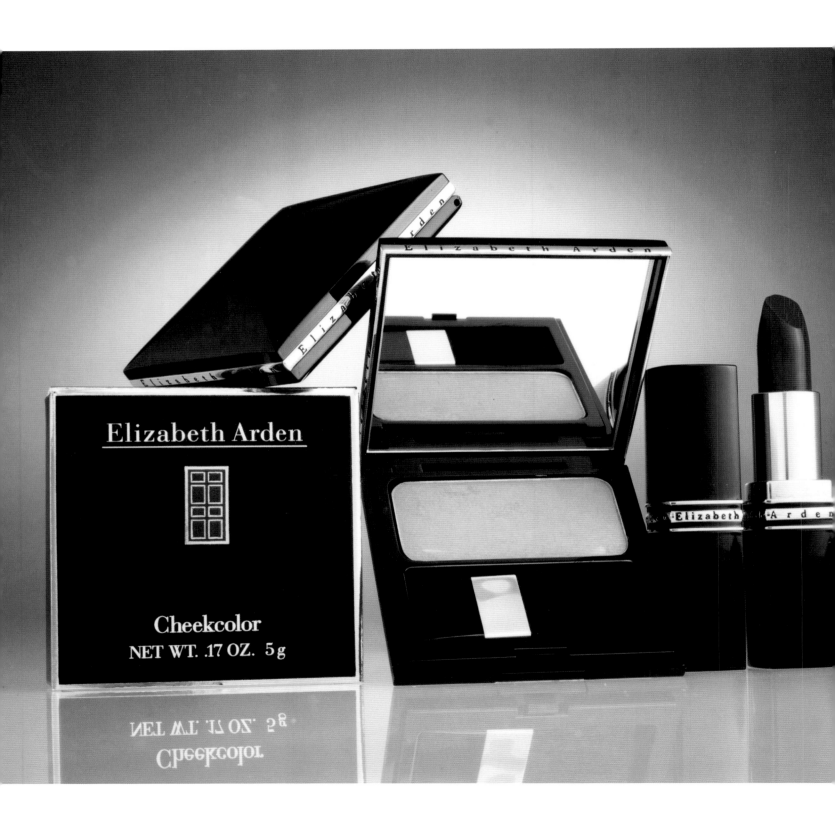

‹ BEAUTY PRODUCT PACKAGING: ELIZABETH ARDEN ›

DON'T UNDERESTIMATE LIPSTICK. NOT ONLY DOES THIS PRODUCT HAVE TO HOLD ITS OWN IN A COMPETITIVE MARKETPLACE, BUT ITS PACKAGING MUST PROJECT A BEAUTIFUL IMAGE, WHILE BEING FUNCTIONAL. MOST OF ALL, IT MUST HAVE "PURSE APPEAL"—BE A PRODUCT THAT THE CUSTOMER WOULDN'T MIND SHOWING OFF IN PUBLIC.

The user's emotional bond with a product and its image are important to consider when creating an interface design, and nowhere is this more evident than with the design and packaging of beauty products. These are products that promise a sort of luxury and personal improvement for the user, yet they must be able to stand alone as objects, whether being pulled from a purse or sitting on a vanity. Practically, they must function well, ably dispensing the product, while being as aesthetically appealing as the image they represent.

Compound these specific interface considerations with the fact that the beauty industry is a very crowded, competitive marketplace. A visit to the cosmetics department in any shopping mall testifies to this—dozens of counters representing different cosmetic companies compete for users. In order for a cosmetic product line to succeed, its company must earn the loyalty and trust of the user.

Projecting Image Through Design

Knowing the users and responding to their wants, needs, and perceptions of your product is critical to designing an effective interface. Elizabeth Arden has used an effective packaging interface to keep its products, and subsequent brand image, in conspicuous view of users. Part of this strategy has been by keeping a keen eye to the market, testing users, and adjusting the company image accordingly. It was user feedback that helped initiate a redesign of the product interface in 1996.

ABOVE: The Elizabeth Arden brand encompasses a wide variety of different products—the interface needed a design element to unite all items as part of one brand. Designers found that users connected Elizabeth Arden's famous Red Door Salon on Fifth Avenue in New York City with the quality and elegance that the company wanted their products to convey. Thus, a red door logo was used as the icon that tied together the design of all Elizabeth Arden products, except for fragrances.
PHOTO: PAUL TILLINGHAST

The redesign started in response to some red flags that were raised in user focus groups and through conversations with Elizabeth Arden retailers. "We discovered that consumers believe that we're a company who offers quality, and that we have a good, strong name in the marketplace," says Michelle Nahum-Albright, Elizabeth Arden's Senior Design Director. "But we also discovered that we were perceived as 'old.' Not trendy, not particularly interesting. We felt that this was an issue that needed to be addressed in several parts of the company, but the first one, and the one that would take a lot of time, was packaging."

LEFT & OPPOSITE: Consistency in brand image is essential for successful product interface design, but designers still needed a way to set apart different products from others. Although the different lines of Elizabeth Arden products were designed using similar packaging, unifying colors were used to identify each brand segment. To keep the product interfaces subtle and clean, consistent with the image Elizabeth Arden hoped to project, designers used a subtle palette with colors like champagne gold, silver, and white. The consistencies in color allowed customers to quickly identify the product they wanted when shopping at the cosmetics counter.
PHOTO CREDIT: PAUL TILLINGHAST

Knowing exactly whom you wish to reach is essential to developing an effective user interface. Arden's target demographic were women in their 20s and 30s, yet it was just as important not to alienate current users who were comfortable with the current design and product. "The redesign was about taking who we were as a brand, dusting ourselves off, and updating ourselves," Nahum-Albright says. It was also important to create a sense of continuity for the entire brand across lines so users would know to associate the qualities they were looking for in cosmetic products as part of a comprehensive line of beauty products. These two needs: modernizing the look and unifying the design, were the driving forces behind the redesign.

One of the first steps to unifying the interface across brands was using a logo for branding. "Through focus groups, we found that many people identified the Elizabeth Arden Red Door Salon on Fifth Avenue in New York as a strong symbol of quality and elegance," Nahum-Albright says. "When we redesigned the packaging, we not only redesigned the typeface, but we used the Red Door symbol as a logo that we used to identify our products across the board."

The second significant way Arden updated their packaging interface was by toning down the existing design. "One of the primary elements of the old packaging was a gold wave on the treatment products [such as lotions or toners]," Nahum-Albright says. "We felt there was too much gold. It seemed to speak to another time period—the excesses of the '70s and '80s. This was not a modern interpretation of luxury. We felt that a more modern, streamlined form was called for."

The understated design approach echoed throughout the interface of all the packaging. "With every primary package we designed, the form itself was simple," Nahum-Albright says. "We added a translucent caps and bottles to the treatment line because we felt that translucency was a very modern attitude, verses total opacity.

The palette chosen for the cartons conveyed a subtle continuity within the product interface, again uniting the different products across brands, yet speaking to the unique nature of each product. A soft metallic and white palette is used for the treatment lines, each signature brand and color subtly indicating qualities of the product it contains (the ceramide line is for an older customer—the champagne gold was found attractive by this demographic— while the whitening line targeting Asian customers was packaged in a matte white box). Cosmetics are packaged in a square, glossy, black package.

The Psychology Of Packaging

There is a psychological quality to creating any interface— you want the user to connect with it. When considering an item as intimate to the user as a cosmetics product, cementing this bond is essential. "It's important when creating image to pay attention to displays, advertising, and how it looks behind the counter," says Nahum-Albright. "But when the product goes home with the customer, it's the packaging that stays on her dresser. It's what she picks up every day to touch, use, and remember. The package must have a friendly and intimate relationship with the user, be comfortable to use in function and feel. Each time the user picks up the product, you're reminding her why she bought it and creating loyalty."

When it comes to creating an emotional connection with a user of a cosmetic, Nahum-Albright cites a rather unscientific necessity: purse appeal. "When it comes to something like a lipstick or a compact, we like to think of them as being something the customer is proud to be seen in public with," Nahum-Albright says. "Something that's not only functional, but something she wants to show off a bit. We have to understand that customer quality and design something appropriate for her to use."

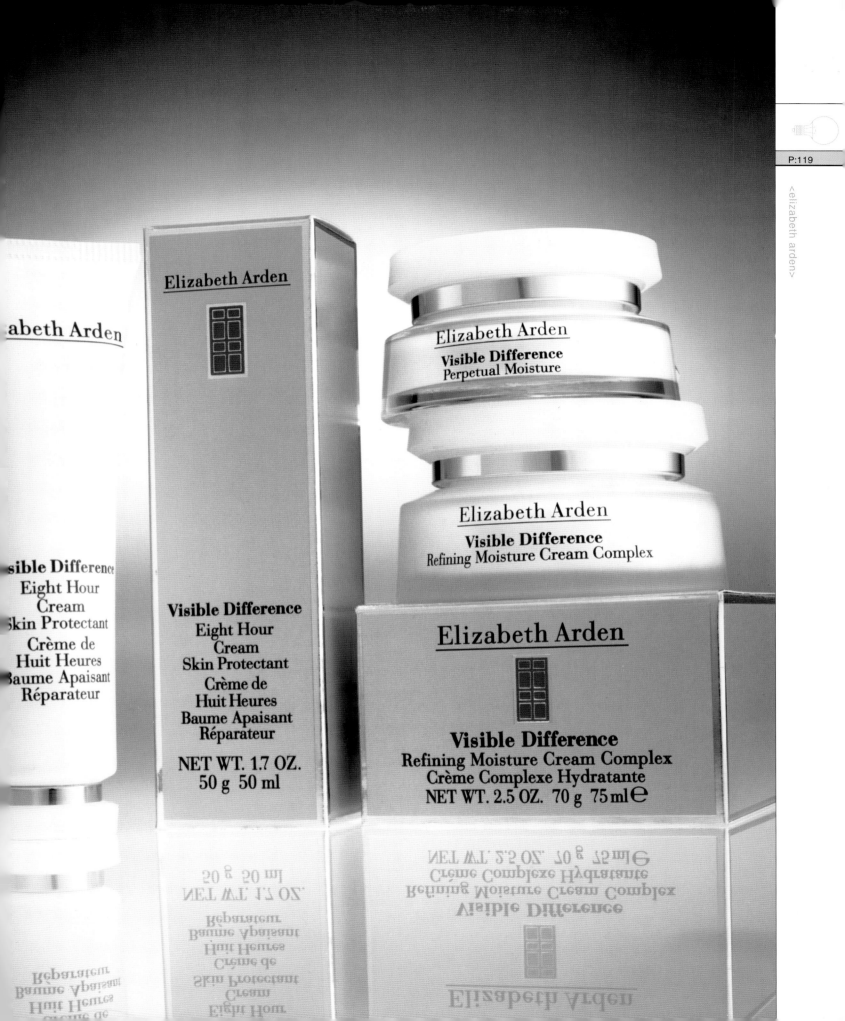

ABOVE & OPPOSITE: The interface of fragrance packaging must convey a very different image from cosmetics and treatment products. "Fragrance is all about image and what the scent represents to the user," says Nahum-Albright. "It's the most personal of all beauty-care products. The image carries through the advertising, marketing, and collateral." To support the breezy, fresh, calming qualities of Elizabeth Arden's Green Tea fragrance, the interface is intentionally casual, packaged in a green die-cut cardboard box. The box was designed so it could be merchandised from either side, and the die-cut created an ethereal 3D effect that pulled the eye to the glowing liquid. The leaf pattern on the bottle plays off the leaf pattern on the box, bringing the design together.

BELOW: When Elizabeth Arden decided that it needed to bring its product interface up-to-date to appeal to modern customers, one of the first things it did was tone down its design. The primary element on the old packaging was a gold wave, and treatment bottles had heavy gold caps with ribs on them. This was abandoned for a sleek, subtle interface that used gold sparingly and very simple design elements. "We felt there was too much gold," Nahum-Albright says. "It seemed to speak to the excesses of the 70s and 80s—it wasn't a modern interpretation of luxury. We felt that a more modern look was a streamlined, beautiful form."

PHOTO CREDIT: PAUL TILLINGHAST

To create a purse-worthy public persona, the Arden cosmetics are designed with understated, sleek lines. Creating the right interface for each product was all about discovering what sort of images different designs projected. Since black is a color classically considered to be consistent with elegance and quality, this was the basis for the design for cosmetics, used liberally in the secondary packaging and the container for the product itself. The cosmetics were designed to be contained in sophisticated, soft square containers, bisected by gold bands engraved with the company name ("Engraving is perceived as a hallmark of quality," says Nahum-Albright). Everything about the interface of the cosmetics is about projecting an intended image to the user, and when it comes to cosmetic packaging, image is the primary motivation compelling the user to buy the product.

Form Follows Function

But the hallmark of any successful user interface design—no matter how aesthetically driven the product is—is that it is functional and practically serves the needs of the user. This is where the designer must think less like an artist and more like an engineer. "When designing packaging for a product, you must not only consider who it is for, but how they use it, what's inside, and how does what's inside affect the outer packaging," Nahum-Albright says. "In addition to image issues, there are always functional issues."

The functional needs of a particular product line are influenced strongly by the practical considerations of the product itself. For these particular products, issues like whether the mechanical parts are appropriate for the product (does the pump dispense the right amount of product for the user?), or if the closure system is adequate (is that toner going to leak all over my suitcase when it travels through baggage claim?). The chemical makeup of the products must always be compatible with the packaging.

"You want to service customers on a conscious and subconscious level," Nahum-Albright says. "If a particular package doesn't work well, she may become briefly annoyed. When she returns to repurchase, she won't specifically remember what she didn't like, but she'll know it was something to do that product. So she will possibly try something else. By servicing the customer in every way possible, you keep her loyal."

The Arden line is also proof that in order for a package to be functional, it doesn't have to be unattractive. An excellent example of this is Elizabeth Arden's line of ceramide capsules. These capsules are packaged in a clear oval spaceship-shaped container with a gold band around the middle; to open the container, the user simply unscrews the top from the bottom. These individual gelatin capsules are clear, oval, and small, echoing the shape of the container, with the only difference being a protruding tab. To get to the liquid inside the capsules, the user turns the tab twice, breaking it off, and squeezes the capsule for application to the eye or face. The capsule dispenses the precise amount needed for one application, while the entire package itself is elegant enough to stand on its own on a user's vanity or bathroom sink.

Designing For User Perceptions

How users buy products strongly impacts how the interface needs to be designed. Sometimes user buying patterns necessitate breaking from the continuity of the product line, to set a product apart. This is determined by the user perception of the product. Elizabeth Arden discovered during user studies that the way their customers buy fragrance is significantly different from how they buy products from the rest of their line.

"Treatments are utilitarian products," Nahum-Albright says. "When you buy a treatment product, you want a specific result. You want to see wrinkles disappear, you want to feel your skin become smoother, yet you're buying a luxury product. Cosmetics are non-utilitarian products, but still functional. You may like red lipstick, or choose a certain foundation because it matches your skin tone well. Fragrance, however, is all about image and what a scent represents to the individual consumer. It is the most personal of all beauty-care products. A scent doesn't smell the same on everyone. Consumers decide if they like the scent and if they buy the 'dream' the scent evokes. This dream is apparent in advertising and in-store visuals as well as the package."

These were the ideas propelling the design interface of Elizabeth Arden's fragrance, Green Tea. It is set off distinctly from the rest of the Arden products because it doesn't feature the Red Door logo or even the standard palette used in the packaging of the rest of the line. This was necessary to create a distinct image for this fragrance. This meant looking to the unique qualities of the fragrance and conveying that to the consumer through design.

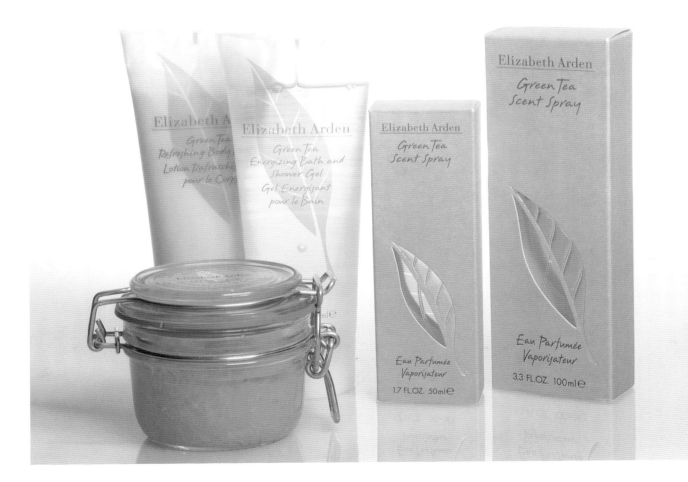

OPPOSITE: The informal, friendly interface of the Green Tea fragrance is carried through with a product line of shower gel, body lotion, and salt scrub. Instead of creating precious, ornate packaging, the interface was designed with a comfortable, casual look consistent with the image the line hoped to project. "We wanted this product line to be one the customer looked forward to using," Nahum-Albright says. "Its design is created to appeal to a user's natural, whimsical side."

BELOW: Not only is the interface of the Elizabeth Arden products as elegant and beautiful as the image it represented, but it's functional, too. The packaging for the ceramide eye capsules are contained in a clear oval-shaped package with a gold band with the brand and product name along the center-an object that would proudly hold its own standing on a user's vanity or bathroom sink. Inside the package are small clear capsules that are in the same shape as the container and include exactly one application of the eye treatment inside.

"We looked at the product and said, 'This is fresh, it's casual,'" Nahum-Albright says. "The popularity of green tea itself spoke about a healthy, natural attitude, and a more natural, calm state. All of these qualities needed to be embodied in the package. We used a fresh, natural green color, but also something that was bright and crisp."

Marketing the product through the box itself was an important consideration and Nahum-Albright used the box's interface to convey as much about the product as possible, while playing upon the product's mystery. The bottle was merchandised in a box with a die-cut leaf on both sides that allowed light to penetrate the product, giving it a three-dimensional effect. One side of the box was green, the other white, which allowed the product to be effectively marketed from either side.

"We used the Green Tea packaging in a way that was unusual," Nahum-Albright says. "We wanted the package to speak in its own voice, to be very noticeable. I liked the idea of having a product that could be merchandised on either side—the white or the green. The idea that you could see the glowing liquid through either side when light comes through added a special dimension to the packaging because most fragrance packaging is closed. It cannot take from its environment. The use of the die-cut window created a three-dimensional icon with the frosted leaf printed on the perfume bottle itself, which allowed me to give the product depth in a way that was quite unusual."

The user Elizabeth Arden hoped to attract with Green Tea wasn't someone looking for a precious, overly lavish fragrance. Instead, Nahum-Albright hoped to use the product's design to appeal to users' natural, whimsical side. "We wanted this to be an affordable fragrance," Nahum-Albright says. "So, for this, I chose a stock bottle, something with a comfortable, modern shape that was sleek and easy to hold and use. We wanted this to be a friendly, fun product that the consumer looks forward to using."

"It's important when creating image to pay attention to displays, advertising, and how it looks behind the counter," says Nahum-Albright.

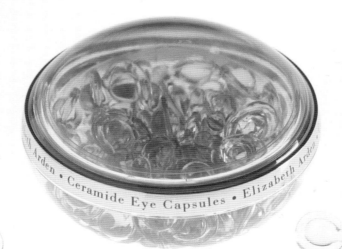

BELOW: When it comes to designing the interface of cosmetics, a very important concept must be projected: purse appeal. "You not only want users to like the product, you want them to be proud of it," Nahum-Albright says. "You want them to show it off a bit. We have to understand that about our consumer and design something appropriate for her to use." The answer was a sleek, streamlined look in black, accented with gold.

OPPOSITE: Although the interfaces of the different treatment products in the Elizabeth Arden line had to meet high standards for aesthetics and image, it was also extremely important that the packaging was functional. "When designing packaging for the treatment products, we work hand-in-hand with a development engineer," says Nahum-Albright. "We make sure the closure systems are proper and appropriate for the product and don't interfere with its chemical makeup. Compatibility of materials is a major issue, as is cost of materials."

Cross-Cultural Packaging

Knowing the cultural preferences of your user is a very important quality to creating successful interface design. For Elizabeth Arden, this was an important issue when they developed a line of products specifically targeting Asian customers.

"Whitening products—products that create an even, unblemished skin tone—are a very big cosmetic category in the Asia-Pacific area," Nahum-Albright says. "Asian companies do the largest volume in this category, but to be a player in the Asian market, you must service the desire for whitening. The challenge here was how do I, an American company with a lower percentage of the category, create something that will appeal to the Asian customer and remain affordable."

Instead of using the metallic palette used with the other Elizabeth Arden treatment lines, Nahum-Albright used a palette that was, simply enough, white. Yet, it was important to keep costs down when developing a line that might not yield as high a volume as the other, more established Elizabeth Arden lines. The solution was to design the Visible Difference product line with the Asian customer in mind. The bottles and caps were simply recolored to appeal to a strictly Asian market.

"For this, we used a matte white coloring on both the containers and outer carton," Nahum-Albright says. "The outer package carries through the continuity of the packaging system—here, we balance a white pearl against white matte."

Servicing the user of luxury cosmetics is all about using the product's interface design to appeal to the aesthetic and feminine qualities she hopes to find in the product. Although functional considerations remain important, the main user focus is on creating a beautiful package representative of the image she seeks.

</elizabeth arden>

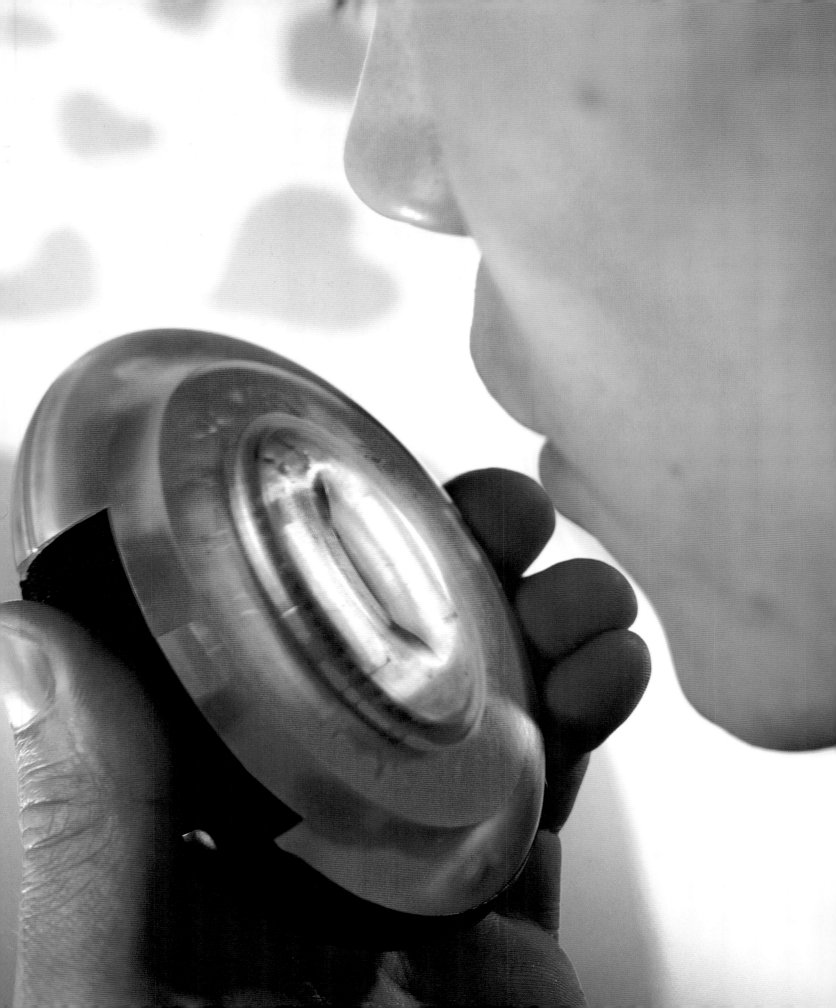

OPPOSITE: The interface of the Kiss Communicator prototype developed by IDEO is conspicuously devoid of buttons, a keyboard, or mouse. Since the nature of the information being passed between users was emotional, the product's designers felt it was important for the interface to be intuitive, and not technical. To create a message, the user must interact with the product in a very personal way uncommon to technical devices—by squeezing it gently or holding it up to his mouth and blowing into it, creating a pattern of light. It was left up to the users how to interpret received messages, a quality that indicated a great deal of intimacy between users.
PHOTO: BEVERLEY HARPER

‹ ELECTRONIC PRODUCTS: IDEO ›

MOST PEOPLE WILL TELL YOU THAT EMOTIONAL, WORDLESS SENTIMENTS CAN'T BE EXPRESSED DIGITALLY. IDEO, A DESIGN AND PRODUCT DEVELOPMENT FIRM WITH OFFICES EVERYWHERE FROM LONDON TO GRAND RAPIDS TO TEL AVIV, CHALLENGED CONVENTION BY DEVELOPING TECHNOLOGICAL PRODUCTS APPEALING TO A USER'S NEED TO COMMUNICATE EMOTIONALLY, RATHER THAN JUST FACTUALLY. THESE PROJECTS WERE BORN FROM THE REALITY THAT A CELL PHONE CAN'T CONVEY A WAVE FROM ACROSS A ROOM, AN EMAIL MESSAGE CAN'T SEND A GESTURE OR WINK (EMOTICONS DON'T COUNT), AND A PAGER CAN'T EXPRESS A TOUCH. IT WAS THIS VOID THAT COMPELLED IDEO SAN FRANCISCO (IDEO SF) TO CREATE CONCEPT PROTOTYPES THAT FOCUSED ON THE EMOTIONAL QUALITY OF COMMUNICATION FOR A SOCIETY SUFFERING FROM FACTUAL INFORMATION OVERLOAD.

Two-Way Communication

IDEO SF Interaction Designer Duncan Kerr, together with IDEO SF intern Heather Martin, knew that the world was already teeming with communication technology. "We're surrounded by communication technology—telephone, email, teleconferencing, the Web," Kerr says. "Yet, we have a deep need to connect with the people we love all the time. We all have a lot of noise in our lives, and we want to turn it off. The idea was to create a product that was its own unique channel of communication."

Enter the Kiss Communicator, a working prototype of an electronic product (running on 9-volt batteries) whose interface conspicuously lacks a keyboard, mouse, stylus, screen, or even buttons. Designed to facilitate the exchange of emotional content between people separated by a great physical distance, the Kiss Communicator uses wireless technology to transmit the digital equivalent of a personal gesture, like a wave, wink, or a kiss. The interface of this product was designed to be wholly unobtrusive and largely intuitive. And in order to preserve the intimacy of communication, each unit could communicate only with the other, creating a personal, one-on-one exchange.

From the packaging down to the message, the Kiss Communicator was all about facilitating two-way communication. The product comes packaged with both Communicators joined together in an egg shape—to use them, the users must break them apart. "The basic idea was this was a product for a pair of lovers, something they can buy so they feel that they're with one another throughout the day," Kerr says. "If I wanted to tell my lover I was thinking of her, I would grab my Communicator and squeeze it gently. It would respond by sort of glowing to indicate it's awake. I would then blow into it, and as I did, I would create a message in light as the Communicator responds to the breath. When I stop blowing, the Communicator proceeds to play the light message back to me, so I can see what it looks like and add more to the message if I want to. When I'm happy with it, I just release the Communicator, and the light display changes, indicating that the message has been sent."

The Communicator uses wireless technology to transmit the light message to the recipient. "Wherever my partner is, on the other side of the planet, or just down the street, her Communicator would start to glow very subtly, very gently, to tell her that there's a message waiting for her," Kerr says. "Should she not notice it right away, the object would subtly get brighter and brighter to attract her attention. To retrieve the message, she picks up the Communicator and squeezes the two pressure points. The light message plays and loops around and repeats the message. The more it loops, the more it gradually fades away, like a memory."

Quality Interaction

It was important for the interface of this emotionally driven product to be simple and subtle, and not interfere with the sensual process of sending and receiving messages. For this reason, the designers avoided incorporating elements like buttons and wires. "We wanted to keep the nature of the physical object as simple as possible, so the interaction was more about the experiential message and less about the physical object," Kerr says. "It was necessary for the user to have an emotional experience with the Communicator and not spend time thinking about the product itself or how to use it."

The product's interface requires people to use it in a way that most aren't accustomed to interacting with a technical product. "When designing the Kiss Communicator, we were trying to create an experience for the user that would have a lot of emotional value and personal meaning to people when they were using it," Kerr says. "To use the Communicator, you must pick it up and gently squeeze it, giving it just the right amount of pressure. You must hold it up to your face and blow into it. These are unfamiliar things to do with a product, and we wanted to keep these sort of human intimate aspects in mind."

The message the Kiss Communicator delivers is every bit as subtle as the interface. "The product's design was all about preserving the quality of the interaction," Kerr says. "We wanted the interaction, in an abstract way, to have the subtleties and qualities of interaction between people in the real world. Like having someone blow on your cheek or brush their foot against yours under the table. Basically, it's about communication that has no factual content, but is loaded with emotional content. It was all about the quality of the interaction."

When designing a product whose function is delivering an emotionally charged message, it was important to design the interface with an ambiguity that would allow the users to develop their own layer of interpretation. "One thing we were conscious of during design was leaving room for people to develop their own language with it," Kerr says. "What one wave across the room means is different from another wave across the room. People could develop their own language with their partner through the light image."

BELOW: Instead of creating another mass-communication tool like email, telephone, or a fax machine, the Kiss Communicator's interface was designed exclusively for one-on-one communication. "It was a way to create a channel of communication between you and the most special person in your life," Duncan Kerr, designer of the Kiss Communicator says. When one partner creates a message for the other, the light pattern is sent via wireless transmission to its recipient. The recipient's Communicator glows to alert him that there is a message waiting. Receiving a message is designed to be every bit as intimate as sending one-to view a message, the recipient gently squeezes the Communicator. The messages were even designed with lifelike qualities. For instance, the light message plays and loops around on itself, playing until it "fades away like a memory" as Kerr says.
PHOTO: BEVERLEY HARPER

The interface of this product was designed to be wholly unobtrusive and largely intuitive.

Objective + Subjective

Where the Kiss Communicator was about conveying purely emotional messages, homEmail, a concept prototype designed by IDEO SF Interaction Designer Marion Buchenau, fused the exchange of both emotional and factual information. Developed while she was a student at London's Royal College of Art, Buchenau took media most everyone is accustomed to using—email and fax—and created a tool that could convey both factual and emotional information in an intuitive, friendly interface.

The product's interface design was created to fill a void in contemporary email clients—the delivery of a sensual, emotionally rich message that would be easily incorporated into a home environment by any user, regardless of computer skills. "Consider the difference of receiving letter by mail verses receiving an email message," Buchenau says. "With a traditional letter, you get a sense for what's inside the envelope based on the weight of the letter. The handwriting indicates whom it's from. You tear open the envelope, take the pages out and get a sense for the kind of paper chosen. You also get a very different feeling based on if the letter is handwritten or typed. These experiences tell you so much, and there's a whole process in receiving a message that is lost with an email client. If I click on a message in my email account, there it is. Although the process is efficient, it's not subtle, personal, or rich."

Interface For The Home User

The interface of the typical computer, with its boxy base and monitor, doesn't necessary blend well into the home environment. From its conception, homEmail was designed to look more like a piece of furniture than a piece of computer equipment. To serve as an email system for the home user, it was important that the interface wouldn't interfere with the space it occupied, but instead, become a part of the room's interior design.

"I felt that plastic molded gray boxes don't share the environment well with the other objects I have in my home," Buchenau says. "My strategy was to find a way to blend the design of a digital appliance with a piece of furniture in the home's physical environment. I wanted to create something that would integrate well into the home, so when designing this product, I used materials like wood and glass." Made of wood, homEmail's base stands on the floor and supports its horizontal glass top, the system's screen. Messages are projected up from the base to the glass screen.

The needs of the home user were also major factors in how homEmail was designed. "Because homEmail was designed for the home environment, the core user group focused on friends and family rather than office correspondence," Buchenau says. "This doesn't mean that you can't send messages to office colleagues, but this product was really designed more for personal usage. I wanted a way to send something to my lover, my friend, my mom, or whomever I'm particularly close to, without having to state my sentiments in explicit words."

The product's interface was also simple and intuitive, more akin to writing a letter than typing out a message—in fact homEmail messages are entered entirely by a stylus (no keyboard was incorporated into the design). "While I was designing for the home environment, I was also creating something for people who weren't necessarily highly skilled, experienced computer users," Buchenau says. "This product was designed to be a messaging system for people who aren't necessarily computer literate. When designing, I kept thinking of how to create a product my mom would use."

LEFT: The interface for the design prototype of homEmail was designed to look more like a piece of furniture than an electronic communications tool. Aiming to distance this product from the molded gray plastic monitors and bases that most people use to send email and faxes, designer Marion Buchenau constructed a look more familiar to the home environment, using wood and glass. This product was designed to blend into its environment and interact with it through the ambient light reflected from it through its base.

ABOVE OPPOSITE: Rather than function as a sophisticated technical communication tool, homEmail was designed for even the most novice computer users. The interface was created to be analogous to writing a letter. And although this product theoretically could be used for office correspondence, its design was more in tune with the home user. Instead of using keyboards, messages are written by hand with a stylus.

BELOW OPPOSITE: The user is given a series of different clear pen-like objects that he can assign to represent different people. He can even personalize his interface by moving these around on the glass, anywhere he chooses. The user is alerted when a message arrives from someone who has a dedicated pen by a light that appears underneath and fades in and out, illuminating the pen. This way, the interface subtly lets the user know that he has messages from a distance in a very unobtrusive way that integrates well into the home. One stylus represents all the messages that arrive, alerting the user to when any messages at all arrive.

<ideo>

How It Works

The user can customize homEmail's interface according to her preferences. The product comes with five or six clear perspex "pens," which sit atop the glass surface, seated in metal bases. The user can dedicate all but one pen (which collects all messages and acts as an indicator when any message—regardless of the sender—arrives) to represent specific email correspondents. For instance, one pen may represent the user's mother, the other her partner, providing physical representations of each person. The pens can be arranged anywhere on the glass surface, allowing the user to create an interface that's customized to her personal preferences and style.

The interface lets the user know at a glance what messages she has and from whom. When a message arrives from someone with a dedicated pen, a light illuminates the perspex (projected from below), fading in and out. The light's color is determined by the color the sender has chosen as the background for the message, and type projected on the screen alongside the pen indicates the user's name and subject line. When a message arrives from anyone, light glows underneath the pen used as a repository for messages.

To retrieve the message, the user takes the pen from where it was positioned on the interface and moves it into a highlighted area in the center of the screen. The color the sender has chosen for the background then illuminates the entire glass interface, reflecting on surrounding objects and subsequently interacting with its environment. The written message then also fills the screen.

The process for composing a message is influenced strongly by the tactile process of letter writing, and the interface reflects this. The first thing the user does to create a new message is to select the pen representing the person he wishes to communicate with (or if it's a user without a dedicated pen, the "repository" pen). He slides the pen across the bottom of the interface to a series of colored dots, which allow him to select a color for the background as if he were choosing a piece of paper to write on. The background then illuminates with the chosen color and the user can begin using his pen to write on the screen to compose the message. The user can choose to have his message sent in his own handwriting or converted to typewritten text if he chooses. To send the message, all he does is return the pen to its metal base.

"This product was designed to be a messaging system for people w aren't necessarily computer literate. When designing, I kept thinking how to create a product my mom would use."

RIGHT: The interface lets the user preview a variety of messages from multiple senders at once. If a message comes from a user with a dedicated stylus, the color the sender has chosen for the background of his message appears underneath the stylus, along with the approximate time the message arrived and the message header. When the user calls up a message, homEmail interacts with its environment by projecting light onto the areas around it.

BELOW RIGHT: Light is an essential part of homEmail's interface, adding another layer of expression to the correspondence. "The meaning of light colors can be mapped by the user," Buchenau says. "For example, it can be used as a signature or to indicate the expressive qualities or can be sent without accompanying text as a subtle signal between friends-for instance, red could mean 'I just thought of you.'" To select a color, the user slides the stylus along the bottom of the interface and chooses one like a person would choose a certain paper when writing a letter.

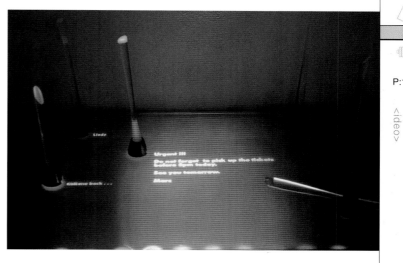

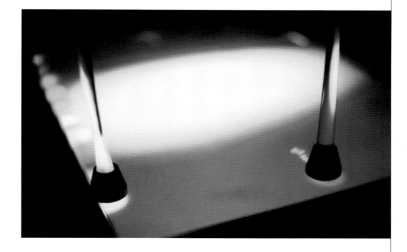

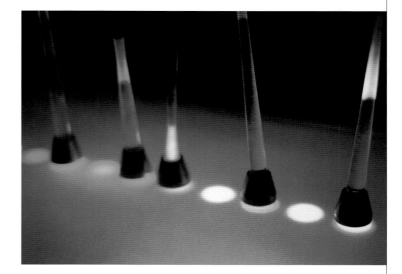

What Words Can't Express

The interface of homEmail allows the user to create a message that means different things to different people. "With the system, users can create color codes to give their messages more meaning," Buchenau says. "If I sent a red message without any text to my lover, it might mean 'I'm thinking of you.' On the other hand, a red message sent to my boss could signify that this was a very important message to read right away. It depends on the meaning the users have established. It's important to have that flexibility, it's part of personal intimacy."

Since the product is a part of the user's home, it was important for the interface's message alerts to be subtle, not disruptive and jarring. When new messages arrive, the lights that illuminate the pens fade in and out. If there is a message sent that has gone unread for a certain amount of time, the light begins to gradually fade in and out more slowly.

"The way an answering machine light blinks when the user has messages is really harsh—I feel like the light is shouting at me," Buchenau says. "I wanted to develop a way to let users know they have messages that they could choose to ignore if they wanted to. Users can glance over at homEmail and see multiple lights slowly fading in and out at different speeds, the pens indicating who the messages are from, the speed of the lights indicating what messages are the newest, and the colors conveying personal characteristics."

Using the subtle speed of lights fading in and out also lent lifelike qualities to the messages, and thus the interface. "I wanted to have some way to portray the personality of the message as a sort of living organism within the system," Buchenau says. "There's some randomness to the interface, it's not always the same. The randomness comes by the speed of the lights fading in and out and the colors used."

What IDEO has developed with these products are interfaces that don't respond exclusively to the practical needs of the user, but expand their designs to reach out to emotional, subjective user needs. These products provide evidence that just because an object is technological doesn't mean that it must be devoid of emotional qualities.

</ideo>

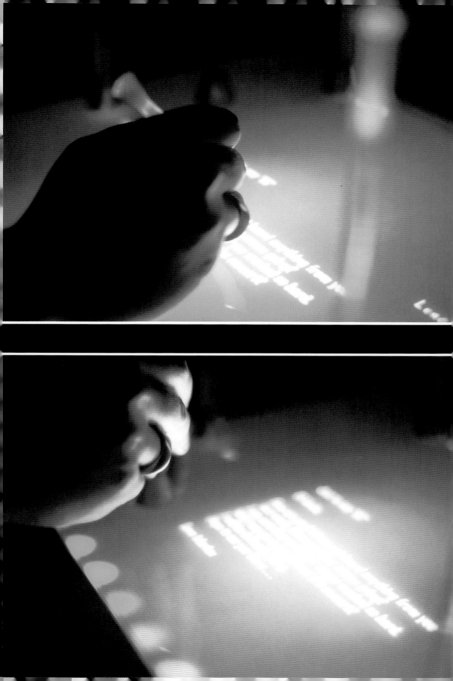

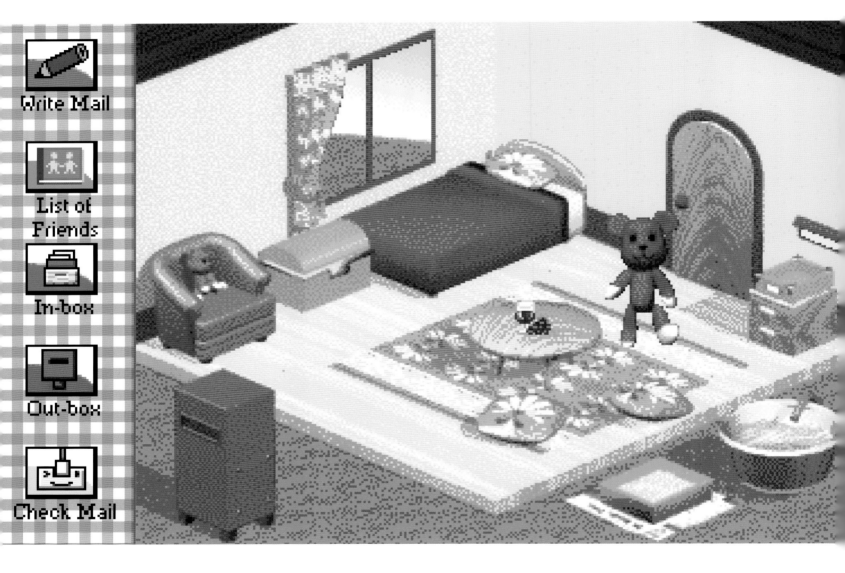

Write Mail

List of Friends

In-box

Out-box

Check Mail

‹ POSTPET SOFTWARE: PetWORKs ›

IF TALK IS CHEAP, EMAIL IS A STEAL. HASTILY WRITTEN EMAIL MESSAGES CAN BE FIRED OFF TO HUNDREDS OF PEOPLE WITH THE CLICK OF A BUTTON. INSTEAD OF SPENDING TIME WRITING MESSAGES BY HAND OR PRINTING TYPED LETTERS TO PAPER, EMAIL ALLOWS USERS TO SEND MESSAGES ALMOST AS QUICKLY AS THEY ARE COMPOSED. AS A RESULT, NEARLY ANYONE WILL TELL YOU THAT MOST OF THE EMAIL WE GET IS JUNK—ADVERTISING MESSAGES THAT FLOOD THE EMAILBOXES OF ANYONE WHOSE EMAIL ADDRESS ADVERTISERS CAN GET THEIR HANDS ON; BUSINESS CORRESPONDENCE DASHED OFF, REPLETE WITH MISSPELLINGS, FRAGMENTED SENTENCES, AND INCOMPLETE THOUGHTS; IDLE CHIT-CHAT; EVEN RECYCLED JOKES.

It was the quality of email communication that inspired Tokyo-based PetWORKs to design PostPet for Sony. Think Eudora meets the Tamagotchi virtual pet. This software allows users to use animated virtual "pets" to deliver email messages to other PostPet users. These pets have personalities, unique temperaments, and quirky characteristics. They also write to their owners, make friends with other pets, and keep a diary.

Intimate Communication

The explosion of email communications overlooked one important aspect of its interface design—the intimacy of one-to-one communication. Like Marion Buchenau's homEmail, this was one of the inspirations for the design of PostPet. "I tried to introduce the old style of communication—such as ordinary mail or even carrier pigeons—into the email world," says Kazuhiko Hachiya, the creator of PostPet. "For example, if you want to send a piece of mail to someone with feelings of friendship or love, you might choose a nicely designed envelope, lovely stamps, and so on. As much as the message of a letter, these things can express your emotions. When you receive an email message, you cannot tell the difference between a business letter and a love letter by its appearance. I wanted to design the email software so that you can express the sentiment 'you are a precious person to me' beyond words."

The interface of PostPet is subsequently about as warm and fuzzy as you can imagine a software interface to be. Users choose to adopt one of eight cuddly pets, which lives in a brightly furnished room in a window on the user's screen. PostPet is intentionally designed not to be the spam-spewing engine that other email clients are. The user clicks on simple icons to compose email messages, and depending on the recipient, either has the pet or postman deliver the message. Pets can only deliver messages to recipients who also use PostPet—the postman, a robot on inline skates, is used to deliver multiple messages and mail to recipients who aren't PostPet users. When receiving an email message from a PostPet user, the sender's pet physically travels to the recipient's "house," leaving the email on the table. The pet will then write in his secret diary, play with the user and/or the user's pet, and return home. If the recipient isn't online, the pet will wait at his house for a while (usually 12-24 hours), or leave the mail at the house before returning home.

Type:	Teddy Bear
Name:	Momo
Sex:	Male
Age:	0 days
Happiness:	Feeling like sunshine
Intelligence:	Average
Condition:	Very mischievous
Hunger:	Just fine
Style:	Everyone takes a 2nd look!
Money:	100 Pt

Comments
The owner is Mama.
Has carried 0 messages.
Novice messenger.

ABOVE: In order for PostPet to function the way it was designed to, it was necessary for the interface to encourage users to become personally invested in their pets. One of the ways designers did this was by giving the virtual pets a variety of lifelike characteristics, from mood to style to hunger. From the menu bar, users can access the current status of their pet. In this case, Momo's degree of happiness is described as "feeling like sunshine" and his personal style is noted as "everyone takes a second look!" If users are wondering if it's time to feed their pet (the software is designed so the user must care for the pet in order for him to deliver messages), they can simply check his status. The status also serves the practical function of indicating how many messages the pet has delivered.
© Sony Communication Network Corporation

Playing at speed.

Playing like the wind.

To keep the correspondence intimate between friends and the user's interaction with the pet high, it isn't easy to send out a long string of email messages using PostPet. For instance, you cannot ask your pet to deliver more than one email message at a time. The PostPet site explains, "You want to avoid the long absence of your pet. It's also because you only have one pet and it cannot be in two places at one time."

The interface was designed to give the pets lifelike characteristics to offer personality to the messages sent and engage users in the process of sending and receiving PostPet images. Considering the more mail a pet carries, the shorter its lifespan will be, PostPet users must be judicious with whom they choose to send messages to. "The software is designed so users can use pets to send messages only to their most precious friends," Hachiya explains. "This also means that a friend who has chosen to send you a message considers you one of his precious friends. The pet is a metaphor for special stamps people use to send letters. As you use more, you have less, so you choose to use it only for close friends."

Designing For The User

Admittedly, the messages delivered by an adorable, playful pet may impress your sweetie, but not the company CEO. But PostPet wasn't designed for global email use. Instead, it was designed for the beginning Web user and those who wanted to convey more than ASCII text could convey.

"People ask, 'Is PostPet for kids?'" Hachiya says. "This is not the case. In Japan, the ratio of male to female users is 50/50, and most users are in their 20s and 30s. We know that there are users who are kids and teens, but this doesn't mean that the software is exclusively for them. More specifically, PostPet is for computer novices who are just beginning to use email."

Rather than the business-oriented, text-only interface other email clients feature, PostPet's interface is designed to be graphics-driven, and, for lack of a better word, cute. The pet lives in a cartoon-like room rendered in bright colors and icons represent the different basic functions of the email program. The interface is created to appeal to users who may have never sent an email before by keeping the design extremely simple.

"I tried to make the purpose of this software clear," Hachiya says. "Ordinary email software is designed for business use, built to send and receive more mail in less time. But if you think about email software for private use, or for beginners, you have to change the concept."

A Fun And Functional Interface

The interface is designed to be streamlined and simple, and easy for beginning computer users to learn. "I am tired of the various different menus and buttons found in email programs," Hachiya says. "So my policy [when designing PostPet] was to delete the functions used only once a year or functions that are hard for beginners to understand." There are no filtering or blind carbon copy features, for instance, but the functions included support the software's lighthearted concept and beginning user. "Beginners do not have many people to exchange email with, so they receive fewer emails," Hachiya says. "These people won't check incoming mail as often. So I created the software's design to make people want to check email more frequently." Users are compelled to stay online to await the arrival of friends' pets, care for their own pet, or just check in on their pet's virtual world.

Although sending and receiving of email is most fun when exchanged between PostPet users' pets, PostPet's practical needs are met with the postman. The postman can "deliver mail very quickly because he wears inline skates," according to the PostPet Web site. The Postman can be used to deliver mail when the user's pet isn't home, or when he needs to deliver the message to more than one person. "PostPet is designed to be both a game and a tool," Hachiya says. "I created the Postman to deal with problems like delivering mail when the pet is away and sending carbon copies. Of course, I wanted the program to cover basic functions. The postman is created together with the pets, because I thought developing the aspect of using PostPet as a tool was also important."

Many of the features designed as part of the PostPet interface were created so users feel comfortable creating and sending messages, especially that messages are arriving at their destination. "I know email is convenient," Hachiya says. "But at the same time, people who may have never touched a PC might be worried about email, wondering, 'Is my message getting to you?' PostPet was designed to remove such worries."

RIGHT: Since the interface is so interactive, users are compelled to find ways to keep their pets busy and happy when they aren't delivering mail. For this, several different toys are available for download from PostPetPark, a subscription site for PostPet users. What toys the pet bonds with depends on his or her personality, but PostPet has graciously developed a variety of different toys that are sure to make things interesting.

© Sony Communication Network Corporation

BELOW: One of the joys of using PostPet is seeing your pet interact with its environment. Here, Momo is obviously enjoying playing with his Momo doll. Treat your pet well, and hopefully he will demonstrate the same kindness with his own doll.

© Sony Communication Network Corporation

Type	Name	Advice
	Banana peel	Someone seems to have eaten the banana and left the peel. Some pets know this joke, but some clever Postpets might not play along.
	Momo doll	This is a Momo doll (small size). Whether your Pet appreciates dolls depends on its personality. If you've always treated your Pet well, it will usually take good care of the doll.
	Record Player	This is an old-fashioned record player. There are pets that enjoy music, and those that do not. If you played some music to your pet, using a CD or microphone, you might see something

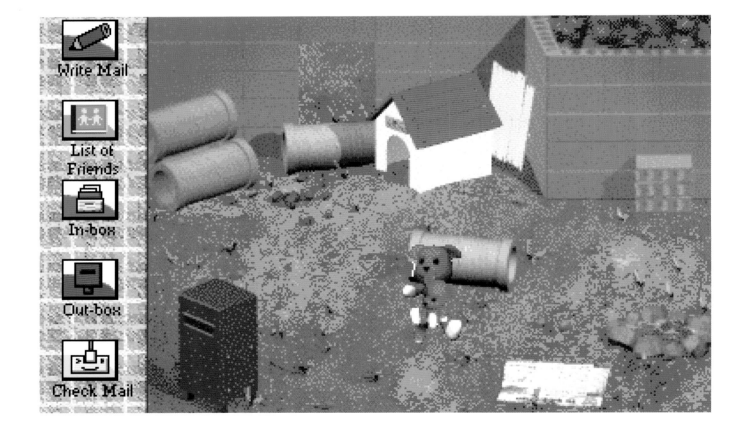

characteristics to offer personality to the messages sent and engage users in the process of sending and receiving PostPet images.

LEFT: Although PostPet is fun to interact with as a game, first and foremost, it is a powerful way of interacting with others outside your pet through the use of email. Colorful icons along the side of the software's window provide the basic functions of an email client: writing mail, an address book of friends, a button to check mail, etc. The software is purposefully designed not to support the complicated demands found with contemporary mail clients like filtering, blind carbon copies, etc. "My policy is to delete the functions used only once a year or functions hard for beginners to understand," says Kazuhiko Hachiya, PostPet's creator.
© Sony Communication Network Corporation

BELOW: The interface makes AOL's "You've got mail" mantra downright cold. Here, a friend's pet delivers a message, which Momo, the user's pet, eagerly accepts. The interaction between pets is part of the software's experience, allowing users to build relationships with each other through pets. Mail can only be delivered when the recipient's pet is home-if a recipient's friend isn't online, the pet will wait there for a while (usually 12-24 hours) or leave the mail and return home
© Sony Communication Network Corporation

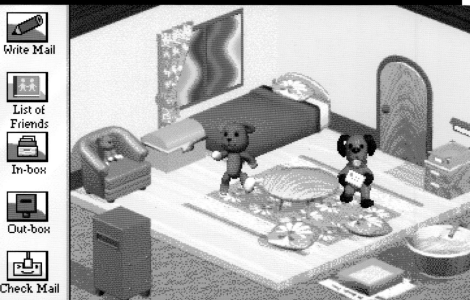

ぷまリビング

お客様のご予算: **100 Pt**
現在のお買い上げ総額: **40 Pt**

ヘルプ　　　お会計

壁紙	床板	ドア	ベッド	ポスト	テーブル	宝箱	トイレ	お風呂
10 Pt	20 Pt	10 Pt	0 Pt	0 Pt	0 Pt	0 Pt	0 Pt	0 Pt

ドア　ゲストの第一印象はドアで決まります。

無地
[Design: AGES5&UP]　　　**5 Pt**
無地のドアです。

ドア
[Design: AGES5&UP]　　　**10 Pt**
オーソドックスな（ホントは紙だけど）ドアです。

木製ドア
[Design: AGES5&UP]　　　**10 Pt**
木製（コレも紙だけど）のドアです。

スチール製ドア
[Design: AGES5&UP]　　　**20 Pt**
スチール製（やっぱり紙だけど）のドアです。

あのドア

家具を最初から選択しなおす →

When the mail is sent and received, you receive a confirmation, in the form of your pet's secret diary, designed to be consistent with its playful interface. "When you use PostPet to exchange mail with other PostPet users, a report by your pet called a 'secret diary' is sent to you," Hachiya says. "The pet writes how it is treated by the recipient. When the recipient did not receive the message while the pet's there, it records that the person wasn't there. This makes sure that you know your message was received by your friend and that you feel connected."

Pet Personalities

Perhaps the most engaging quality of the PostPet interface is that it was given a personality through the qualities of the pets. Available for adoption are the teddy bear, Momo, with an intelligence level of a 3- to -7-year-old and a gentle disposition. Sumiko, the tortoise, has an intelligence level of your average 20- to 85-year-old, and is described as "argumentative and ironic—but writes interesting emails." The mongrel cat, Furo, has an intelligence of a 7- to 14-year-old, is temperamental and needs a great deal of care and attention, but will write several email messages to you and your friends. The miniature rabbit, Mippi, has the intelligence of a 5- to 10-year-old, and is a little shy. The pets grow up, and yes, die. "Life is like that," the PostPet Web site explains. The pets have a lifespan of about two or three years.

But the personalities and qualities of the pets serve a practical interface purpose as well. When users see a visiting pet in their house, it's easy to tell who sent it, if the pet is recognized as that of a friend. According to Hachiya, "The different pets also allow you to identify the taste of its owner." Did you peg your best friend as a teddy bear person, when he chose the temperamental mongrel cat? The pet's personalities play into the actual experience of using the software since the pets themselves sometimes send mail to you and your friends.

LEFT: One of the most essential qualities of PostPet is maintaining a loyal and enthusiastic user group. After all, without fellow users to exchange PostPet email with, the system won't work. Here is part of a Yellow Pages search directory on PostPetPark that allows users to find the addresses of PostPet friends.
© Sony Communication Network Corporation

BELOW: Although it's most fun to exchange email with users who are PostPet subscribers, it was also necessary for the software designers to not compromise email's efficiency by creating a way to send mail to recipients who don't use PostPet, and to send multiple email messages at once. The solution was a character known as Postman, who is empowered with the ability to deliver many messages at the same time, can be used to deliver mail when the user's pet isn't home, and also guarantees delivery. Consistent with the software's playful spirit, Postman has a biography that describes him as "gentle, considerate, and earnest." He's also able to deliver mail quickly "because he wears inline skates."
© Sony Communication Network Corporation

(c)1997 Sony Communication
Network Corporation.

Since PostPet was not only a software tool, but also a game, the interface allows users to interact with the pets. You can pat (or even hit) your pet, or other pets when they come to deliver email. But beware: Too much hitting may make your pet distrust or dislike you, and it may run away from home. There's also a basic level of care you have to afford your pet—you've got to wash your pet and clean out the litter sometimes. If you neglect your duties, flies may come, or your friend's pet may be disgusted by your stinky animal.

In order to keep the experience of using PostPet constantly exciting and new, designers created a series of plug-ins and options for customizing the room's interior and giving your pets snacks. When your pet gets sick, you tend to it with a sickness plug in, and you can even dabble with the mystery of the "secret" plug-in.

The most exciting part of PostPet is that the pet interacts with the user. In addition to writing in its diary or sending mail to the user or the user's friends, the pet is very resourceful. The pet can deliver greeting cards, make other pet friends, quarrel with other pets, and even fall in love. Along the way, a pet may learn weird dances or bring you back treasures from its travels. The interface allows the user to become personally invested in the software, so it becomes much more than just a communication tool.

Although it may sound hokey, PostPet bills itself as "an Internet communication tool for making friends." Whether or not you agree with this, you have to agree that you've got to be a little proud when little Momo composes his first email to you, his master. What has Microsoft Outlook done for you lately?

(c)1997 Sony Communication
Network Corporation.

(c)1997 Sony Communication
Network Corporation.

(c)1997 Sony Communication
Network Corporation.

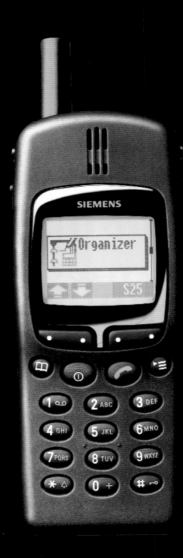

OPPOSITE: Personalization is an interface consideration for almost any product—the more adaptable the product is to the user's personal preferences, the more satisfied the customer will be. The S25 was made available in different two different colors—silver and dark blue.

‹ MOBILE PHONE: SIEMENS ›

ALTHOUGH THE TELEPHONE HAS CERTAINLY EVOLVED OVER ITS LIFETIME, THE ENTIRE CONCEPT OF TELEPHONE COMMUNICATION WAS REDEFINED WITH THE INTRODUCTION OF THE MOBILE PHONE. WITH THIS INVENTION, NO LONGER WERE TELEPHONE USERS TETHERED TO THEIR HOMES OR DESKS. RATHER, MOBILE PHONES GAVE USERS THE FREEDOM TO PRETTY MUCH GO WHEREVER THEY WANTED TO RECEIVE AND MAKE CALLS. AS MOBILE PHONE TECHNOLOGY GOT MORE SOPHISTICATED, THE PHONE'S FUNCTIONS WERE FUSED WITH OTHER COMMUNICATIONS DEVICES LIKE PAGERS, PDAS, AND EVEN WEB BROWSERS.

Meanwhile, the phone itself got smaller. It was clear that portable communication wasn't enough—users wanted something that would integrate the rest of their communication tools and that would fit in a shirt pocket. The challenge for the phone's interface designers was to create a phone that supported the demands of modern users in a diminutive size.

Siemens is an international product development company that specializes in electronics like PCs, mobile phones, telecom networks, and more. When designing S25, a high-end mobile phone, Siemens looked closely to the preceding model, the S10. Taking the new functions that were to be incorporated into the S25 together with the improvements to the S10's interface, Rainer Volland, project leader for User Interface Product Support for Mobile Phones at Siemens in Munchen, Germany, set out to design an interface that was user driven, not technology driven.

Meeting Customer Needs

Since there are a variety of different mobile phone users in the marketplace—users who use the phones strictly for emergencies, those who use them primarily for personal calls, others who replace their home phone with mobile service—it was essential for designers to first determine who the target user for the S25 would be. From here, the appropriate interface followed. "The S25 was designed for business people and heavy users," Volland says. "We wanted to provide all possible functionality and make it really usable."

Not only was the user a consideration when determining the physical look and feel of the phone, but also when deciding what features to include. Since users were likely to demand the most sophisticated features on the market, it was necessary to design a practical tool that met user technological needs. For the S25's target user, the product needed to be more than just a portable phone. It needed to integrate a variety of different communication functions within one tool.

ABOVE: It was important for every aspect of the phone's interface to support its core appeal—portability. Several accessories were developed for the S25 that allowed users to easily take it with them wherever they went—the clip provides yet another way to keep the S25 at the ready for frequent use. The clip itself is easy to connect to the user's belt, by simply slipping the belt through the notch.

The S25 included the standard mobile phone features, like digital phone book, date and time display, and high-resolution graphics display. But in order to hold its own in the marketplace, it was necessary to incorporate the most innovative technology available. Included is an integrated modem for data and fax transmissions, games, a calculator, currency converter, and a vibrating call alert. A voice recorder allows the user to record voice memos and users can enter up to 250 entries into the phone book. Personalization is always a crucial element of successful interface design, so the phone was designed with three different games (and the opportunity to add more), 40 different call melodies to personalize the rings, and the opportunity to download graphics and sounds to the phone.

Taking the phone's design a step further, the interface includes a personal organizer that allows users to schedule appointments and reminders, and an e-business card function that allows users to beam information to other users. This option takes the schedule planning functionality of products like the popular PDAs and integrates that functionality as part of the mobile phone. Adding options like these make the phone even more useful for the heavy business user, allowing them to streamline their tasks and tools with one product. The organizer's information is included in the phone's digital display, where users can scroll up and down to read the information. Although the interface was at a practical disadvantage when it came to screen size, it redeems itself by fusing the functionality of two important business tools.

The S25 organizer interface was designed similarly to the popular PDAs familiar to most other users, making for a small learning curve. "The organizer has a sync option with the PC," Volland says. "It works similarly to other handheld PDAs. You can enter appointments on your PC for a given date, and transfer the information to your phone. By default, an alarm is set to notify you for each scheduled event, and users can select from a month, week, or day view."

A function that opens the phone's interface literally to an infinite amount of information is the support for the WAP Browser from Phone.com. This Web browser allows users to browse WML (a script language similar to HTML for wireless use) pages on the Internet through a wireless application protocol (WAP). "Using it, you can access lots of services that are provided by any content provider," Volland says. "For example, airlines have working prototypes of a database that allows travelers to check the arrival and departures of their planes. Other services will include mobile banking, tourist information, and much more."

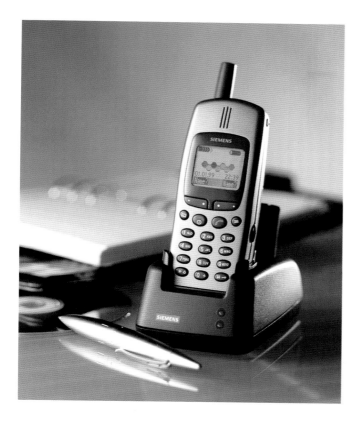

LEFT: Reliability was an important quality to consider when designing the S25 interface, especially considering a product designed for the business user. In order to charge the phone's battery, the user attaches it to its cradle—the full charging process takes about an hour. This enables the phone to be functional for up to 10 hours of talking time, 400 hours of standby-features crucial to allowing the user the confidence that the phone will perform when needed. An extended-use battery provides backup for when the original battery dies. The charger is energy-efficient, automatically switching to "trickle charging" when the phone is fully charged.

BELOW: The display is the most important part of the mobile phone's interface—it allows users to interact with the phone in a dynamic way, accessing the variety of functions and obtaining important information about the phone's performance. "We prioritized the symbols to be shown onscreen," Volland says. "At most, two symbols can be shown simultaneously between field strength [indicating the power of local service] and battery status." The high-resolution screen was designed to be easy to navigate, including symbols for different functions (such as for a locked keypad, tones off, etc.), allowing the user to read information at a glance.

OPPOSITE: To meet special needs of different users, designers created different accessories that users could use to tailor-make the phone for their different needs. A headset was developed that allowed users maximum freedom of movement when using the phone, making it useful for car phone adaptation, or use during active times.

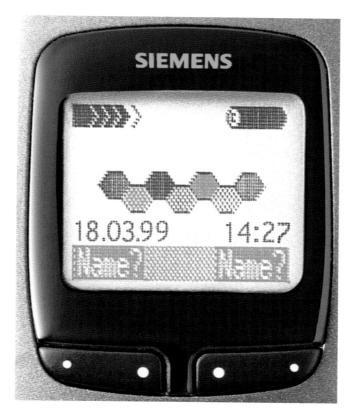

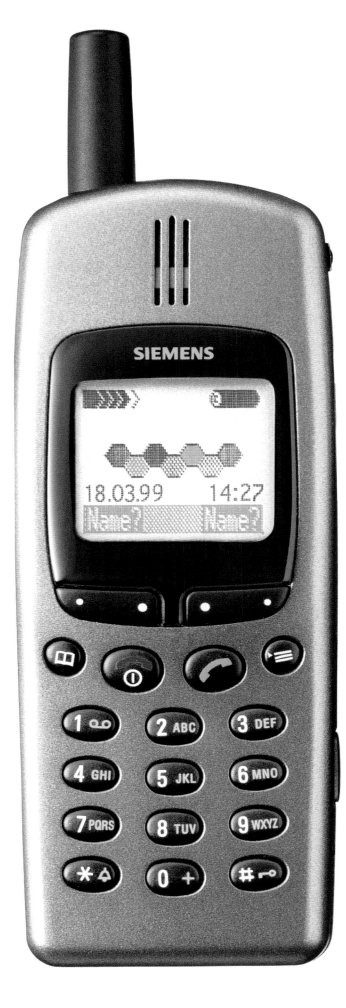

THIS SPREAD: The S25 was designed to meet the needs of the high-powered user who craved the most sophisticated technology available with a mobile phone. An interface challenge for designers was taking the design of the existing Siemens mobile phones and scaling it down, while adding functions. The final product weighs only 125 grams and is small enough to fit in a shirt pocket, although it adds several new functions from the previous version. This was achieved by keeping the display screen the same size, but eliminating superfluous menu information, reducing the size of the keypad, and adding icons for symbolic representation of different functions.

User-Centered Design

To determine exactly how to meet user needs, Siemens administered a series of user tests. Since the way users interact with the phone is primarily through the keys, their findings led to a redesign of the way keys are used on the phone. Subsequently, one of the most innovative additions was the development of two "softkeys," whose function changes depending what menu items the user has chosen on the display (similar to a two-button mouse). These keys are located directly underneath the display and are used by rocking them back and forth horizontally. "With the rocking keys, in certain cases, we can place two functions on each key," Volland says. "For instance, in the menu mode, we use the left part of the left rocker for scrolling up, and the other for scrolling down."

In an effort to streamline the S25's interface, Volland was careful to make each of the phone's functions as simple as possible. With some mobile phones, a function like entering a new listing into the phonebook required the user to access the correct menu option on the display to accept new numbers, and perform a complicated series of steps to enter the number. The S25 allows the user to enter new phonebook entries directly from the phone's standby mode, with an automatic save option on the right softkey. The user is always aware what function is active on the display when entering information like this, since the function is shown in bold, and pulled out in a box.

A big selling point for contemporary mobile phones is the relative ease of one-hand operation- an essential quality to keep in mind when designing the S25 interface. "We made sure the user's thumb doesn't have to move a lot over the phone's surface when handling it," Volland says. "For example, to turn the ringer tone on or off, you just press and hold the 'star' key. Other phones use a combination of keys for that function, like opening the menu and pressing the 'star' key afterwards."

Beyond the interface of the S25, it was important for all the Siemens mobile and cordless phones to feature a similar design to create a brand consistency. "In my department, the cordless phones' user interface is also specified," Volland says. "Therefore, we can ensure consistency with the most important design principles by supporting all brands the same way. For example, the rocking softkeys are also used with our latest cordless phones."

RIGHT: In order to combine the uses of a variety of different business tools in one product, designers integrated aspects of PDAs into the S25's interface. The organizer provides users the ability to schedule events, use a calculator and currency converter and even beam electronic business cards to other users. Not only does this addition add functionality to the phone, but by incorporating this into the design of one product, it allows the user to rely on one tool for business use, instead of two.

OPPOSITE: The keypad was part of the S25's interface that was significantly scaled down from the previous version. Although several new functions were made to the S25 model, designers did not add more keys. In fact, they scaled down the size of the keys enabling one-hand operation and reducing the phone's size.

Streamlining Interaction

Possibly the most important part of any mobile phone's interface is its display screen. The display creates a dynamic exchange of information with the user by displaying information, and allowing the user to select functions onscreen. The display screen is literally the point of access for the various functions the phone has. In order for this interface to work effectively, the function of this screen had to be user-friendly.

It was necessary that the information onscreen was clear and easy to read, while displaying all the relevant information the user will need in order to access the phone's different functions. It was necessary that the interface had a consistency across functions so the user didn't have to learn different processes for each different procedure. Lastly, the user interface needed to be homogenous, while easily integrating different third-party software.

To meet market demands for portability, designers scaled down the size of the S25. The S10 was 147x46x25 millimeters, and weighed 185 grams. In comparison, the S25 was 117x47x23.5 millimeters, and weighed only 125 grams. However, one of the challenges of the new interface design was adding functions to a smaller overall unit. Since the display was the phone's most important source of interaction with the user, in order to convey the information and provide the necessary options to the user, it was necessary to keep the display at the same size. Where designers saw a great opportunity for scaling down the design was in the keypad area.

Far from a novelty, the S25's interface allowed users the ability to merge a variety of different information and communication with one tool and make that tool something totally portable. Although all the different bells and whistles the S25 includes may entice the user, it is the sleek interface of the phone that puts them to good use.

Dialog driven editor in s10

- just name or number visible on screen

- unnecessary display of SIM memory location

- two different cursors

- too much text

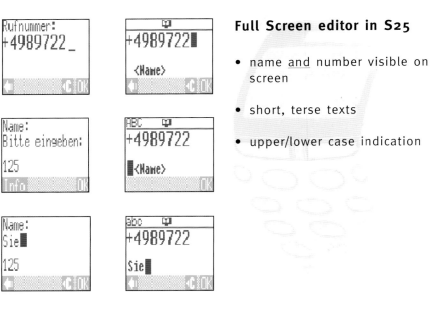

Full Screen editor in S25

- name and number visible on screen

- short, terse texts

- upper/lower case indication

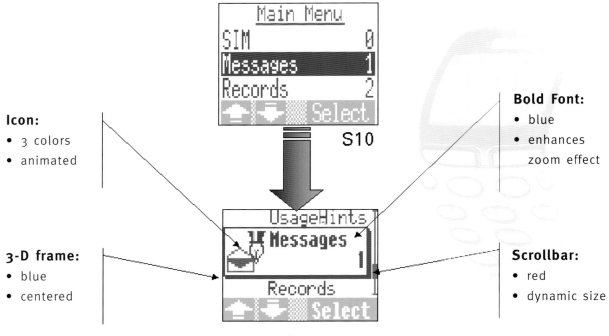

Icon:
- 3 colors
- animated

3-D frame:
- blue
- centered

Bold Font:
- blue
- enhances zoom effect

Scrollbar:
- red
- dynamic size

S25

OPPOSITE ABOVE: Since the display space was so small, it was necessary to use every pixel wisely. In the design of the S10 (left), the user could read only the name or number of the person they wanted to call—with the S25 (right), the user could see both on one screen. The S25 design also eliminated unnecessary text, replacing it with icons, and short, terse text. Lastly, a icon in the upper-left corner indicates if the user is typing in upper or lower case, for better control over information entered.

OPPOSITE BELOW: The interface of the menu in the S25 (bottom) eliminated the superfluous menu title found in the S10 (top: "Alert Tones"), allowing more space to convey information to the user. When a user uses the keys to select an option, it zooms in and gets bigger, allowing the user to know without a doubt which selection he has chosen. Icons are also used for added interest in the design, while the scrollbar shows the user where he is in the menu.

LEFT: In order make the phone even more portable, the design of the S25 (right) was scaled down from the side of the S10 (left). It was important to keep the display the same size, so it was comprehensible to users, and so they could easily navigate through the phone's functions. But keys on the keypad were made smaller, enhancing the user's ability to use it with one hand. The number of keys was not increased to accommodate the new functions, but instead they were consolidated into a streamlined keypad that took up less space.

BELOW: Even in its idle state, the S25 needed to convey a great deal of information. As a default, it indicated the date and time, the coverage area, charge level of the battery and operator logo. With the use of symbols and streamlined display area, the interface was able to convey more information to users at a glance.

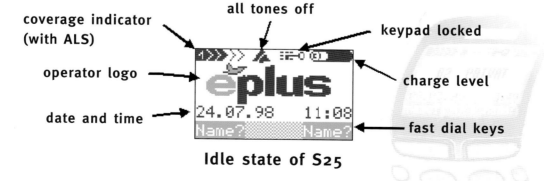

coverage indicator (with ALS)

all tones off

keypad locked

operator logo

charge level

date and time

fast dial keys

Idle state of S25

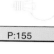

The metaphors used to describe the success or failure of other interfaces take on a literal meaning when it comes to environmental design. A poorly designed environmental interface may cause the user to literally get lost inside. Poor navigational clues—like confusing signage—may baffle users, and stand between them and the information they seek.

There are many qualities that make for a successful environmental interface—and many more that stand in its way. Too often, physical spaces are treated as a place to dump a lot of stuff, leaving it to the user to figure it out. Just as designers should dump every last piece of information about a company on its Web site, determining the contents of an environmental space is as important to a successful interface as the walls surrounding it. And although it isn't necessary to script the user's journey, subtle physical clues should lead the user from area to area. The most important goal of an environmental interface is to echo the nature of its content—the space as an extension of its occupants.

Following are three very different environments and how their interfaces contribute to their relative success. The first is a trade-show booth for Hammermill Paper's line, Via. It was important for this booth to meet the needs of both customers and sales representatives, while reinforcing the brand identity to the discerning audience of designers and

▶▶

‹ e n v i r o n m e n t a l i n t e r f a c e ›
NOT JUST
WANDERING AROUND

printers. The solution, as conceived by Williams and House consulting firm, was to keep it simple. The only signage you'll find is the Via brand name, and the brand's signature horizontal stripes are echoed in the products, walls, and overall design. Informal, lightweight chairs and storage buckets make for a casual atmosphere, and an easy way to customize the space. The booth's overall simplicity also makes it easy to pack up and travel from show to show.

The second section features a permanent exhibit showing off the features of Baan Systems software designed by Oh Boy, A Design Company. The software itself was sophisticated, specifically designed to meet the engineering needs of the aerospace and defense industry. When dealing with a subject matter this dense, it was necessary to design the space to convey information both generally in layman's terms, and more specifically for engineering experts. To convey basics of the software's function immediately upon entrance, Oh Boy designed an environmental interface that introduced users to the basics of the software's functionality through wall panels and applications to real-world projects. For those drawn in by the introduction, more in-depth information was provided through a series of kiosks. Keeping the interface flexible, the room was designed to be accessible both for self-guided tours and company presentations.

Retail space has forever been changed by the advent of the Internet—instead of competing with the store across town, retailers are finding themselves competing with e-commerce sites. To carve its own niche in this competitive industry, Levi's created a highly interactive and stimulating retail store in downtown San Francisco. More of a destination in of itself, the interface is designed liberally with original artwork, while hip music is piped in over the store's speakers. From films screened on the store's exterior after dark, to an in-house DJ booth, the store's interface is designed to stimulate the user's senses and creativity. As a way to provide unique products and services users won't find elsewhere, several personalization elements are incorporated into the store's design, including a shrink-to-fit in-store hot tub and 3D body scanner to produce measurements for the perfect fit of jeans.

Keeping the user in mind also means keeping an eye to their changing needs. Although environments aren't as easily modified as Web sites, the design of each environment's interface is intentionally flexible. The nature of current users is that they are fickle, and as the concept of meeting user needs through environmental interface design grows, environments will need to constantly evolve to meet the changing needs. All the while, the environmental interface must echo the nature of its content—the space as an extension of its occupants.
</environmentalintro>

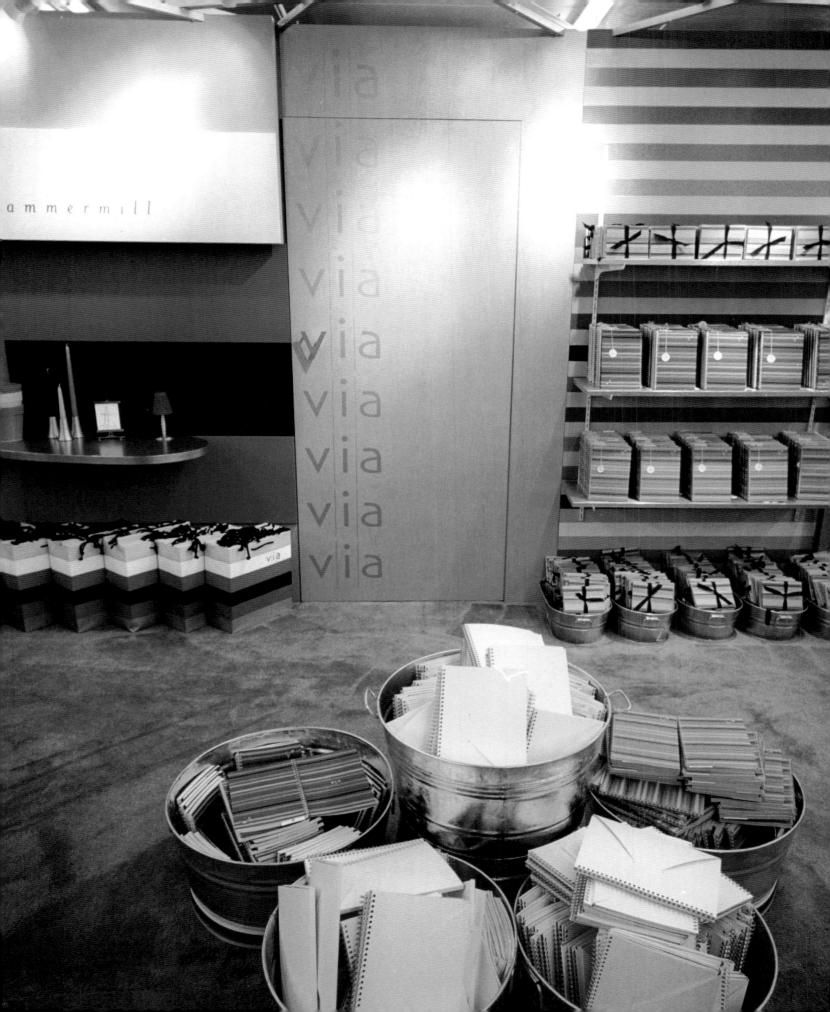

OPPOSITE: Every detail of the Via booth interface—down to the tiniest details—underscores the brand identity. Even the doorknob shown here reinforces the brand, by seizing the opportunity to incorporate the letter "V".

P:161

<williams and house>

‹ HAMMERMILL VIA TRADESHOW BOOTH: WILLIAMS AND HOUSE ›

WHEN DESIGNING AN INTERFACE FOR A TRADE SHOW BOOTH, YOU MUST CONSIDER THAT THERE ARE TWO FUNCTIONS THE BOOTH WILL SERVE. THE BOOTH IS MOST CONSPICUOUSLY A RETAIL ENVIRONMENT WHERE CUSTOMERS CAN INTERACT WITH SALES REPRESENTATIVES, LEARN MORE ABOUT THE PRODUCT AND/OR COMPANY, AND (HOPEFULLY) PLACE ORDERS. WHILE THE INTERFACE MUST BE AS CUSTOMER-FRIENDLY AND COMFORTABLE AS POSSIBLE, IT ALSO NEEDS TO BE PORTABLE, SHIPPABLE, AND ABLE TO TAKE ITS SHOW ON THE ROAD AT A MOMENT'S NOTICE.

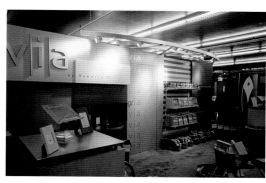

ABOVE: Instead of trying to use the exhibit's interface to pre-plan the user's experience in the Via booth, designers tried to do the exact opposite—design her own experience by allowing her to browse the area at her own pace... The space is intentionally open so the customer won't feel confined. Product is left out allowing visitors to browse freely and take samples of the products they are interested in without sales reps breathing down their necks. But visitors aren't left high-and-dry, either. At both ends of the booth stand two greeting stations. This allows Via sales reps to welcome users when they enter the space and provides a "home base" where visitors can go for help if they need it. The entire experience is very low-pressure.

These dueling factors were two of the main issues Williams and House, a strategic communications consulting firm based in Avon, Connecticut, faced when they took on the challenge to design a trade-show booth to support the launch of Hammermill Paper's new text and cover line, Via.

Conveying Personality

Since the target audience—designers and printers—is an aesthetically savvy bunch, the booth needed a stylish, sophisticated design. Customers needed to walk away remembering the Via name and understanding what makes it a great line of paper. From the beginning, Williams and House faced the unique challenge of making Via distinct from what Hammermill was primarily known for in the industry, which was the manufacturing of photocopy paper.

"We needed to find a way to get potential customers like designers and printers to start thinking about Hammermill in terms of premium uncoated text papers," says Pam Williams, principal of Williams and House. "In the text and cover business, everything has to do with the grade name, not the paper company. Our focus was really on the Via brand."

To cement the brand identity in the customer's memory, Williams and House, working with Memphis-based Matt Young of Chung Design, made the strategic decision to closely tie the booth's interface to the packaging of the product, and subsequently, the aesthetic and qualities of the paper line. "The first thing visitors notice when they look at the exhibit is the Via name, featured boldly," Williams says. "If they don't happen to catch it the first time, it's echoed on the wall next to it nine times. The next thing is the use of colors. Color is a primarily selling point for paper, and we were careful to reproduce the colors of the papers faithfully in the design."

Establishing Via's identity in a crowded premium paper market was no small task. For this, the Williams and House team developed a three-tiered personality for the brand, using the design to underscore these traits.

Since the end users—designers and printers—need to be able to specify paper in an uncomplicated way, the first trait of the booth's interface design was simplicity. "Everything in the exhibit is designed to reflect the simplicity of the paper line," Williams says. "The design is intentionally clean and very easy on the eye. To keep the focus on the product itself, the exhibit is devoid of any extra graphics or text."

In order to convey the different applications and versatility of the brand, the design team used the booth's interface design to convey the freshness of the brand. Using the brand's characteristic stripe patterns, a variety of different striped color combinations were created and applied to the different promotional products featured in the booth. "Each new pattern we create becomes a jumping-off point for a customer to think of how to use the Via products with their clients."

The qualities of versatility and freshness apply to the interface of the booth itself, a vital attribute from a user standpoint for the staff members who must tear down and reassemble the booth for different shows. The design had to translate well in different venues and not quickly look dated. "Depending on what's in the exhibit at any certain time, the stripe patterns in the exhibit combined with whatever promotional items are on display work together to convey a feeling of freshness," Williams says. "There's always something new, even in the backdrop."

Wide, Open Spaces

Accessibility was the third characteristic Williams and House felt was crucial to convey, not only through the booth's interface but through the products being featured. Customers need to move about easily in the space and find the information and products that they are looking for.

The interface was intentionally designed to be as open, airy, and unrestrictive as possible. The promotional materials are kept on shelving units in the exhibit. "Customers can walk up at their leisure and pick things up—we're careful not to use the exhibit's design to push the product on the customer," Williams says. "We want the customer to walk in and feel comfortable, not that they would be immediately attacked by piranhas."

Rather than designing the exhibit with the Via sales reps in mind, the booth's interface was created with the customer in mind, a nod to the user whose opinion mattered most in the booth's design. "We call it an exhibit, but like to think of it as an environment," Williams says. "We wanted to create a place that was comfortable, where customers would feel relaxed enough to hang out for a while. There are no enclosed walls, the spaces are open. Customers can enter from anywhere; they're not confined."

"Everything in the exhibit is designed to reflect the simplicity of the paper line," Williams says. "The design is intentionally clean and very easy on the eye. To keep the focus on the product itself, the exhibit is devoid of any extra graphics or text."

BELOW LEFT: One of the most successful qualities of the Via booth design is the accessibility of the product by the customer. Samples and promotional items are housed in galvanized tubs in strategic areas around the booth, inviting customers to pick them up. Shelves along the back wall allow the products to be shelved attractively, but also invite browsing since the space is open and inviting. Every detail is thought of in the design of the space, as a way to convey the brand's upscale quality.

BELOW RIGHT: Since lighting for the booth varies with the venue, the design team carefully designed a subtle lighting system for the booth. "We had to make sure that the colors in the booth stood out, no matter where the exhibit traveled or what kind of space it was in," Williams says. To ensure lighting consistency, designers created a light-support structure that juts out slightly over the back wall so it illuminates the colored stripes, but doesn't create a glare. Since the paper is uncoated, it was important to keep this reproduction faithful.

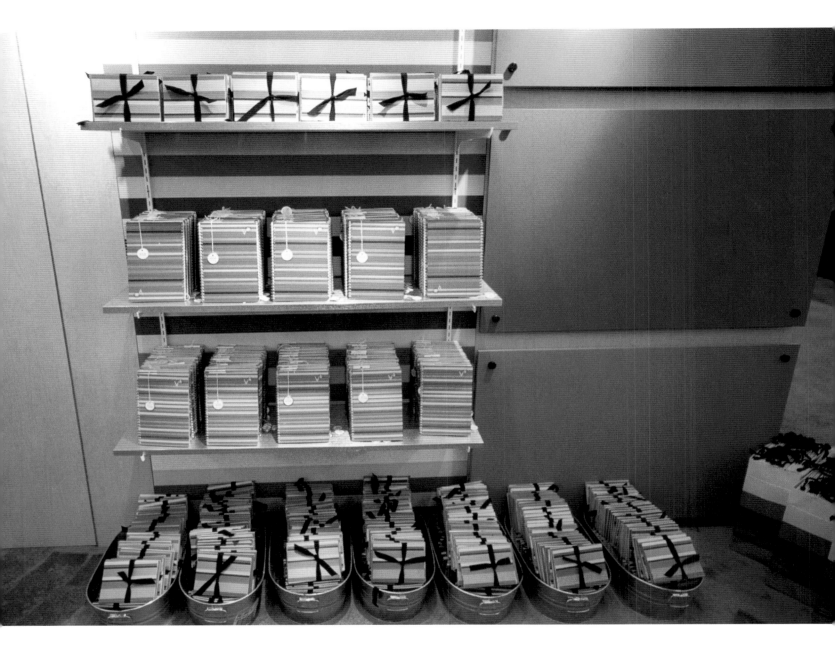

Facilitating Interaction

As important as it was to design the booth's interface so the customer could, in effect, browse without being disturbed, it was important that customers could also easily interact with sales reps when they were ready. The booth's interface was designed specifically so the customer would know exactly where to find a sales rep if she needed to.

"Imagine going into a small store, and there's a sales rep behind the counter," Williams says. "Sometimes you feel like the person behind the counter is watching your every move. It can be claustrophobic. Our booth was designed so if there's one person in there, the sales rep can disappear or be absent and let the customer browse. At the same time, there are greeting stations at either end of the booth that allow customers to easily ask for help if they need it. The booth's design allows the user to define the kind of interaction they want to have. This helps the sales rep in the sense that they can be comfortable in any area of the space."

Consistent with the functionality of a trade-show booth, much of the booth is easily customizable to the space it occupies. In addition to the shelving units along the back wall, the products are also housed in containers that change depending on the type of space. Sometimes galvanized tubs or storage units are used, so users can stoop down to pick up samples. "For storage, we used things that sit on the floor comfortably," Williams says. "They're always placed strategically so they're accessible."

Functionality

Although the idea of using plush, comfortable couches and chairs in the booth's design is attractive to anyone who has ever spent hours at a trade show, the design team decided to use lightweight chairs with this particular booth design.

"From a functional standpoint, we wanted people to be able to move around if they wanted to," Williams says. "The chairs are lightweight and can be moved around easily. But people can sit down if they need to."

Since the nature of the lighting was likely to vary depending on the venue where the exhibit would be, Williams and House paid special attention to designing the booth's lighting so the user's eye would be drawn to the important parts of the exhibit. The lighting structures jut out slightly from the back wall, illuminating the color bands. Since all the papers in the Via line are uncoated, the lighting is designed not to create a glare.

Another nice interface touch was the use of carpeting, creating a warm environment that is easy on convention-hall-weary feet. Besides the fact that carpeting makes the booth look more attractive, it has the added, subtle bonus of being a destination people are likely to spend more time in by virtue of comfort.

Although the primary emphasis of the interface design was tailor-making the booth to make the customer's experience as pleasant as possible, the sales reps' needs—the ones who would be spending the most time in the booth—weren't ignored. "There's a hidden closet in the middle of the exhibit to store materials," Williams says. "There's also room enough for a couple of people there so they can escape for a moment if they need to."

Less important to the functionality, but necessary for branding itself as thinking of everything, was the attention paid to the smallest of details. For example, the door handle of the exhibit's booth is a "V." "We wanted to achieve an upscale look," Williams says. "The entire exhibit conveys not only an upscale look, but the feeling that we thought through every detail."
</williams and house>

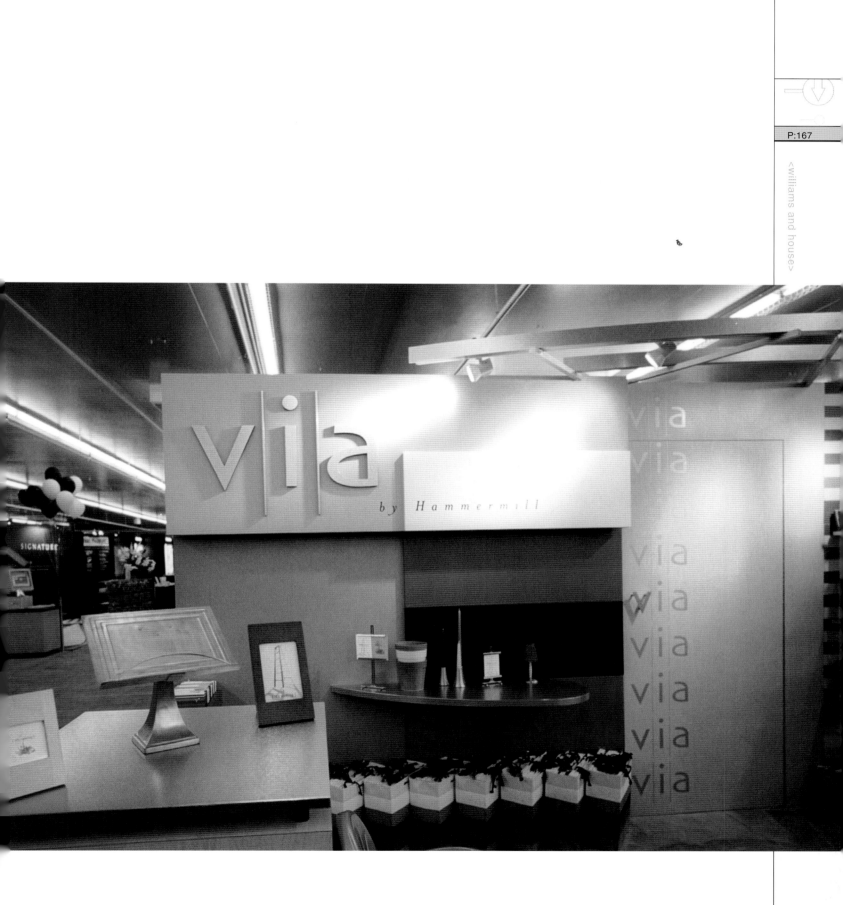

The Apache Helicopter

After the Gulf War, the U.S. Army's Apache Helicopter was thoroughly overhauled to include wide-ranging improvements in its communication system, airframe, and radar system. These complex technical changes substantially increased the Apache's flexibility to respond to battlefield changes.

For Aerospace and Defense, the end of the Cold War's collision with the exponential growth of the Information Age challenges the old verities of conducting business.

Incremental deregulation forces manufacturers to rethink traditional business processes and create hybrids that span the contract-driven world of defense and the project-driven world of commercial aviation. Made-to-order and engineer-to-order are more the rule than the exception. Key products are adopted constantly with each variation piled on to the one before it. Companies cut production costs by running design functions through a "virtual" environment that requires the most sophisticated information technology available. Global competition raises the quality bar; time to market speeds to a dizzying pace.

Managing a highly complex manufacturing project is always daunting, but these current issues combined with increased margin pressures—create an entirely new set of challenges for the Aerospace and Defense industry. Managers must respond quickly to changing requirements up and down the business flow. Real-time communication—from suppliers to subcontractors to customers—and the ability to view and control a project from start to finish are essential.

Baan's enterprise resource planning (ERP) software is the best tool for managing your critical business processes. It sharpens and expands your business vision. It pulls together your critical enterprise to help accurately forecast whether changes in business processes will enhance profits. And it helps you react to change, providing unprecedented control over all phases of your project.

< BAAN COMPANY EXHIBIT:
OH BOY, A DESIGN COMPANY >

KNOWING YOUR USERS AND FINDING A WAY FOR THEM TO CONNECT WITH YOUR DESIGN (AND THUS, PRODUCT) IS CRUCIAL TO SUCCESSFUL USER INTERFACE DESIGN. WHEN SAN FRANCISCO'S OH BOY, A DESIGN COMPANY WAS COMMISSIONED TO DESIGN A PERMANENT EXHIBIT DEMONSTRATING THE BAAN COMPANY'S SOLUTIONS FOR AEROSPACE AND DEFENSE, THEY NEEDED A WAY TO SELL BAAN'S PRODUCT TO THE BUYERS AND MANUFACTURERS WHO WOULD BE TOURING THE EXHIBIT. BUT THEY NEEDED TO DO THIS IN AN INTERACTIVE, ENGAGING WAY THAT SHOWED USERS EXACTLY WHAT MAKES BAAN'S PRODUCTS UNIQUE.

The exhibit needed to illustrate a variety of software components. First of all, it needed to facilitate both group presentations delivered by Baan staff and self-guided group tours by individuals. Simply, the design needed to lend itself to formal presentations and provide a way for users to interact with it and learn on their own. These were two qualities that drove the interface design from the beginning.

"When planning the installation, we decided that parts of it were going to be interactive and parts of it were going to be museum-like," says David Salanitro, Oh Boy's principal and creative director. "We spent a lot of time determining the best way to lead people through both independently and in guided presentations."

The suite of products (Baan IV) that Oh Boy was to represent in this exhibition were adaptable ERP (enterprise resource planning) solutions for the aerospace and defense industry. Successfully designing an installation for Baan's product involved using the installment to effectively communicate the malleable uses of the product suite and finding a way for users to personally understand the product's value to their enterprise.

Delivering The Information

"There are five components to the Baan IV ERP solution," says Salanitro. "Each component is customized to work for the end user and with other Baan and third-party software. Once an installation was complete, information about any aspect of a project was available and comparable to any other. Our challenge was to show the breadth and interactivity of Baan's ERP solution for aerospace and defense, and at the same time, illustrate its ability to drill down and provide specific information about project details."

OPPOSITE: When designing the kiosks, Oh Boy had a keen eye for the many different needs of the user. The glass panels on the side provide valuable information about the software highlighted there, and when they are flipped to the other side, they can be used as a whiteboard on which presenters can pen salient points. Keyboards can be pulled out to interact with the software, or stored away for a streamlined look. To eliminate visual clutter and keep the users focused on the kiosk itself and not on extraneous electrical paraphernalia, keyboards, mice, and cords are hidden in small keyboard trays that are only opened as necessary during a full-product demo. The most effective aspect of each kiosk's interface design is the fact that it focuses on specific software components, making the entire solution easier to comprehend.

The space needed to convey the different functions of each of the different software components and make the potential buyer understand fully what each did. To keep the user focused on each component, Oh Boy designed a series of five kiosks. Each kiosk was designed to include an onscreen overview of each component and testimonial videos from Baan users. Visitors to the Solutions Center could explore the exhibit solo, observing demonstrations running at each kiosk. When the time came for a more advanced presentation of the product, the kiosks pivoted to face the center of the room allowing product demos to be run by Baan staff. Each of the five software components ran one of the five kiosks. Visitors could stand in the midst of all the kiosks and see how any alteration to any component affected the other four.

Knowing The Audience

Possibly the biggest challenge when designing this installment from a user interface point of view was that there were two different potential users with two very different needs who would be interacting with the design. The first, and arguably the more important user, was the customer— the person who would potentially be purchasing this software. The second type of user was the Baan staff member who would be making presentations to more effectively pitch the product.

The construction of the kiosks is crafted to meet the needs of both Baan staff members delivering a presentation or prospective customers touring the exhibit. For instance, the kiosks are designed so they can swivel and move to accommodate both small and large group presentations— when a presentation is being made, the kiosks turned to face the audience. The use of a ceiling/floor track allows the presenters to move the kiosks closer together for small group presentations, and farther apart for larger group presentations.

Other details make the interface design tailored for the needs of both presenters and audience. For instance, hollow pipes hide the computer's cable wires, keeping the presentation neat and uncluttered, therefore preserving the streamlined look of the interface and subsequently ensuring that users focus on the exhibit itself. The individual kiosks were designed so the keyboards can be hidden during self-guided tours, but pulled out again so users can interact with the software during presentations. Another clever component of the kiosk interface is the glass panel alongside the kiosk. The panel includes information about a particular component featured in each kiosk and examples of how that component might be utilized. The panels were sandblasted, however, so they could also be turned around and used as a whiteboard during presentations.

The space needed to convey the different functions of each of the different software components and make the potential buyer understand fully what each did.

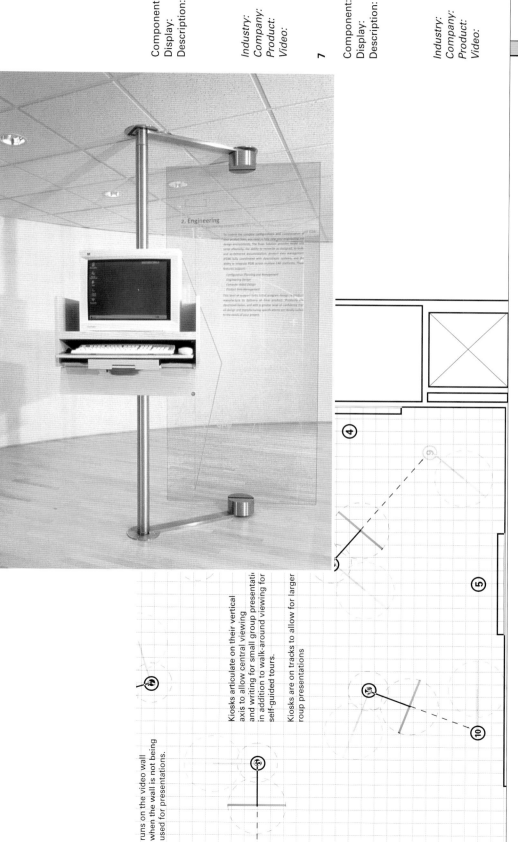

Component: Control/Finance
Display: Kiosk
Description: Material costs, labor, overhead, "earned value" (actual to estimated cost and time comparison), master schedule.
Industry: *Commercial Aircraft*
Company: *Boeing CAG*
Product: *777*
Video: *testimonial*

7

Component: Engineering
Display: Kiosk
Description: 1) Develop CAD drawings and solicit internal approvals electronically.
2) Develop Bill of Material and solicit internal approvals.
Industry: *Commercial Avionics*
Company: *Lockheed Martin Electronics.*
Product: *Radar*
Video: *testimonial*

2. Engineering

runs on the video wall when the wall is not being used for presentations.

Kiosks articulate on their vertical axis to allow central viewing and writing for small group presentati in addition to walk-around viewing for self-guided tours.

Kiosks are on tracks to allow for larger roup presentations

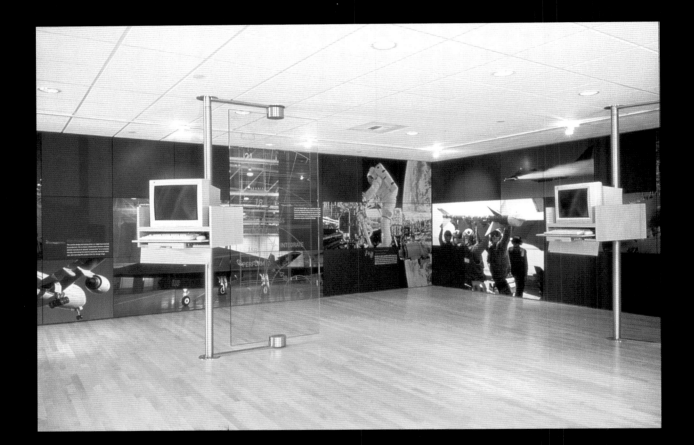

OPPOSITE: One of the most challenging aspects of designing this installation for Baan was the fact that there were two different users who would be interacting with it. The installation's design needed to facilitate use by individuals who were exploring the exhibit on their own and Baan employees who might be facilitating large or small group presentations. The kiosks were designed to move on floor and ceiling tracks and allow themselves to be moved to facilitate group presentations. The surrounding walls echo the messages that each kiosk conveys, using real-life examples of the applications of the Baan software pieced together with a grid system.

BELOW: The interface of the panels alongside each kiosk were designed to provide information about the software's different functions as the users attend a presentation or interact directly with the kiosk. The back side can be used as a whiteboard during presentations.

9718 BAAN Floorplan.B/rev1

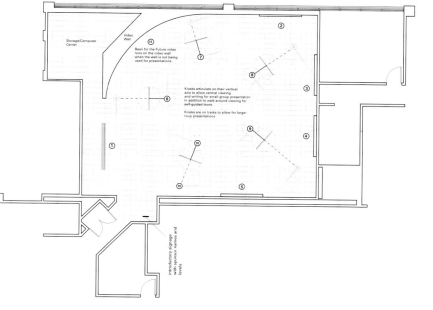

1-5

Model:	1. Concept
	2. Engineering
	3. Planning
	4. Manufacturing
	5. Assembly

6

Component:	Control/Finance
Display:	Kiosk
Description:	Material costs, labor, overhead, "earned value" (actual to estimated cost and time comparison), master schedule.
Industry:	Commercial Aircraft
Company:	Boeing CAG
Product:	777
Video:	testimonial

7

Component:	Engineering
Display:	Kiosk
Description:	1) Develop CAD drawings and solicit internal approvals electronically. 2) Develop Bill of Material and solicit internal approvals.
Industry:	Commercial Avionics
Company:	Lockheed Martin Electronics.
Product:	Radar
Video:	testimonial

8

Component:	Planning
Display:	Kiosk
Description:	Distribution of Bill of Material and plans, electronically. Schedule internal labor and sub-assembly.
Industry:	Commercial Avionics
Company:	Lockheed Martin Electronics.
Product:	Radar
Video:	testimonial

8a

Component:	Change Order
Display:	Sublevel Signage

9

Component:	Subassembly
Display:	Kiosk
Description:	"Planned POs" (issued electronically), sub-assembly manufacturing and quality control.
Industry:	Defense Electronics
Company:	Transfield Defense
Product:	Navigational Equipment
Video:	testimonial

10

Component:	Final Assembly
Display:	Kiosk
Description:	On site fabrication, on line assembly instructions, on line "shop orders" (internal POs), resource capacity.
Industry:	Space
Company:	Rockwell
Product:	Tiles for Space Shuttle
Video:	testimonial

11

Component:	Baan for the future
Display:	Video Wall.

"The engineers at Baan were uncomfortable giving presentations without whiteboard," Salanitro says. "We designed the graphics on the glass panel to be unobtrusive when seen in reverse. That way, the presenter could turn them around and write on the other side."

Bringing It All Together

The software's strength revolves around the notion that it would allow engineers to determine what components of a product needed to be upgraded and replaced to meet new expectations, and develop a way to strengthen those without having to rebuild the entire machine. Instead of requiring engineers to start from scratch when they wanted to upgrade the design of their objects, the software allowed the user to retain existing components that worked and only make changes when necessary. This concept—called the "legacy system"—inspired the installation's design.

Oh Boy carried the concept of a legacy system through to the installment's interface design—mirroring this quality with the interface design was crucial to creating a successful exhibit. A grid of 30-inch panels on the walls were posted, jigsaw-style, to convey a variety of information about the Baan products and their application to real life. For instance, one section of the wall includes different panels that piece together the image of an Apache Helicopter. But a panel including written information about the Baan software and its application to the helicopter's design completes the picture. This modular grid system allows Baan to easily replace panels should information become outdated or panels damaged. The panels were designed so that they can easily be removed and replaced, much like the theory behind the legacy system itself.

BELOW LEFT: To give the complicated software a real-world orientation, the interface was designed to highlight high-profile Baan projects. For instance, these panels serve to introduce the user to objects like the Sidewinder Missile and show how Baan's software played a role in its production.

BELOW RIGHT: The exhibit's interface was designed to be analogous to the software itself. Baan's product allows users to make individual modifications to units; the panels lining the exhibit's walls were done in a grid, mimicking Baan's product by allowing different panels to be swapped out for new ones as improvements are added to the software's functionality over time.

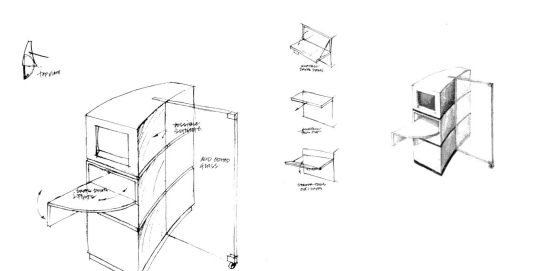

Another way the gridded walls worked with the design of the installment was through a synergistic relationship with the kiosks. The exhibition was designed so that during the self-led tours, the users could interact with each kiosk individually, but when they looked up at the facing wall, they would see information about the software they were interacting with. While the interface of the kiosk design focused on the individual applications of the product, the surrounding walls brought the entire exhibit together. Each is devoted to a different kind of functionality and illustrates possible industry applications, from space to commercial avionics.

Thinking Through The Details

A successful interface—especially when dealing with environmental design—requires making every inch count. Subsequently, every detail of the 2,500 square foot room was put to good use. A curved wall along the northwest side was used to run a continuous video on the Baan systems, when it wasn't already being used for presentations. Hidden behind the curved wall are the computers.

Self-guided tours direct visitors around the circumference of the room when the kiosks are articulated outward on their pivoting axes. However, when the kiosks are turned inward, visitors gather in the center of the room to view all five kiosks at once. The entire package's streamlined, clean design subtly underscores the focus of the software while keeping the focus where it should be—on the product.

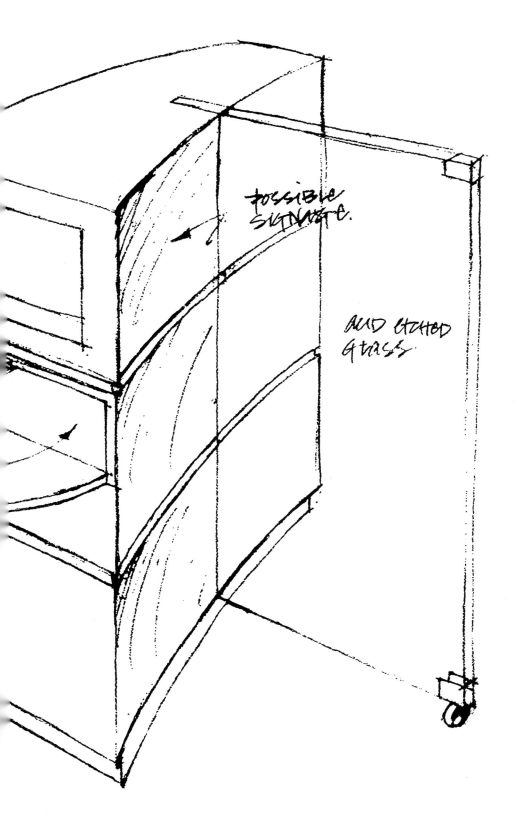

POSSIBLE SIGNAGE.

ACID ETCHED GLASS

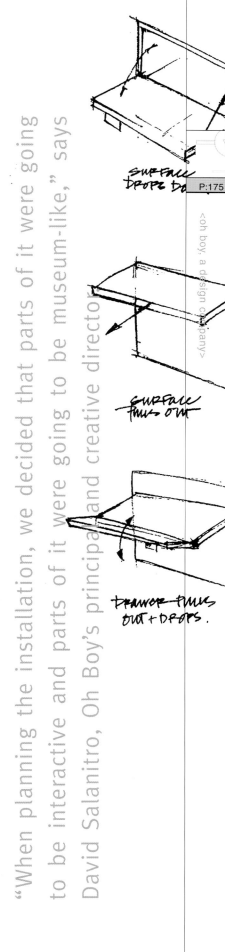

SURFACE DROPS DO

DRAWER FALLS OUT + DROPS.

<oh boy, a design company>

"When planning the installation, we decided that parts of it were going to be interactive and parts of it were going to be museum-like," says David Salanitro, Oh Boy's principal and creative director

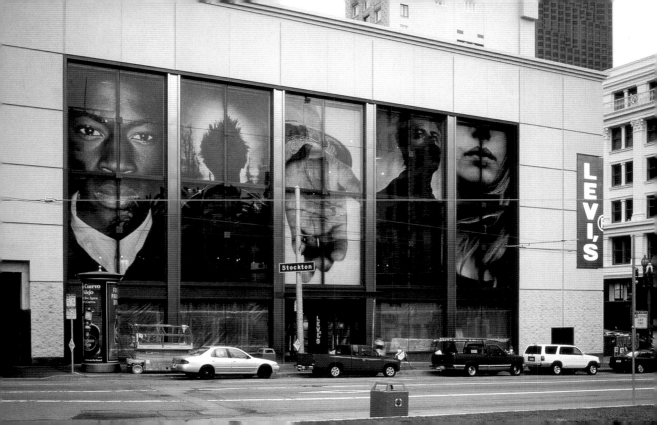

OPPOSITE & BELOW: The store's interface design starts with its facade, the designers' way of enticing users in off the street to come explore the store. During the day, three-story windows display black-and-white fashion photography, a high-art, sophisticated way to attract interest. At street level, artistic, unconventional window displays created by artists both pique the interest of passersby, while promoting the brand by using Levi products as the medium. When illuminated from within, the store advertises its urban/industrial design.

‹ LEVI'S RETAIL STORE ›

THE INTERNET HAS CHANGED US FOREVER AS CONSUMERS. WE CAN NOW QUICKLY ACCESS MILLIONS OF ITEMS FROM OUR HOME COMPUTERS, ORDERING BOOKS, CDS, CLOTHING, EVEN CARS ONLINE—WHILE WEARING NOTHING BUT OUR UNDERWEAR. HOW'S A REAL-WORLD RETAIL ENVIRONMENT TO SURVIVE THE ADVENT OF THE VIRTUAL MARKETPLACE? BY TAKING SOME TIPS FOR IMPROVED INTERACTIVITY FROM ONLINE RETAILERS AND GIVING CONSUMERS A REASON TO PUT ON SOME CLOTHES AND GET OUT FROM BEHIND THE SCREEN.

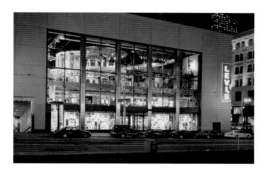

The interface of the Levi's San Francisco Store fuses entertainment and interactive elements to engage the target demographic—customers aged 15-24—in a unique shopping experience. The four-story, 24,000 square foot store includes a DJ/VJ booth with listening stations where customers can sample new music and an in-store communal tub where visitors can don their new jeans, hop in, and shrink them to fit. A customization factory on the third floor allows customers to have their items personalized with everything from traditional embroidery to space-age laser etching. A modernistic 3D body scan machine takes precise measurements and prescribes the appropriate perfect size jeans for the consumer. Take that, Amazon.com!

"The design of the Levi's San Francisco store is all about creating an experience for the consumer," says Jimmy Hornbeak, Creative Director and Curator for Levi's Global Retailing. "We wanted the store to be young. We wanted it to break the retail mold and create a youthful environment where kids could shop and find things in a great environment. But also along the way, we wanted to get customers to interact with the space, as a way to heighten the experience."

From The Outside In

The interface design strategy of the Levi's store begins with the building's exterior, which is created to entice customers inside from San Francisco's bustling Union Square shopping district. The exterior is designed to attract customers in two ways. From a distance, passersby can't help but notice the enormous black-and-white fashion photography displayed in the store's series of three-story windows. Yet, at street level, people walking by see compelling window displays that are created by local artists. Instead of mannequins and setup displays, the street windows feature artistic compositions, often using the store's clothes as the media. "We wanted to create conversations with the customer on two levels," Hornbeak says. "The large fashion photography on the outside scrims attracts customers to the space. But when they get close to the building, we're able to have a more intimate dialogue with them through the street windows."

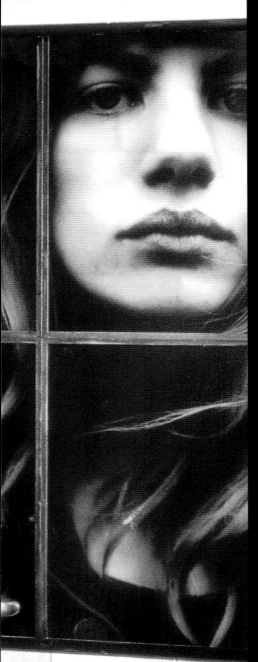

At night, the store's exterior interface reinvents itself altogether. Three of the immense store windows become makeshift projection screens, where independent films are shown from 8-11 every night. Keeping with the store's endorsement of creative spirit, the films are chosen in partnership with ifilm.com, an Internet-based independent film distribution channel and online community. "The projection screens really change the store's exterior," Hornbeak says. "The facade becomes alive when you put a moving picture on it. It becomes much more interesting and stimulating."

Interior Navigation

Considering the size of the store and variety of unique elements incorporated into its design, it was crucial for the store's interface to have clear navigation. The first, and most practical way this is done is through a series of store directories projected on television screens that identify each floor and what the consumer will find in each place. The different floors are segmented according to product and the subsequent sentiment Levi's hoped to convey in that area.

Another way users can navigate through the space is a bit voyeuristic—through the use of video periscope directories that allow visitors to take a virtual tour of the space. Located immediately inside the store's main entrance, each periscope is connected to four remote-control video cameras that allow the user to pan, zoom, and spy on any floor in the store via real-time video feed. Text prompts on the periscopes allow users to find the information they want and virtually jump around the space for a preview when they first walk in.

Beyond the visual devices used to orient the customer, the store's interface design itself is designed to guide customers instinctively from one area to the next. "The space is designed so the customer will flow easily from one area to the next," Hornbeak says. "The curvature of the Vortex—the spiral staircase featured in the center of the store—guides the customers to each floor with artwork and film acting as stimulus along the way. The space is designed to be very open, so you can peer up into different levels. Even the elevator is glass."

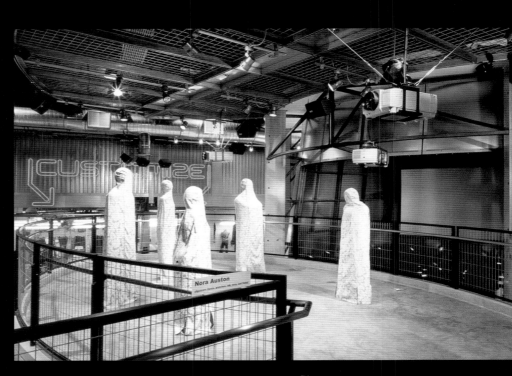

"The space is designed so the customer will flow easily from one area to the next," Hornbeak says.

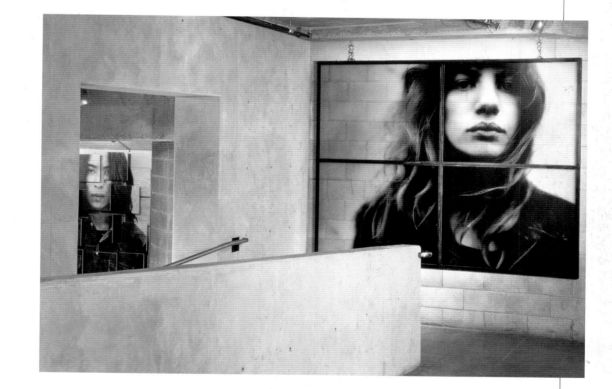

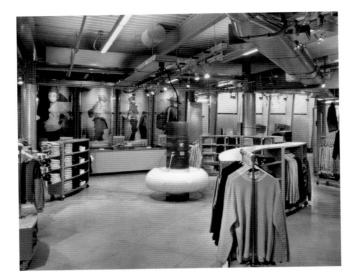

Curating A Retail Space

The store's first level includes a collection of higher-priced premium products like Levi's Vintage Clothing, Crinkle 501 (from Japan), and Levi's American Red Line brand. This floor's interface is designed to focus on the glamour of these brands. For instance, the product displays are designed more like art exhibits than retail displays. Instead of creating traditional displays featuring mannequins outfitted in the featured clothes, the product displays are very unconventional. For example, jeans are twisted and stretched out on wires, creating a sort of modern-art piece using the jeans as a medium. "I wanted to curate the space as one would a gallery or museum," Hornbeak says. "Part of this was thinking through every step the customer would take in the store—what they saw, heard, and smelled at each juncture. We kept the customer's point of view in mind throughout the entire process. The store's design is about individual expression, so we wanted to set things up with a sort of gallery sensibility. It's about stimulating people aesthetically."

And as with an art gallery, the art and film on exhibit is constantly changing. "There's always something new," Hornbeak says. "The digital exhibits are constantly changing, the gallery exhibits are replaced with work from new and different artists. It gives customers a reason to come back and see what's new."

Consequently, it was necessary for the store's interface to lend itself well to flexibility, to accommodate the changing exhibits. "We developed a fixture system that's very flexible," Hornbeak says. "The fixtures can be easily be turned, moved, or modified—even the dressing rooms are designed to be mobile. The store's design was about breaking the retail mold and reinventing ourselves."

A Balance Of Product And Entertainment

From the first level, the space loops around into the Vortex, which features three video screens that constantly project work by independent filmmakers. As the customer makes his way up to the second level, he may pause to watch these films, examine the artwork along the perimeter where artists have used Levi's jeans as their media, or check out the small monitors embedded in the wall featuring experimental animation.

The interface of the second level is designed to focus more closely on fashion, featuring a wide range of Levi's domestic and international products. The floor is separated, with women's clothes on one side, men's on the other. The dialogue with the consumer was an extremely important quality of the store's interface design. Even the tags identifying the gender and sizes of the clothes were given careful consideration in response to target consumers. "Most of our signage is created in four languages: Japanese, German, Spanish and English," Hornbeak says. "We chose these languages because they are the leading nationalities of shoppers in the Union Square area."

The store's interface tries to anticipate and accommodate every customer need in this space, and it uses the power of the Internet to allow customers access to items outside the store. Terminal connections to levi.com are incorporated into the second level's interface, allowing users the option of ordering items online.

< levi's retail store>

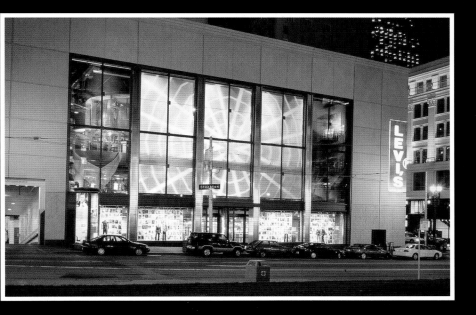

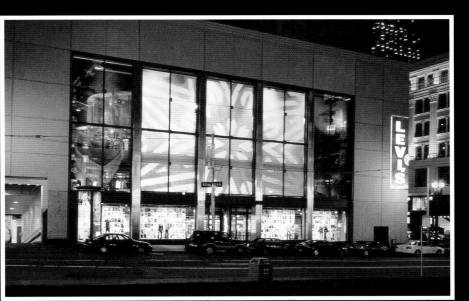

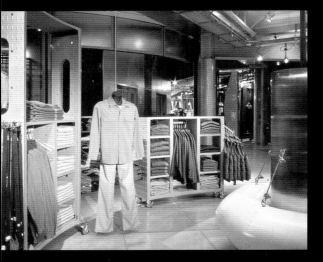

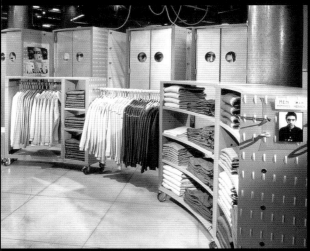

Entertainment Options

The second level is also where serious entertainment—driven e[...] incorporated. One of the most prominent ways the store reach[...] is through the DJ/VJ Booth, six different listening stations, and [...] customers can buy vinyl or CDs. With this area, what the store[...] destination where customers won't mind hanging out and prov[...] something they aren't likely to find elsewhere in a retail store.[...] have DJs come in to play music," Hornbeak says. "All the musi[...] throughout the store is part of a carefully curated mix that is [...] to the time of day."

Another fun element incorporated into the store's interface on [...] is the Image Catcher photo booth. Here, visitors can get their [...] and superimposed against a variety of different San Francisco-i[...] backdrops (like runaway cable cars or high-rise Victorians). Bet[...] choose to email this image to up to 10 people, or make it into [...] screen savers. "We wanted to create throughout the store way[...] visitors to interact with the space," Hornbeak says. "The Image[...] become very popular with visitors—it has really sparked their [...]

Personalization and Expression

One of the elements that makes the Internet sales interface suc[...] to accommodate a great degree of personalization and customi[...] these ideas and incorporated them into the store's interface us[...] low-tech elements. On the store's third level, the interface desi[...] taking the stimulation gleaned from the rest of the store and g[...] ability to channel that inspiration into personal expression. "W[...] design, we hoped to create a space that would stimulate the v[...] Hornbeak says. "By the time customers get to the third level, v[...] inspired to develop something that's their own personalized pr[...] store's design speaks to self-expression."

One of the ways that the store's interface invites customers to [...] passive consumers, but take a role in creating their own perso[...] through a customization area. This "factory" is where users can[...] bought in the store and customize them by adding embroidery,[...] abrasion heat transfer, and fabric ornamentation. The area feat[...]

One of the ways that the store's interface invites customers to not merely be passive consumers, but take a role in creating their own personalized items, is through a customization area.

< levi's retail store >

BELOW: The interface of the entire store is connected by a central spiral staircase designers called the "Vortex." This area includes three independent projection videos and surround-sound environments that project experimental films and smaller monitors featuring animated short films. Periodic art exhibits are included around the perimeter, while its design allows visitors to peer up through the open space to any of the floors. The Vortex pulls the design concept of art and music together in one place, while allowing customers to navigate to any floor.

The store's interface supports its customers' individuality by giving them the opportunity to get a custom pair of jeans designed according to their specific measurements using sophisticated technology. Instead of trying to fit every person into a predetermined size, the Levi's Original Spin 3D Body Scan takes the user's measurements, allowing tailor-made jeans specifically designed for the user. The interface of the Original Spin itself is very interactive. First, users select from three different styles, five different fits, 10 different fabrics, and button or zipper fly at the Original Spin terminals. Users then enter a dressing room, remove their clothes, and in special garments, enter a chamber where the computer talks them through the process while they are scanned in total privacy. The jeans are made and mailed later to the customer according to their unique specifications.

Even more space age than the Original Spin when it comes to personalization is the Biometrics Finger Scanners that are positioned at several points throughout the store. After registering their identification information on the store computers, customers can simply scan their index finger and log in. By scanning their finger, they are recognized by name at the CD Listening Stations, Levi's Original Spin, levi.com terminals, and Image Catcher. "The finger scanner allows us to be very responsive to consumers," Hornbeak says. "By allowing us to greet customers by name in different parts of the store, we're able to have a more intimate conversation with our consumers."

When using something as personal as the fingerprint scanner with the store's design, it was necessary to amply protect the customers' privacy. When a customer registers his fingerprint, a screen spells out how the information will be used, provides a disclosure agreement, and lets him know he has an option not to proceed. "Whether you choose to be part of that experience or not is your choice," Hornbeak says. "If you don't want to register your fingerprint, you can still do anything in the store. The fingerprint scanner just acts as a sort of password that allows you to customize your experience more easily."

The willingness to provide this information has become largely a generational issue. Often, younger customers who have grown up on computers are more likely to volunteer this information than their parents. "Young people aren't cynical about giving out information about themselves," Hornbeak says. "Maybe it's because the younger generations haven't had to fight for the privacy issues that the older generations have, but they are more willing to provide this information."

Possibly the most memorable interactive customization element of the store's interface is the Shrink-To-Fit tub. Users have the opportunity to don their new pair of jeans, and soak in a hot tub in the middle of the store so the jeans will shrink to fit perfectly to their body. They can then either stand in a waist-down Human Dryer (while watching videos on monitors above), or throw their jeans in a commercial dryer and keep shopping. Not only are users able to specifically customize their jeans to fit, but the tub creates a fun interactive elements with other customers. "If you come in on a Saturday afternoon, you may find many people sitting together in the tub," Hornbeak says. "It may seem surprising that people want to come in, take their clothes off, put on disposable underwear and their 501 jeans, and get in a tub in front of a store with other people. But it becomes interactive for everyone—the people in the tub, and the others watching."

<levi's retail store>

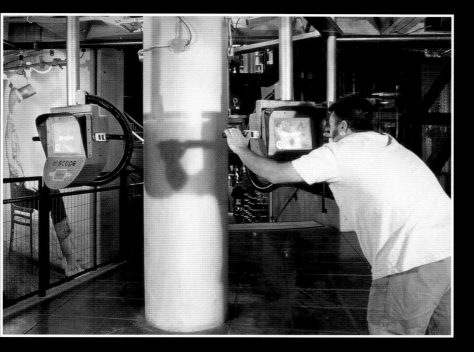

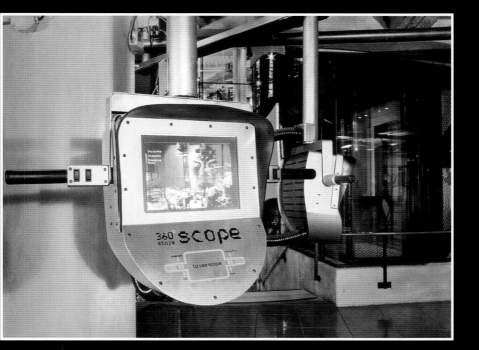

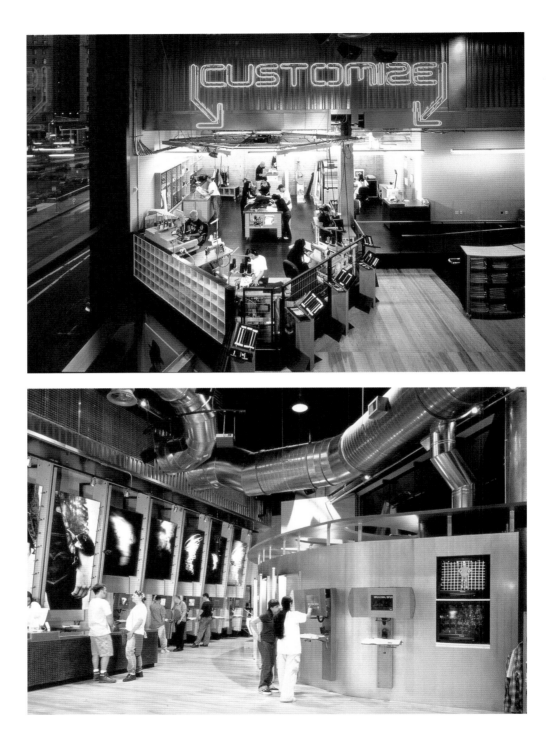

OPPOSITE ABOVE: On the third floor, Levi's offers users a customization area, where they can add embroidery, etchings, heat transfers, hand painting, and just about anything else to their jeans. This area was designed to reside on the third floor, because designers hoped the art exhibits, music, and screenings on the first two floors would inspire customers to create artistic creations of their own.

OPPOSITE BELOW: Anticipating and meeting user needs was a concept that drove the store's interface design. With the Levi's Original Spin body scanner, Levi's hoped to meet what many may have considered to be an impossible dream—a device that scans the user's body, producing the perfect-fitting pair of jeans. Customers don a special body suit, enter a chamber, and the computer talks them through the scanning process. The measurements taken are used to produce a custom-made pair of jeans for the user.

BELOW: Customization was one of the guiding factors influencing the store's interface design—yet not every effect was necessarily high-tech. The shrink-to-fit tub allows users to put on their new jeans and hop in, shrinking them to fit. To dry, they can either stand in a waist-high human dryer or change, throw the jeans in a conventional dryer, and keep shopping. Designers found this was a way users even interacted with each other. "If you come in on a Saturday, you might find eight people in the tub together," says Hornbeak. "It becomes interactive for everyone."

Pulling It All Together

Following the Vortex stairway up to the fourth floor, the focus is entirely on artwork, not Levi's product, bringing the focus back to entertainment, individuality, and creativity. This area serves as a space for featuring exhibits of multimedia, photography, sculpture, and fine art. But the way the store's interface is constructed, the fourth floor also acts as means of pulling the entire store together. You can peer down through the different levels and get an overview of the entire store. The store's open design not only invokes interest, but also gives users visual orientation for where they are and where they'd like to go in the store.

"As you walk up the stairs, to the fourth floor art gallery, you can glance down over many levels," Hornbeak says. "This area serves as a good vantage point for the store. As this is the last stop, we hope people leave this space sensing the Levi brand's originality and become inspired to buy by the blend of fashion, music, and art that they just experienced."

The overall interface of the store pulls together a retail experience where the space actively interacts with the consumer, and encourages the consumer to respond. By taking many of the elements that have made online sales successful and integrating them into a real-world retail environment, Levi's has created a space specifically for the preferences and shopping habits of its customers, and creating a unique retail experience at the same time.

‹ directory ›

Cahan & Associates
171 Second St., Fifth Floor
San Francisco, CA 94105
415.621.0915
www.cahanassociates.com

Chronicle Books
85 Second St., Sixth Floor
San Francisco, CA 94105
415.537.3730
www.chroniclebooks.com
frontdesk@chroniclebooks.com

Elizabeth Arden
1345 Avenue of the Americas
New York, NY 10105
212.261.1140

IDEO
Pier 28 Annex
The Embarcadero
San Francisco, CA 94105
415.778.4700
www.ideo.com

Itch
Studio B3L
Metropolitan Wharf
Wapping Wall
London E1 9SS
44 (0) 171 265 0146
www.itch.co.uk
mail@itch.co.uk

Levi-Strauss
1155 Battery St.
Levi-Strauss Building
San Francisco, CA 94111
415.544.6000
www.levistrauss.com

MetaDesign Berlin
Bergmannstrasse 102
D-10961 Berlin
(030)69 57 92-00
contact@metadesign.de

Oh Boy, A Design Company
49 Geary St., Suite 530
San Francisco, CA 94108
415.834.9063
www.ohboyco.com
postmaster@ohboyco.com

PetWORKS
2-7-4 Higashi Shibuy A-Ku
Tokyo, Japan
150-00181-3-5408-2535
www.petworks.co.jp

Plumb Design
157 Chambers St
New York, NY 10007
212.285.8600
www.plumbdesign.com
info@plumbdesign.com

Sagmeister, Inc.
222 W. 14th St. #15A
New York, NY 10011
212.647.1789
ssagmeiste@aol.com

Siemens AG
Wittelsbacherplatz 2
D-80312 Munich
Germany
www.siemens.com
www@siemens.de

Speak Magazine
301 8th St., Suite #240
San Francisco, CA 94103
415.431.5395
publish@speakmag.com

Erik Spiekermann
Motzstrasse 58
D-10777
Berlin, Germany
40 30 2147-3017
erik@metadesign.de

Volkswagen of America, Inc.
3800 Hamlin Rd.
Auburn Hills, MI 48326
248.340.5000
www.vw.com

Williams and House
296 Country Club Rd.
Avon, CT 06001
860.675.4140
williams.and.house@snet.com

Wired Digital
660 Third St.
Fourth Floor
San Francisco, CA
415.276.8400
www.hotwired.com

Yahoo!
3420 Central Expressway
Santa Clara, CA 95051
408.731.3300
www.yahoo.com

‹about the author›

Lisa Baggerman is Web Site Manager for Chronicle Books in San Francisco, California, where she oversees the design and content for chroniclebooks.com. Formerly Senior Editor for *HOW* magazine, she has written extensively on design and technology issues.